Pray God and Keep Walking

Pray God and Keep Walking

STORIES OF WOMEN REFUGEES

by

BEATRICE NIED HACKETT

with a foreword by JUDY MAYOTTE

McFarland & Company, Inc., Publishers
Jefferson, North Carolina, and London

British Library Cataloguing-in-Publication data are available

Library of Congress Cataloguing-in-Publication Data

Hackett, Beatrice Nied, 1933–
 Pray God and keep walking : stories of women refugees / by
Beatrice Nied Hackett ; with a foreword by Judy Mayotte.
 p. cm.
 Includes bibliographical references and index. ∞
 ISBN 0-7864-0089-7 (lib. bdg. : 55# alk. paper)
 1. Women refugees—Interviews—Case studies. 2. Women
refugees—Social conditions—Case studies. I. Title.
HV640.H29 1996
362.87'082—dc20 95-36699
 CIP

Manufactured in the United States of America

McFarland & Company, Inc., Publishers
 Box 611, Jefferson, North Carolina 28640

For those women and men
who fled their countries to perish with untold stories

and for
Georgia, Katherine, Juliana, Caroline,
Phillip, Sawyer, Tyler, Amelia, Patrick, John Henry, and Peter
who I hope will never have to look far for safety

TABLE OF CONTENTS

FOREWORD

by Judy Mayotte

In our world today there are 18 million refugees who have fled their homelands and crossed international borders and more than 25 million internally displaced within their own countries. Women and children comprise 75 to 80 percent of all displaced populations. The numbers are staggering, and we are numbed by viewing masses of them on our television screens weakened and dispirited: the Ethiopians, Cambodians and Vietnamese in the 1970s and 1980s, the 60-mile column of Kurds inching over rugged mountain terrain in 1991, and more recently boatloads of Haitians interdicted at sea and returned to Haiti. In this book Beatrice Hackett allows individual voices to be heard—one by one, for she recognizes each refugee woman as an individual with a unique history and story. Each voice rises out of the masses to become the woman she is—transformed by the experience of being a refugee. These women speak for all who are fleeing today from and within Bosnia-Herzegovina, southern Sudan, Rwanda, Burundi, and Peru; or who remain in refugee camps in Pakistan, Malawi, or Mexico; or who are returning to war-torn homelands like Mozambique, Cambodia, and Eritrea.

Resettled in the United States and Germany, these women recount their passage through the horrors of unrest and war to a new life. With transformed identities, they have determined against all odds to move beyond mere survival and to grow where they are planted.

The human cost of displacement is immeasurable, as the stories of these women attest. At one time they were rooted in the security of family, tradition, and homeland. Violence shattered their security into a million

Dr. Judy Mayotte is past-chair of the Women's Commission for Refugee Women and Children and is a board member of the International Rescue Committee. She is the author of Disposable People? The Plight of Refugees *(1992) and is the 1994 recipient of the Mickey Leland Award for her work on behalf of refugees.*

fragments and sent them fleeing, family members often separated from one another, everyone separated from home. Those who were wives and mothers suffered physically, psychologically, and spiritually, for they not only lost their material possessions when they fled, but frequently faced the fragmentation of their families and the loss of their dignity and self-esteem. Many left their homes on a moment's notice, were forced to leave loved ones behind and lost children along the way. They were stalked by violence, imprisoned, tortured, and were raped and exploited by soldiers and thugs.

With their lives centered on their families, caring for and nourishing their husbands and children, these women were not prepared for the very fabric of the family to be torn apart. They were not prepared for separation or widowhood, especially when they were left with children to raise. Coming generally from societies in which women are dependent on men, most did not feel competent when thrown into the unaccustomed role of bread-winner in a strange country with unfamiliar customs and language. If husbands were present, they too were thrust into unfamiliar roles, and many could not adapt or prosper in a new society. Their women had to keep their spirits up and be attentive to their husbands' breaking points and their potential for violence against those they loved most when their feel-ings of emasculation took them to the edge.

Though sapped by the trauma of flight, there were sparks of energy within these women that were ignited. They brought with them into exile their skills, education, knowledge, culture, experience, plans and visions for the future. With these they recreated their lives and families.

Of those who were children when they fled, many ran only after they had witnessed the destruction of their town or village and the massacre of those they knew and loved. Childhood ended abruptly and the children began to preface their thoughts about the future with "If I grow up," rather than "When I grow up." Among those who survived and were inserted into a new culture, many, particularly teenagers, found it difficult to learn a new language and new customs, and to adapt to the ways of strangers who were now their peers.

The vast majority of refugee and internally displaced women do not settle in a third country like the United States or Germany. Most often, they flee from some of the world's poorest countries and receive asylum in countries just as desperately poor. Most of today's 18 million refugees have lived at least five years in exile—some for as many as thirty or forty years. In large, crowded camps, refugees attempt to resume a semblance of nor-malcy, even though they are forced to rethink and reshape their lives.

With the end of the Cold War and the surrogate conflicts fueled by

the cold warriors, many refugees are returning to their war-torn homelands of Eritrea, Mozambique, Cambodia, Ethiopia, Afghanistan, and others. These countries are starting from scratch. The infrastructure has been decimated. There are few or no roads, schools, hospitals, or even clean water. Land has not been tilled or cleared for years, and much of it is strewn with mines—literally millions of them that will kill and maim without discriminating between the footfall of a soldier, a woman planting rice, or a child playing in a field.

With no economic base, there is no way to rebuild unless each country receives massive infusions of support from donor nations. But changing strategic interests and domestic economic problems in donor countries offer little hope that sufficient money will be forthcoming for assistance in returning millions of refugees or in rehabilitating the land. These countries can be viable, productive nations if we lend a hand in helping their citizens reestablish their homelands and broken lives. It is vital to our national interests and to the peace and security of the world that we act. In fact, we cannot afford politically, strategically, or morally to act otherwise.

While millions are returning home, millions more are fleeing ethnic, religious, tribal, and linguistic conflict around the globe in places like Bosnia-Herzegovina, southern Sudan, Peru, Georgia, and Azerbaijan. Most victims of these conflicts—mainly women, children and the elderly—are internally displaced, bereft of the protection or even the humanitarian assistance accorded those who do become recognized refugees or those who are resettled in third countries.

In light of the increasing numbers of internally displaced, the international community is forced to grapple with the complex issue of conflict between national sovereignty and protection of the basic human rights of the internally displaced, and humanitarian access to them. Today, for example, the situation in southern Sudan challenges the international community to act. For more than a decade, the sovereign government of this nation has been set on a course of eradicating a particular segment of its population. A principal weapon in this civil war, instigated by the government of Sudan and followed by rebel factions of the Sudan People's Liberation Army, is the withholding of food from civilian populations, an action which causes them to flee to survive. The internal displacement of people through a scorched-earth policy and interference with food and relief distribution are not byproducts of the war, but an intentional military strategy targeting civilians. The U.S. Committee for Refugees, in a 1993 "Working Document," estimates that since 1983, 1.3 million civilians have died unnecessary war-related deaths, many by starvation. In some places no child under the age of five has survived.

In countries like Sudan, can the international community tolerate the warring parties' obstruction of international relief? Can a government punish with impunity its people for being who they are ethnically, religiously, racially? Do other nations have a responsibility to act? —and if so, to what extent? Are there basic human rights such as access to food, shelter, water, clothing, and medical assistance that cannot be violated, particularly when the denial of such rights is used by a government to eradicate a segment of its population? Is there a point beyond which a government cannot be permitted to go in abusing those citizens it is bound to protect?

With uncommon resiliency, the women in this book as well as those who remain in refugee camps, are internally displaced, or are returning to ravaged homelands want to be encouraged and empowered to develop their potential and to participate in creating an environment in which they and their families can live in dignity, peace and security. Theirs are voices worthy of our attention.

ACKNOWLEDGMENTS

I am grateful to many people who have helped make this book a reality. My husband, Clifford Hackett, and my friends and colleagues Ruth Landman, Linda Camino and Joan Newlon Radner not only encouraged me, but read early drafts of the manuscript, commented freely and contributed their suggestions. Ana Wenig, Dorothy Nied, Kathy Lipp and Carole Katinas helped with translations from Spanish, Sabina Bjelogrlic translated a Bosnian story and Mohamed Omar O. Sharif translated a Somali story. Friends and colleagues who work with and for refugees have, over many years, introduced me to men and women who have fled their countries for safety elsewhere. I am especially grateful to Vilay Chalenreuth, Lori Kaplan, Priscilla Coudoux, the Reverend Maximo Ortiz, Kathy Lipp, Dieter Matzenauer, Reinhard Kapsichke, Timmie Jensen, Mary Kay Crangle, Virginia Jeffries, Elaine Daniels, Mohammed Omar O. Sharif, Molly Schuchat and Sister Regina Griffin. Marta Brendan and Barbara Francis were untiringly helpful in guiding me through the intricacies of official language and policies, but obviously any mistakes in the book are mine, not theirs. The title of the book comes from one of the Haitian women's stories.

Mostly, I am grateful to the women who told me their stories. This is their book. I appreciate their confidence, dignity and insights.

PREFACE

The roots of this book go back to 1980 when a Chinese refugee from Cambodia told me her story. She talked not just about what made her flee, but about the many different persons she was to herself and others along the way and in her new home in the United States.

I began to collect the stories of other resettled refugees, both men and women, and noticed that women's stories differed from men's in their intimacy and their assumptions that, because I was a woman, I shared certain concerns and responsibilities with the narrators. I wanted to celebrate these women and others like them, whose courage and efforts to survive and live as they want rise above news accounts of refugee tragedy and destruction. I wanted others to explore the stories' intimacy and assumptions for themselves, to listen to what the women say or imply about how they think of themselves and who they are, and about how what others—bureaucrats, employers, family members, outsiders—call them has affected their status.

What these women share with other women lies in being mothers, daughters, sisters, wives, lovers and friends, and in recognizing and accepting responsibilities as part of those relationships. What they share only with other refugees is the experience of having been forced to flee; the consequent loss of homes, families, material possessions, and professions, together constituting much of what had given them identities before; and the effect that being refugees has on those identities and relationships to others.

When a Cambodian woman says "There were just me and my mom then" and "A lot of women were raped, but I was little, so I was still okay," or a German woman says "I was twelve years old when we had to leave. My mother, my two sisters and me," she is saying something about situations common to *women* refugees. When an Ethiopian refugee says that she and her husband agree "We are not helpless," or a German Jewish refugee says "I didn't want to be a refugee. I wanted to be an immigrant," or a Chinese refugee from Cambodia says "I will take care of myself,"

1

she is saying something about herself and her interpretation of being a *refugee*.

Here, in their own words, 28 women talk about how their lives have been shaped and rearranged by flight and loss, by refugee camps, by resettlement and government policies, and by their own individual responses, skills and initiatives.

Life Stories

Anthropologists, sociologists and historians recognize the value of individual life stories in helping them understand how people make sense of their situations.[1] Life stories give people their own voices in relating themselves to their societies and cultures and to events occurring around them. In this book, these women's stories are so compelling, I believe, that other listeners will be drawn into them and find themes to examine in the narrators' accounts of themselves as women and as refugees. The stories provide more than ample material for analysis, but my promise to the women was to be merely the means by which others could "listen" to them, not to take the stories apart and put them back together differently myself.

I made no attempt to find a narrator from every refugee situation in our world and am myself surprised at the range of situations the stories represent. I concentrated on resettled refugee women, starting with stories I had already gathered before beginning this book, and initially chose new narrators from among refugee communities I knew well (Southeast Asians and Central Americans in the United States and Germans displaced from Third Reich Germany's eastern territories after 1945), who were willing to spend the time needed. Later, I realized I knew other refugee women but had never formally listened to their stories. I invited them to be part of this project. I wanted, however, a representative group of refugee women who, having survived the flight, had coped with resettlement, so through refugee workers and colleagues, I sought other women refugees in communities and locations I did not know well in order to broaden the historical, geographical and political scope of the stories.

Most of the refugees who told me their stories are now resettled in the eastern part of the United States; five are in Germany. A few of the stories were told in the speakers' languages (two Spanish, one Somali, one Serbo-Croatian, and five German) and translated into English. I translated the German stories. Spanish-speaking, Somali-speaking and Serbo-Croatian-speaking friends sat in on the telling of these stories, which started off in English but shifted, as we expected, to the narrator's language as the tale

unfolded. Some stories were told in English perfected over many years. Some were told in newly acquired but insistent English which I have rendered, at the narrator's requests, in more conventional syntax. Had they been told in their own languages, after all, their fluency would have been apparent and properly translated. Most were tape recorded and then transcribed. Four women were uneasy with the tape recorder, and their stories were written out as they told them. I have added clarifications in brackets where necessary.

Collecting and retelling stories of other peoples' lives raises ethical and even literary questions. Whose story is to be told, whose voice is to be heard? I have explained how I chose these narrators, but what about my other responsibilities as recorder?[2] Even the anthropologist's legitimate concern to protect the safety and privacy of those who tell their stories makes it appear that I have assigned each narrator yet another identity, or worse, deprived them of a basic identity of their own by using pseudonyms. I discussed the dilemma as I perceived it with the women. None felt pseudonyms had anything at all to do with who they are—they constituted neither deprivation nor imposition in this case. With two exceptions, most argued for omitting family names and using fictitious given names as merely prudent and convenient. A few of the women even chose their pseudonyms; several used the names of sisters or aunts who did not survive the turmoil that caused the flight or the flight itself. One woman, however, wished not to use a pseudonym. She was a "disappeared" person in Argentina, and having been deprived of her identity during part of her imprisonment, she insists now on reclaiming and announcing it. The other woman who uses her real name is closely identified with the formation of a well-known Khmer classical dance troupe in the refugee camp. Two others, who wished to disguise their names and current residences in this book, realized that, with some effort, they could be identified. But because certain identifying elements are necessary and proud parts of their stories, they refused to ignore or conceal them. All but two, then, of the women's names, current residences and workplaces have been disguised to give some measure of protection to the privacy and safety of the narrators and their families.

Most anthropologists are aware that, in spite of claims of neutrality, "a culturally constituted bias" intrudes on "the anthropological gaze," as Crapanzano puts it.[3] I am not a refugee, but a citizen of the country which has offered refuge to those who told their stories. This meant different things to different narrators, and the difference is apparent in their stories. Those who have been in the United States a long time and have even become citizens themselves see me differently from those who have just

3

arrived. I have tried to minimize intrusion by never discussing with the women my own views on the geopolitical situations which forced their flights, the politics of refugee admission or male-female roles and domains. I did not interview these women; rather, I asked them to tell me their stories, inviting them simply to begin by talking about what happened to them and how they came to be where they are now. I had to prod two of the newly arrived Vietnamese women with continual suggestions to "tell me more about that." I have tried to stay aware of difficulties and to let the women control the encounter and tell their stories without interruption or question except to clarify specific points such as dates or locations. It became tempting, as the number of stories increased and themes seemed to be emerging, to mention these themes in an offhand way as I arranged the tape recorder, hoping a narrator might include them in her story. I did not yield to that temptation, but it made me listen more closely.

Simply in transcribing audiotapes, one loses the rhythm of speech and the inflections of voice, the smiles and facial expressions that give life to narration.[4] Can one ever know for certain that an inadvertent lift of the eyebrow or a movement of the hand toward the tape recorder did or did not change what a narrator was about to say? But describing and emphasizing the researcher's overly scrupulous or tortured examinations of conscience, it seems to me, runs the risk of changing the focus of the book and detracting from the stories themselves. I have tried to keep the voices of the women both paramount and intact. Would some of the women have told a different story to someone who looked like them or who openly supported their political statements? Perhaps, but perhaps not. These are the stories these women told me; they are valid and important.[5]

Each narrator was offered her transcribed story for review of the factual matter; 22 accepted. One, whose reading ability in English is limited, asked me to read the transcribed story back to her. The remaining narrators were content to let the stories stand without their review.

In the second book of his trilogy about war and warriors, *Officers and Gentlemen*, Evelyn Waugh's principal character wonders "Could there be experience without memory? Could there be memory where fact and fancy were indistinguishable, where time was fragmentary and elastic, made up of minutes that seemed like days, of days like minutes?" People tend to remember and recall dramatically events and circumstances which greatly affected them; these women do that. They repeat; they emphasize; they move back and forth in time. We cannot know just what has been left out of the stories, or how important it might have been, or if it was important once, why it is no longer. We can guess why some narrators tell portions of their stories in vague terms, but we probably should not. Motives for

4

actions taken in extreme circumstances can be explained, distorted, justified or forgotten. Experience filtered through time can leave a residue in which motives—the narrator's or those attributed to perpetrators—are ambiguous, just as easily as it can harden initial judgments of right and wrong.

A life story differs from what a journalist or a historian might report. A life story is intensely personal; it is a set of recollections, a series of images, an interpretation of facts. The truth of memory is not perfect or complete or objective knowledge. How these women refugees remember and act on their interpretations of the facts of their lives makes their own truths.

While I have done no formal analysis of the stories, I have mentioned the theme of transforming identities which runs through the stories because it is this theme which first drew me into them. The incidence of implied and stated references to changes in roles and identities is spontaneous and striking. I did not ask the women to reflect on this theme; it is simply there. It is this theme, too, that makes these stories unique and important and more than merely a collection of refugee tales.

The Women Refugees of the Stories

A large majority of all refugees are women and their dependent children.[6] Men and women can share equally the danger of battle, the circumstances that lead to upheaval and refugee flight, the misery of prison or refugee camps and the tension of resettlement. However, in many situations women alone bear the burden of escape and the responsibility for their families during the flight because men, who may be fighting in war or guerrilla actions, have been taken prisoners or have died, simply are not present. Women then take on roles usually reserved for men—the sometimes unfamiliar and potentially dangerous role of family head and provider—along with those they traditionally carry out as women. That experience can carry over in resettlement. Even those women refugees who flee with husbands, brothers or fathers find their roles often combine traditional elements with new and innovative ones.

Women refugees suffer sexual harrassment and abuse, and the tortures devised for them often have to do with their being women and challenge not only their notions of self, but their responsibilities.

These women's stories show that it is not only the flight itself which brings about changes; the traumatic circumstances leading up to the flight often call for new social behaviors as well. Certainly resettlement in a third country presents new and sometimes conflicting roles for these women.

Their responses to new demands are not uniform, nor are they all in the same direction or at the same rate.

All of the women who tell their stories here are refugees in the popular sense of that term; they were forced to flee their homes by some calamity, and resettled in the United States or Germany. Some of these women are recognized refugees under the United Nations definition or U.S. and German policy; some are not. Some were considered refugees by themselves and others, but were admitted as immigrants or otherwise through normal immigration procedures. Some were admitted through special limited refugee "paroles," giving them temporary admission which might be adjusted later. Some were admitted with presumptive refugee status or through special legislative programs to accommodate great numbers of people who were fleeing communist governments and to whom the United States felt a particular national obligation in the East-West conflict. Some are refugees from fascist or rightist military government abuse.

All of the women who told me their stories are alive and well. They came from many countries and fled under many conditions. They differ in age and marital status, in economic, political, educational, religious and social backgrounds. Some planned their escapes; others fled in panic. Some fled alone, some with husbands or fathers. Many fled with other women. Some have been in prison, a few were tortured. Some mention the sexual harrassment and abuse they feared or met.[7] Some still live in fear. Several clearly tell their stories in much broader contexts and with greater reflection than others.

These women were part of particular societies and cultures, and experienced what happened to them differently as members of those societies and cultures. But the stories show women refugees who, for the most part, did not merely adjust to the historical changes imposed on them, but reinterpreted and gave meaning to their changing situations, and then acted on those meanings.[8]

I hope other listeners will hear these women's voices against the background of violence, fear, despair or panic which forced them to flee and with an awareness of the personal, cultural and institutional influences which bear on how they identify themselves and begin new lives.

NOTES

1. For a concise review of life history research and method in anthropology, see especially Lawrence C. Watson and Maria-Barbara Watson-Franke's book, *Interpreting Life Histories: An Anthropological Inquiry* (New Brunswick, N.J.: Rutgers University Press, 1985).

2. These points and others are made in three spirited discussions of some ethical issues involved when women use the stories of other women for their professional purposes. They are: (1) Hill Gates' 1987 *Chinese Working Class Lives* (Ithaca: Cornell University Press, pp. 10–17); (2) Kamala Visweswaran's "Refusing the Subject: Feminist Ethnographic Encounters" (Paper delivered at the 1991 American Anthropological Association Meeting, Chicago, Illinois, November 22, 1991); and (3) *Interpreting Women's Lives: Feminist Theory & Personal Narratives*, Personal Narratives Group, eds. (Bloomington: Indiana University Press, 1989, pp. 201–03). This final citation poses the specific questions I repeat in this text.

3. Vincent Crapanzano, in *Tuhami: Portrait of a Moroccan* (Chicago: University of Chicago Press, 1980), discusses some of the difficulties inherent in claiming neutrality in the ethnographic encounter and the illusion of understanding "one's counterpart and his reality."

4. Dennis Tedlock, in his 1983 *The Spoken Word & the Work of Interpretation* (Philadelphia: University of Pennsylvania Press, p. 9), discusses similar problems. In the context of a discussion of transcribing recorded poetics, he worries about those who used "too many parentheses, underlines, exclamation points — and maybe even indulged in the use of CAPITALS."

5. Those interested in the analysis of narrated accounts should refer to Michael Agar's 1980 "Stories, Background, Knowledge, and Themes: Problems in the Analysis of Life History Narratives" (*American Ethnologist* 7[2]:223–35); Mark Luborsky's 1987 "Analysis of Multiple Life History Narratives" (ETHOS 15(4):366–81); Nicole Gagnon's 1981 "On the Analysis of Life Accounts" (in *Biography & Society*, Daniel Bertoux, ed.: Sage Studies in International Sociology, pp. 47–60); and Marie-Francoise Chanfrault-Duchet's 1991 "Narrative Structures, Social Models, and Symbolic Representation in the Life Story" (in *Women's Words: The Feminist Practice of Oral History*, S.B. Gluck and D. Patai, eds. New York: Routledge, pp. 77–92).

6. Susan Forbes-Martin, director of policy research and programs at the Refugee Policy Group and cofounder of the Women's Commission for Refugee Women and Children, cites a figure of 75 percent and discusses the problems of counting women refugees and their dependent children in her 1992 book, *Refugee Women* (London: Zed Press, pp. 1, 12–15).

7. For more information on U.N. High Commissioner for Refugees (UNHCR) guidelines for the protection of women refugees, see *Refugees*, Vol. 87, October 1991, pp. 40–41, UNHCR: Geneva, Switzerland. The UNHCR also publishes *Refugee Women: Selected & Annotated Bibliography 1989*, through its Centre for Documentation on Refugees, Geneva.

8. Edward Bruner describes this process and develops the notion of a person "actively engaged in constructing interpretations" and "attributing meaning to the changing situation." See particularly his "Tradition and Modernization in Batik Society" in George A. De Vos, ed., *Responses to Change: Society, Culture and Personality* (Berkeley: University of California Press, 1976, pp. 234–52). See also George De Vos's discussion of changes in terms of acculturation and adjustment in the introduction to this same volume (pp. 1–11).

1

DEFINING AND
RESETTLING REFUGEES

In order to understand why and how these women refugees were resettled where they are, some historical and political background on refugee admission policies seem appropriate. Obviously, a full discussion of the intricacies of such procedures is impossible here, but a sketch of what is involved provides perspective not only for the stories, but for the women's reactions; it gives a sense of the bureaucratic and official structures which guide or even limit human responses.

We commonly think of a refugee as a person who flees some danger for safety elsewhere, and often the term is loosely applied to anyone forced to flee his or her home. At the turn of the twentieth century, Americans often referred to impoverished Europeans arriving on U.S. shores as refugees from poverty, famine, intolerance and injustice in that popular sense although they were admitted as legal immigrants. When the United States stemmed the great immigration flow by instituting a quota system in the 1920s, special provisions for refugees were still not considered. Gradually the term refugee came to be applied more carefully to particular people fleeing specific circumstances, and the admission of refugees was distinguished from general immigration policy.[1]

There have always been refugees in the popular sense of that word. Invasion, oppression, persecution, famine and economic bad times have driven people from their homes to look for relief and safety elsewhere. But the refugee phenomenon as we know it today belongs essentially to the twentieth century. The massive and prolific weapons of destruction in this century's wars drastically changed the scale of displacement and the movements of people. There were in 1994, according to the U.S. Committee for Refugees, over 18 million refugees worldwide. There are probably even more internally displaced people—that is, uprooted people who have not crossed an international border.

The enormous numbers of people displaced by World War II compelled the international community to consider its collective responsibilities to refugees and to develop a definition of refugee status that nations could act upon. United Nations (U.N.) member nations accepted the definition declared by United Nations Resolution 428(V) and the 1951 *Convention Relating to the Status of Refugees,* which stated that to be considered a refugee one must be outside the country of one's nationality, have a well-founded fear of being persecuted for reasons of race, religion, nationality, membership in a particular social group, or political opinion and, because of that fear of persecution, be unable or unwilling to expect the protection of that country.[2]

The definition does not cover all cases of traumatic displacement, and the term refugee is often used, even by officials, in a much broader sense. The criteria of the basic U.N. definition have not limited admission to those perceived as refugees in broader terms when receiving nations are willing to accept them, but there is no bureaucratic or international consensus of who is always an admissable refugee.

The mandate of the United Nations High Commissioner for Refugees (UNHCR), aided by other relief agencies who carry out the hands-on work, is protecting refugees and finding durable solutions to their problems, including voluntary repatriation once a disruptive situation has stabilized; settlement in place, usually in the neighboring country whose borders refugees first cross (the country of first asylum); or, in some circumstances, resettlement in a third country.[3] The international community relies on the U.N., through UNHCR, to assist refugees in need, but refugee asylum, admissions and resettlement policies remain national concerns and responsibilities.

Refugee resettlement in the United States, in spite of its generosity, has often been the result of an *ad hoc* policy of humanitarian concern and political response dictated by the Cold War. Since World War II, U.S. refugee admissions policy developed largely within an East-West context, and refugee admissions and assistance reflected U.S.–Soviet confrontation and competition.[4] Germany's refugee policy also, developed on principles derived from World War II and the loss of former German eastern territory to Poland and the Soviet Union, the Cold War, and particularly the postwar division of Germany into the Federal Republic of Germany, or West Germany, and the German Democratic Republic, or East Germany. Five of the six German women who tell their stories here were displaced within what was at the time their own country; they did not qualify as refugees under the U.N. definition since technically they were not outside the country of their national origin and there was little international

10

sympathy for them after the collapse of the Third Reich. Their experience, however, and that of millions like them who fled or were expelled from former "German" territories, underlies much of current German asylum policy.[5] Refugee admission policy in both the United States and Germany has long been linked to foreign policy concerns.

To be resettled in most Western nations today, one must not merely be displaced, but be granted refugee, asylum, parole or other such status by the receiving nation, be approved for resettlement and be within the number allowed admission in any given fiscal year. Temporary safe haven may be offered under such programs as the U.S. Extended Voluntary Departure Program (EVDP) which provides refuge rather than resettlement on the explicit understanding that the person will return to his or her country.

Administrative or bureaucratic designation of those seeking refuge and asylum is not the only status which affects these women and other newcomers. It is basic, however, because it is that which admits them legally and in it are reflected other aspects of how these women are seen by others. The official classification of a newcomer as immigrant, refugee, recipient of asylum, parolee, asylum-seeker, or—failing any of these—as undocumented person or illegal, influences how one is received, the programs or services to which one may be entitled, whether or not one may become a citizen and the reactions of hosts, neighbors and friends. Administrative designation reflects both popular perception of the refugee's plight and the receiving nation's obligation expressed in public policy. Administrative designations influence the newcomer's own assessment of her situation and the way she identifies herself. Such designations can be embraced or rejected by the individual; they can be seen either as opportunity or barrier.

Lately, the pressure of massive movements of displaced populations and the demand for refuge and asylum have created difficulties for the traditional refugee receiving countries, which are themselves struggling with economic and resources problems. Fewer than 1 percent of all refugees are ever resettled in a third country, yet while the plight of those newly displaced and dispossessed by ethnic or tribal fighting or famine, as in Rwanda, Somalia and Sudan, is recognized and deplored, the international response has become tinged with hesitation. One can almost feel collective breaths being held by many western European and North American government officials in the hope that they will not have to welcome and provide permanent asylum for many more refugees than they have already.

There is little question of United Nations member governments' reneging on their general responsibilities to refugees. There have even been

efforts to enlarge the U.N. definition.[6] But as far as continued permanent resettlement in most of the traditional western receiving nations is concerned, the increasing number of refugees, the decreasing resources willingly allocated for them, the real and perceived abuses of policies and programs, the legacy of a Cold War refugee policy, and uncertainty about what principles should guide refugee admissions in the post–Cold War era have resulted in hesitation to admit many more refugees for resettlement and the tightening or refocusing of the criteria of the U.N. definition.

The U.N. definition of a refugee is decades old. The current American and German interpretation of that definition emphasizing "well-founded fear of persecution" and questioning the legitimacy of each personal claim to asylum on a case-by-case basis is more recent. Clarifying distinctions between those fleeing general economic despair and generalized human rights abuses, on the one hand, and ineligible "economic" refugees on the other, is complex but necessary. What principles should be consistently applied? Proving a "well-founded fear of persecution" is often difficult, especially if that fear can be interpreted differently in different circumstances for different peoples.[7]

There are no signs that the refugee phenomenon will cease or that women and their dependents will no longer continue to have a large and unique role in refugee tragedies. However the current approach is interpreted, whatever principles may be developed, whatever alternatives are arranged, women refugees resettled in the future will reflect that policy when they talk about who they are.

NOTES

1. David Haines makes this point and gives a concise history of the development of refugee policy and programs in the United States in "Refugees and the Refugee Program" in his edited book, *Refugees in the United States* (Westport, Conn.: Greenwood, 1985). Roger Winter, in "U.S. Refugee Policy," a paper presented to the Center for Migration Studies' Eighth Annual National Legal Conference on Immigration and Refugee Policy on March 29, 1985, makes similar points.

2. The logical body to carry out such an endeavor was the United Nations (U.N.). On December 14, 1950, the General Assembly of the United Nations adopted, under Resolution 428(V), the Statute of the Office of the United Nations High Commissioner for Refugees (UNHCR). It adopted a Convention Relating to the Status of Refugees and Stateless Persons in July 1951 and defined a refugee. The Protocol Relating to the Status of Refugees was adopted by the U.N. General Assembly on December 16, 1966, and extended the scope of the 1951 convention by removing the dateline of January 1, 1951, contained in the original definition. A refugee is any person who,

owing to well-founded fear of being persecuted for reasons of race, religion, nationality, membership of particular social group or political opinion, is

outside the country of his nationality and is unable to or owing to such fear, is unwilling to avail himself of the protection of that country; or who, not having a nationality and being outside the country of his former habitual residence. . ., is unable or, owing to such fear, is unwilling to return to it.

3. For further discussion of the UNHCR mandate and approach, see UNHCR's *The State of the World's Refugees* (New York: Penguin Books, 1993) and pages 108–49 of *An Instrument of Peace*, published in 1991 by UNHCR and produced by the UNHCR branch office in Italy to celebrate the fortieth anniversary of UNHCR.

4. Lois McHugh, in a 1990 Congressional Research Service report for Congress, discusses this policy with its complex background and relationships to other policies, and implies its many consequences. She clarifies how the Refugee Act of 1980, the basis of determining which refugees may resettle in the United States, adopts a "country neutral" definition of refugee, but in implementation does not adopt a "country neutral" standard that gives clear admission priority to the most desperately needy individuals who qualify under the definition. Rather, she writes, U.S. refugee admission policy has always been linked to foreign policy concerns ("Refugees in U.S. Foreign Policy," 1990 Congressional Research Service Report for Congress: 90-419F. Washington, D.C.: pp. 2–3). See also Jonathan Moore's 1988 *Refugees Worldwide & U.S. Foreign Policy: Reciprocal Impacts*, published by the U.S. Department of State in Washington.

Joyce C. Vialet of the Library of Congress' Congressional Research Service, in "Issue Brief on Refugee Admissions and Resettlement Policy" (IB 89025: Washington, D.C.), cites the case of admission of Soviet Jews as an example of refugee admissions being in line with American foreign policy objectives. She shows how, before 1988, the Immigration and Naturalization Service had been granting presumptive refugee status to Soviets—almost all who wished to come to the United States and could were admitted. After 1988, the "case-by-case" procedure was instituted based on the principle of "well-founded fear of persecution." But of the 44,000 applicants interviewed in Moscow in fiscal year 1990, 27,000 were approved for refugee status and 17,000 were recommended for parole, which is a less desirable status because it confers no permanent admission status, does not lead to citizenship, and does not include financial benefits. However, later legislation provided for a change in the parole status of those individuals. Thus, there was no reduction of those admitted in line with foreign policy goals at the time. Such admissions do not indicate that any group of refugees is more or less worthy than another, but only that certain foreign policy concerns were paramount during the Cold War.

In the 1930s, when Hitler threatened the Jews of Germany, the United States had no refugee policy to cover their exodus; nor did it create one. Instead, German Jews were admitted as immigrants under existing and limited German quotas during that bleak period.

5. According to the June 1994 issue of the German Information Center's *This Week in Germany; Focus On. . .* newsletter, foreigners seeking residence in Germany can be divided into three groups: asylum seekers and refugees, who are likely to reside temporarily in the country, and foreign-workers, who are long-term or permanent residents. Persons seeking asylum in Germany under the new 1993 asylum law do so under the provision of Article 16a of the Basic Law, which states that "persons persecuted on political grounds shall enjoy the right of asylum"—if, that is, they are recognized by the authorities as being truly in need of asylum. Until the new asylum law was passed, asylum seekers who entered the country and claimed asylum on that basis were entitled to an individual hearing to determine their eligibility. As the number of asylum-seekers rose, a backlog developed, and it routinely took several years before a decision was made

on an application. The new legislation retains the constitutional guarantee of protection against political persecution but seeks to exclude persons who come to Germany for economic reasons. It speeds up the administrative process and excludes persons coming from or through other "safe third states" and from "safe states of origin," that is, member states of the European Union and states in which the application of the Geneva Convention on the Status of Refugees and the European Human Rights Convention is guaranteed. Applications for asylum that cannot be rejected on the grounds listed above may still be rejected if they are judged to be "manifestly unfounded," that is, if unsubstantiated claims are made or the claim is contradictory or based on forged or false evidence.

Other persons excluded from the asylum procedure include refugees from war and civil war, who are granted the right to stay temporarily under the provisions of the law on foreigners but cannot apply for asylum during this period.

6. In 1969 the Organization of African Unity (OAU) enlarged the concept of refugee under the 1951 convention for specific aspects of refugee problems in Africa, by establishing that the term refugee applies not only to any person who suffered persecution or fears of persecution, but also to those forced to leave their country "owing to external aggression, occupation, foreign domination or events seriously disturbing public order in either part or the whole of his country of origin or nationality." This definition has been ratified by 40 African countries of the OAU.

Similarly, in 1984, UNHCR supported a colloquium in Cartagena, Colombia, which offered a definition of refugee resulting from the experiences of violent conflict in Central America. This definition, which at this writing has only the force of an opinion shared by those who drew it up, considers as refugees also those persons "who have fled their country because their lives, safety or freedom have been threatened by generalized violence, foreign aggression, internal conflicts, massive violation of human rights or other circumstances which have seriously disturbed public order." See *State of the World's Refugees*, published by the UNHCR in 1993 and distributed by Penguin Books, for more information.

7. According to the "Refugee Admissions and Resettlement Policy—Congressional Research Service Issue Brief" (Joyce C. Vialet, 1994), all refugees are admitted to the United States under the authority of the Immigration and Nationality Act, as amended by the Refugee Act of 1980. Refugee admissions are separate from immigrant admissions; they are subject to neither the worldwide ceiling and per-country limits, nor the preference system. Refugees may have their status adjusted to that of immigrant or permanent resident alien after residence in the United States for a year, without regard to any numerical limitations.

The term refugee is defined by the law to conform with the definition used in the United Nations Protocol and Convention Relating to the Status of Refugees, to which the United States is a party.

The total annual number of refugee admissions and the allocation of these numbers among regions of the world or refugee groups are determined at the beginning of each fiscal year by the president after consultation with the Congress. The president may determine after appropriate consultation with the Congress that an unforeseen emergency refugee situation exists and that the admission of other refugees is justified by grave humanitarian concerns or is otherwise in the national interest, and may specify an additional number of refugees to be admitted during the succeeding 12-month period. Provision is made for the granting of asylum on a case-by-case basis to aliens who qualify.

Legislation for U.S. admission of refugees is linked to allocations of funds for the temporary assistance of the newcomers through federal agencies, and thus is often questioned by individual legislators on the basis of both money available and policy.

14

DEFINING AND RESETTLING REFUGEES

Ruth E. Wasem and Larry M. Eig, in a 1993 report to Congress, explain that asylum is a discretionary remedy that is available only to aliens who are in the United States or at a port of entry. The current asylum system—meant to provide humanitarian relief to persecuted aliens—is now under review. To receive asylum, an alien must show a well-founded fear of persecution based upon race, religion, nationality, membership in a particular social group, or political opinion. Asylum seekers without legal immigration documents may be kept in detention or may be released under their own recognizance while the case is pending. Aliens who are granted asylum may become permanent residents of the United States after one year, subject to an annual limit of 10,000. Aliens who are denied asylum are then required to leave and may be forced to return to their country of origin (*Immigration: Illustrating the Asylum Process.* Congressional Research Service Report for Congress, Library of Congress 93-865 EPW, Washington, D.C.).

2

CAMBODIA

On April 15, 1975, victorious Khmer Rouge guerrillas marched into Cambodia's capital of Phnom Penh. The euphoria over the end of Cambodia's role in the long Indochina Wars lasted only a short time. Khmer Rouge soldiers began systematically routing the city's population and forcibly marching them into the countryside. Pol Pot, the *nom de guerre* of the Khmer Rouge leader, Saloth Sar, became synonymous with an era of unparalleled violence as he tried to build the socialist Kampuchea of his vision. Some Cambodians escaped then; most did not.

In December 1978, after border violations on both sides, the Vietnamese invaded Cambodia, driving the Khmer Rouge into hiding in jungles near the mountainous Thai border. In the chaos and disarray of the retreat of Khmer Rouge soldiers, tens of thousands of Cambodians began to flee the work camps for safety. (See note, p. 147.)

J. Meo Chten, 1980*

Before Pol Pot I had a father, mother and younger brother. We were four in our family and we lived in Phnom Penh. My parents loved me very much. My father's health was good and his heart was filled with generosity. He delivered groceries from the warehouse to stores. My mother worked when she could; she was a seamstress, but she was sick a lot.

I went to school, the Chinese school, when I was eight. There were many Chinese schools in the neighborhood where we lived. The Chinese community in Phnom Penh was so big that you could live there without ever speaking any Cambodian [Khmer] or meeting any Cambodians. I went to school until I was thirteen years old, then I had to help my mother. We used to take cloth that other people had cut from patterns—take it

*The year that appears after each woman's name is the year in which she left her native country.

16

home to sew. We were paid by the piece, and I was very fast. I could make more money than my mother and I gave it all to her. My mother and father were happy about that. I learned to cut the patterns too and then I taught at the sewing school for two years.

In 1974 I began to help my brother sell fish. He had a business; he would buy the fish wholesale and then sell it. My brother was very intelligent and when I worked with him, we did very well; we worked for three different businesses. My father stopped working and stayed home.

But then in 1975, Pol Pot [the Khmer Rouge guerrillas] came. At first we were all happy because before that there was always shelling and gunfire. No one knew then that Pol Pot was no good. They began to send everyone from the city out into the jungle. We were all supposed to go to work. My father had to carry my sick mother, and I carried the rice, and my brother carried whatever else we could manage to bring. I was twenty-one then; I was born in 1954.

My parents were very frightened for me because I was a young unmarried woman. They didn't think the Cambodian soldiers were good men. The whole time we were walking into the jungle, every night, when we had to sleep on the ground, my mother would sleep close on one side of me and my father on the other.

I didn't know anything about where we were going. I knew about the city, not the countryside. There was no water. There wasn't enough rice. It was always keep moving, keep moving. There was another family related to us; they were nine people, and they were traveling with us. We were thirteen altogether. The soldiers never gave us any food and we ran out of the rice we had brought along. We were so hungry we ate whatever looked okay in the jungle. We ate grass and roots. Some people ate bad things and died. My father became very, very sick from eating something that wasn't meant to be food. Nineteen seventy-five was a very bad year for everyone; many, many people died. People were sick one day and dead the next. In 1975 my mother, my father and my brother died. All nine people in the other family died. I was the only one left. All the others had died; only I didn't die. In 1975 I left my home, my family all died, and I do not miss Cambodia now.

In 1976 I was in a work camp. No one had enough to eat. My legs were swollen and I couldn't work because they were so big. If you didn't work, you wouldn't get any food. I thought, now, for sure, I'm going to die. I went up to a Pol Pot soldier and asked him to help me. I told him my family was all dead and I was the only one left. He looked at my swollen legs. I told him I was not lazy, that I could work if I was well. He said, okay, he would take me to the hospital. I told him there were many people sick like

17

me where we lived. He went to look and many people were close to death. He took all of us, forty-three people, to the hospital! Of course, it wasn't a hospital like here, but they gave us food twice a day without working, rice and water, some sugar and sometimes some fruit. I got better and then I went back and began to work very hard. We cleared the jungle and planted rice, all day, all night sometimes. We would move to a new place and plant more rice. There was never much to eat. Sometimes, at night, when we weren't working in the paddies, we would go into the jungle and look for wild pigs. Just the women. During Pol Pot, men and women were separated and couldn't talk to each other.

In 1979 the Vietnamese came to Cambodia. I didn't leave right away like many people did then. I was working near the Thai border and the Pol Pot soldiers wanted to take us with them, over three mountains. If we wouldn't go, they would shoot us; so we went with them over the mountains and then we came back over the same mountains. I thought I would die if I had to do that again. No one knew anything about what was going on. We had no radio or television. No one knew where the Vietnamese were; we only knew what the Pol Pot soldiers told us. No one talked, everybody was afraid. I just listened. I didn't know where I was, but I knew if I stayed with the Pol Pot soldiers, I would die. At least I wasn't sure that I would die if I went with the Vietnamese. I decided to get out and find the Vietnamese.

One day we were in the jungle with not many soldiers around, so I moved away a little bit. Someone asked where I was going and I said I was going for water or food or to be sick or something. We always went into the jungle a little way to go to the bathroom or to find food. I went farther, looked around, went even farther. I saw no soldiers, no people at all, so I ran. I ran and ran, and came to edge of the jungle by evening. I was tired and didn't know where I was. I just lay down on the ground and slept.

The next day I started to walk and some Vietnamese soldiers found me and put me in jail. I was in jail two days and then they let me go because I was Chinese, not Pol Pot. I was in Battambang then, but I didn't have any food, any money, nothing. I thought this time I really will die. I was so tired, I lay down on the road. Many people were sleeping there too. When I woke up, I looked up—an old man was looking at me. He said I should come with him to his house. He had a wife and four children younger than me. I stayed with that family for about four months. I worked hard for them, but it was not my family. I had had a business in the city and here I wasn't doing anything but carrying water. I heard about people buying and selling at the Thai border. I told the old man I wanted to go there to do business. He said, no, I was a young girl and couldn't go. He

said if I were married, I could go with my husband, that would be all right, but because I was a young girl and he was like my father, he had to say no because people would think I was a bad woman if I went alone. I said yes, I can go by myself. I will take care of myself. They gave me some money when I left.

I stayed at the border four months buying and selling things. I was very good at buying something cheap and then selling it for a little more. I heard about Khao-I-Dang [refugee camp], and I finally decided to go to Thailand. I repaid the old man his money and I walked to Khao-I-Dang. I decided to be a refugee.

In Khao-I-Dang, I started going to church and I became a Christian. The pastor was from Thailand. I was helping teach sewing there. I had no mother or father to help me get married. My husband—he wasn't my husband then—he went to the church too, and he went to the pastor and asked him about marrying me. Some of my husband's family were there in the camp too. My sister-in-law and her husband helped us have a good wedding. We got married in the church and it was very nice. I made my dress and my husband built us a special little house of bamboo so we could be alone for a while.

I was afraid during Pol Pot that I would never have any children, because I didn't have a period for many years. But I became pregnant and my baby girl was born in the United States. We went from Khao-I-Dang in Thailand to the Philippines, and then to the United States. At first we lived in a house with other families from Cambodia, then we got our own apartment, and finally our own house. My husband is a cook in a restaurant and I did sewing at home for a while. Then I saved my money and bought a [mobile] hot dog stand and worked hard. But I sold that when we bought this house. I have two children now, both girls. I work at night in a bakery when my husband comes home.

I'm very happy; it's good here. You can do whatever you want. You can have a good business. I'm an American now; I'm Chinese too, but I got my American citizenship. My husband is a citizen too. My daughters are citizens. They go to school and speak better English than we do. They speak Chinese too. Someday we will have our own restaurant.

S. MEI-LIN, 1980

There were just me and my mom then, when the Vietnamese came. My older sister was working in a different camp. I was only seven in 1975 and almost eleven when the Vietnamese came.

The Vietnamese came and Pol Pot was out and my mother was absolutely determined to head toward Thailand right away. She did not want to stay in Cambodia any more. For two months we looked for my sister and when we finally found her, we started for the border. I wanted to go back to Phnom Penh to look for any relatives who might still be alive. I wanted to know who was left, but my mom said it would be too late then to escape, that we should get out of the country and then look for them. So the three of us set out for Thailand.

We were in Battambang. We went there after we left the jungle camp where we had been living and working. It was a very hard trip. We had to walk a really long walk and we were all so skinny. We had no food and no energy, especially me. My sister was still able to help carry the few things we had, a blanket and a dish, things like that.

Many people hated the Vietnamese, but after all, they saved my life. They might do bad things, but with Pol Pot it would have been worse. During the long walk out of the jungle to Battambang, I was so tired I thought I couldn't make it. My mom saw a Vietnamese soldier who was driving a truck to town with a lot of supplies they were collecting, and she waved to him, and he saw that she was Chinese and all tired; he let us hop in the truck.

When we got to Battambang we met friends we used to know before Pol Pot and we talked about how many people died and who was left, and some people asked my mom to stay, but she was determined to get out of the country. I was young, and now that I had some food, I wondered why we were running away. We might starve again if we ran, but my mom said we had to take that chance. So we began to walk to Thailand with a lot of other people escaping the country too. People told my mom that the paths were mined and set with traps like bamboo sticks sticking up in the ground. A lot of people did die trying to get to Thailand. There were maybe two thousand people. And there were people making a business out of getting other people to the border. They knew the way to Thailand and would take us if we had gold or something like that. My mom didn't have anything like that left and we had used all our rice. But some other people gave them gold for everyone and we started off. But they abandoned us on the way and just turned back and left us wandering in the forest. But there were some people who had been around there before and thought they knew the way. There was still a lot of danger. Some people stepped on the mines and they exploded. Some were killed or wounded, but we still went on.

Suddenly a bunch of pirates showed up with guns and knives. They threatened us for gold and diamonds. They stopped us and wouldn't let us go; they were really nasty. They checked all over you, through your

body, especially the women. A lot of women were raped, but I was little, so I was still okay, I wasn't in danger.

Finally we got to Thailand. At the border we saw some Thais who lived around there, very poor, who were trying to do business with the refugees. We thought we were safe; we thought we were over the Thai border already and waited for the United Nations to get us or something, because there were Thai soldiers who wouldn't let us go any farther into Thailand. A lot of people spoke Thai and the soldiers said they were going to send us to a camp where we would have food and where somebody would look after us and take us to another country.

Some people still had food left from what they carried from Cambodia, but we had nothing. We were so hungry and then suddenly trucks came and they said they were going to take us to a camp to be helped, but they tricked us. They put us into the trucks and drove us deeper into the mountains. It was dark and we couldn't see anything, but we started to get suspicious. Before we knew it we were dumped at a Pol Pot camp. They were Pol Pot soldiers who escaped during the Vietnamese invasion and they couldn't go back, so they stayed in the forest. There were maybe a thousand of them I think, but more of us. I was so shocked just to see those dark [Khmer Rouge] uniforms again. Here we were trying to escape from them, and now we're dumped back where the tiger is. The Thais just drove the trucks away and pushed us to the Pol Pot side of the border. We tried to talk with the Thai leader. We had been through so much. They said they were ordered from the top to do that. They just unloaded us and drove away. We had nothing left, but the Pol Pot soldiers still had rice. I thought I was going to die.

Then everybody stood up. One of the Pol Pot leaders came and asked who wanted to stay with them. My mom and some of the other old people stood up and said we were going to die here, but would not give in to them. And everybody stood together; there were more of us than them. There were still some Thai soldiers guarding us on one side to make sure we didn't cross the border. But during the night, everybody just came together and broke through the Thai soldiers. They couldn't shoot and kill all of us. We would rather die of gunshots than go with Pol Pot again. We started to walk in the night again, trying to get to some little town. When it was dawn, we were rounded up in a group again. Lots of Thai soldiers were guarding us this time and they sent in some Thai gangster and his bunch to do the dirty work, really bad. They knew we weren't afraid of guns anymore, they kicked us and stabbed us, and beat us, and finally, they got us back in trucks and took us to the Pol Pot side again. We stayed together, but I thought this time I would surely die. The place they took us was a

21

small temple. There was a monk there and a few Pol Pot soldiers were inside, but most of the Pol Pot soldiers were deep in the forest. Two or three of them came and said if we wanted to come with them, they offered nothing but rice. We said we would rather die. My mom, along with a couple other people, talked for everyone. They all agreed that no one would take their rice and that we would stay in that place. Then a Red Cross helicopter came and these people who spoke French came out and talked to us and we told them everything. We wrote down all our names and things like that and gave it to them to send on to the United Nations, to some embassy, anywhere to let them know there were hungry people here. We were there thirty days.

One day some rich Thai people came, Chinese-Thai I guess, looking for relatives. One of the men was distantly related to my mom and he recognized her, and then he gave us money and brought food and blankets and people began to get very friendly with my mom. She gave away a lot. Finally he and his friends were able to tell us that we were going to be taken to a refugee camp and then we would go to a third country. The camp wasn't even finished yet, but it was better, close to the beach, but still risky because it was not far from the border. They guarded us all the time and we couldn't go anywhere except maybe to the beach to gather wood for the fire.

We finally went to Bataan in the Philippines, and then to the United States, to San Francisco. My mom got a job, but she couldn't speak English and everything was so strange—the bus, the food, everything. She got sick. So we struggle by ourselves. Things are better now, but my mom, she still gets sick.

X. SREY MACH, 1980

Before 1975 I was a language teacher in the Ponhea Yat High School, which had about three thousand students. I taught French to tenth graders until April 17, 1975, the fall of Cambodia, when the Cambodian Khmer Rouge forces took over Cambodia. They forced all the civilians to leave the capital of Phnom Penh and other cities—to leave their homes, their land—and to go to places in the countryside or the jungle. They said that the Americans would come and bomb the capital and that they would clean out the city of enemy. They said it would only take them three days to accomplish the work of peace. They lied to us about those three days. They told us to take just some food and some clothes and to leave the door

of the house open so they would not have to burn them to get in to look for any enemy hiding there. Some civilians were shot in their houses because they reacted against the commands. The Khmer Rouge troops were mostly children from twelve to fifteen years old, led by one or two adult Khmer Rouge, but each of them carried at least two American or Chinese weapons. Some families committed suicide by driving cars into the river because they could not bear the threatening situation.

We were eighteen members in my family including my parents, my brothers and sisters and their families, and my grandmother. On the road to the western part of Phnom Penh, the Khmer Rouge confiscated all the cars, telling us that Angka Leu [the regime or the authority] needed them for the troops to protect us from the American invasion.

We walked along the Mekong River, the only road that they allowed civilians on. Everywhere there were decomposing corpses of those slain. This was a real scene from hell that I have never seen even in the movie or read about in books. The same day, I saw the uncle of Prince Sihanouk and his family, who stopped near a temple. The next day I heard that they took them back to Phnom Penh because Prince Sihanouk would come back there shortly from Beijing. And I knew that they killed them all.

My grandmother died on the way and they did not allow us to bury her; we left her body on the sidewalk. It took us one month to get to the place they said, Oudong, the former capital of Cambodia. Arriving in a village, they put us together in one group headed by a farmer called the president of the group. There were no shelters to stay; all the abandoned houses and temples had been destroyed by rockets. We had to build shelters by ourselves with our bare hands. We could borrow the blades or cleavers to cut the palm and bamboo to build our small huts in the jungle. April was the beginning of the rainy season; all farmers in the whole country started their farming work to make the fields ready for sowing. We had never had any idea about how to do such work, how to use the excrement of cows or buffalo as fertilizer, nothing. My father was General Director of Telecommunications. He had worked closely with Prince Sihanouk before when he was *chef d'état*, chief of state. Our life had been prosperous and the communist regime transferred our life from heaven to a real hell.

We worked day and night, from the morning star until the sunset, no matter if there was rain, thunder or lightning. They didn't give us much food to eat. The food that we had brought ran out long before. They distributed one small can of rice per person for two days; no meat or fish or salt was given out. We would cook the rice, collect some vegetables and then maybe find some small fish or crab to cut up in with the rice.

The Khmer Rouge started to spy on us, trying to get information

about who we were. We were very careful in the way we talked. The spies were everywhere. At night they stayed under the hut listening to what we were talking about. They were looking for people who had been in the army or the government or had been students. They started to take people away they suspected of belonging to these categories, saying that Angka needed educated people to build the new country. One day they told us that Prince Sihanouk came back from Beijing, and if anyone wanted to welcome him, they could come and register their names. A lot of civilians devoted to the prince were taken away and never came back. The main theory of the communists was to destroy the society and create a brand new one which would consist of a generation who had never been in contact with the larger civilization. Their goal was to draw Cambodia back to the year zero, then educate the children according to the Maoist regime. The leader of our work group had been in the department where my father was administrator. My father didn't recognize him, but he recognized my father. My father was very good to his employees and this man didn't report my father. He kept us there for one month.

Three months later, the Khmer Rouge started to evacuate people to the southwest part of the country where there was spacious land covered with jungle that could be transformed to agricultural areas. They moved thousands of families from different places in the north to that part of the country. Once again we stayed under the trees of the real jungle near the mountains—amid tigers, deer and other wild animals and all kinds of poisonous snakes. All of our clothes got wet; we had nothing to protect ourselves from the furious thunderstorms. We built huts made from twigs and leaves because we did not have any plastic cloth to cover as a roof. At night we heard all kinds of strange noises mixed with the mourning cries of people whose family members died miserably. The next day they put us to work clearing the forest to make the field ready for planting. We did not receive any food from them. I followed some of the people who worked in the same group to look for bulbs of wild plants, catching a snake no matter poisonous or not, scorpions, lizards. I watched the birds to find out which fruits of wild trees were edible. If they ate the fruits, I assumed that humans could eat too. A lot of people died of starvation and disease.

The Khmer Rouge forced us to work in the fields from sunrise to sunset without a break. That time was late in the rainy season and we had to hurry to get the rice planted. Then we had to plant yucca. We got sick and there was no medicine.

During that time, the Angka Leu assigned an irrigation project to dig canals that would join one river to another in order to bring water to the fields. Thousands of teenagers were brought into the area to accomplish

the plan. Without tractors or machines, they used human strength to do that work from the rising of the morning star to the sunset. We did not know if it was Monday, Tuesday, or Sunday; we looked at where the sun was to tell time. They used human beings to replace the cow or buffalo to pull the plows. Every day people died of starvation or disease; I could not know exactly how many—at least a hundred a day. Thousands of mosquitoes flew in the air. The mosquito net that we had brought with us got torn and could not protect us from the bites. Malaria spread from one place to another. A lot of people had malaria, but no medicine to help cure them. They injected coconut juice into the body and that helped alleviate the high fever for a little while. Who died first had relatives or friends who helped bury their bodies. After some months, the place was almost empty. When someone died there was hardly a friend or relative to bury the body.

They took people to kill when they found out they had been teachers, students or soldiers. All the time they were trying to get information about the previous times. They would ask small children, what did your father, your mother, your brothers or your sisters do before? They would give them food to eat and get the information. Or they would threaten them; faced with death and starvation, some children confessed the identity of their parents or relatives. Then at night, they would come for the mother or the father and take them away. Those people never came back. A lot of people died that way. One of the spies recognized my father and they took him—he never came back. After that, they sent my older brother to the mountain for the hydraulic project, but I knew that they killed him because he wore glasses—they identified that with being an intellectual. My younger brother died some weeks after of disease and no food.

The first harvest season came and they sent most of us down to the fields to get the crops. Finally the Khmer Rouge started to provide us with some food, not much. We worked very hard, got the crop in, and they gave us more food then. They gave us some vegetables from the villages around and provided some beef and fish from the Tonle Sap lake. But that did not last long. Two months after that, they sent all the crops to China to pay back the debt they owed the Chinese government, so there was no more food for us to eat. Pol Pot [the *nom de guerre* of Saloth Sar, the Khmer Rouge leader], who had gotten an education in Paris and from the Chinese Communists, had borrowed money to overthrow the Lon Nol government. A lot of people died. We didn't have any kind of medicine at all.

They transferred people to work in one place and after the work was done, they were sent to another place. I was sent to the mountain where the hydraulic project was going on. I had to dig five square meters and carry

the debris up to the edge of the canal in order to get a small bowl of rice soup per day.

Once again we faced starvation. The second rainy season began and we had to prepare the field and sow. My older sister died in the field while she was working. One after another, my younger sister, my sister-in-law. . . . I am not going to tell you all the details. Everyone now knows about the holocaust in Cambodia. The movie *The Killing Fields* described clearly why Cambodia fell into the hands of the communists and three million people were lost in four years.

In the fourth year, on January 7, 1979, Vietnamese troops, along with some Cambodian Communists who betrayed Pol Pot, invaded Cambodia and took control of Phnom Penh. They sent troops straight to the west, to the Thai-Cambodian border on Route 5, to protect the border and to cut off supplies to the Khmer Rouge. In May 1979, some Vietnamese troops went up to the mountain to release us from the Khmer Rouge—five months later! I had only my mother and my daughter left. Everyone else had died. We walked from the work camp to the national road, carrying some rice taken from one village we had crossed. There was no transportation and we stayed one month in the province of Pursat, expecting to find some surviving friends or relatives. I went to the Vietnamese governor's house which was the city hall, to find out if I could get some work to get rice to feed my mother and my daughter. She was eight years old then. They reopened an elementary school after the Khmer Rouge destroyed all schools and temples. I taught more than fifty children in a Buddhist temple; all of them sat on the floor, using charcoal to write on pieces of wooden board. Then I decided to take my mother and my daughter to Phnom Penh by getting a ride on a truck with some Vietnamese troops. I thought I could get some food or find work there.

The first week in Phnom Penh, I found my younger brother who I believed was still studying in France. He went there to study in 1972. In 1976 he came back to Cambodia because the Khmer Rouge government called all the students who were in different countries, the U.S. and Europe, to come back to serve the government, they said. My brother had had no news of the family, so he went back when they sent for him in 1976. It was a shock to see him, but I was so happy that God kept him alive. Thousands of students who went back to Phnom Penh were killed in the Tuol Sleng prison. Tuol Sleng was a high school where I had worked before the fall of Cambodia and before the Khmer Rouge turned it into a prison. It is now a museum to show the atrocities and barbarities of the Communist regime. One of my older brothers, the third child in the family, came to the U.S. in 1961 or 1962. After he got his Ph.D., I think in 1969,

he planned to go back, but my father told him not to come. He told him to try to stay in this country. My brother didn't know what to do, but then the government of Venezuela hired him and he moved to Venezuela in 1970.

My mother wanted to see our old house. When we got to Phnom Penh, I found out we couldn't stay in our house because there were five families already living there. They wouldn't let us in. I found a small apartment near the Monument of Independence where we could live.

The first week in Phnom Penh, I ran into one of my mother's friends who was director of the Department of Education and he offered me a job in a high school near the place we stayed. I started to teach the ninth and tenth grades again, but not teaching French. I had to teach math, geography and communist theory in the Khmer language. When I learned math I learned it in the French language, but sometime around 1966 or '67, they started teaching math and science in Cambodian. Teaching in any other language than Khmer was forbidden. So if I was going to do the job, I had to learn math in Cambodian quickly. We didn't get paid in money—there was no money—we got paid in rice.

I felt some release when I saw some of the former teachers again. Education was resurrected. The National Library had been destroyed. Most of the books were burned under the Khmer Rouge and the rest were sold by the kilo to be recycled. The surviving teachers started to write some books for the department, but under the restrictions of a Vietnamese consultant called an "expert." They changed the methodology of instruction. No history subject was introduced to the program; instead the students had to learn about the theories of Lenin, Stalin and Ho Chi Minh, along with their biographies. As the National Bank was burned down in bombings, there was no currency in use at the time. All items in the market were exchanged for goods or rice measured in kilos. I earned fifteen kilos of rice per month. I had no shoes; I went to work barefoot and I only had one set of clothes. I asked a friend who lived in another part of town; she had some clothes left and gave me a skirt and a shirt. So I had one set to change. After I got paid, I traded rice for a pair of plastic shoes to wear to work.

But then I took my mother to see the old house. She cried a lot. She looked at the house, and she saw my father and all the children who had died. When she went back to the place we stayed, she was very sad. Two months later my mother died of despair and sadness.

My younger brother tried to find a way out, because we knew we could not live under this regime anymore. He remembered the address of our brother in Venezuela and knew a friend at the airport. So we sent him a letter secretly. This friend posted it somewhere, Singapore, maybe. We

told him there were only the three of us alive. Finally, in 1980 my older brother sent money to Khao-I-Dang refugee camp in Thailand, to a friend there, to hire a guide who would come to Phnom Penh and help us escape to Khao-I-Dang.

When this guide reached us, we took a train to Battambang, and then walked from Battambang to the border. It took us five days to walk that distance. That was January 1981—a year and a half after the Vietnamese invasion! When we got to the Thai border, we met a lot of Khmer Rouge soldiers with new equipment, uniforms and weapons going down the road. We were threatened when they stopped us; we thought they would kill us, but after they found out that we were not Vietnamese, they changed their attitude and became nice and gave us water to drink. On that day there was a big attack between the Khmer Rouge and the Vietnamese near Chamcar Kor Khmer Rouge camp. Along the road, we saw an oxen cart blown up by a mine and human heads hanging bloody from the trees. We stayed three hours at Chamcar Kor, but the Khmer Rouge did not let anybody cross the Thai border. We said we just wanted to do some trading, to make a living. I lied and said I had a baby in the village. The guide said I was his wife; he had a very dark complexion. So we played like husband and wife. The Khmer Rouge gave us food and water. They wanted us to stay there of course. We said okay, but we needed to go to the border to sell things from the village. Around nine o'clock, we ran across the border and they shot at us, but no one got hurt. We walked that whole night, and about five A.M. we got to Khao-I-Dang, but we couldn't get in because they weren't letting any more refugees in then. They patrolled around the camp and we decided to do anything we had to to get in.

We started to dig a hole under the fence. I pushed my daughter in, then I crawled under. My brother had gotten married, so he and his wife got in too. My back was bleeding from being cut by the fence. We got to a corner by the hospital and hid near the garden. We decided to wait for daylight, then walk with other people when we saw them moving about. When we saw some people, we got up and walked with them to the friend who my brother had written to. We stayed with him for the day. At Khao-I-Dang we knew one American lady who was director of the hospital and my older brother sent us some money through her. Luckily, one month later there was an influx of refugees toward the third country under the refugee program sponsored by the United States government and our names were on the list. During the processing period, the JVA [Joint Voluntary Agency] conducted the course of orientation for all refugees before leaving to the United States. I learned English. It took me two weeks to remember the English pronunciation of the ABCs instead of the French pronunciation. It

seemed like I lost the habit to remember. I forgot what I had learned before; I even forgot my friends' names.

In September 1981, we arrived here, the place of freedom, education and future. I dreamed of working in a school because I had been a teacher in Cambodia.

I didn't learn much English in the camp. I took ESL [English as a Second Language] classes here and I took secretarial courses for six months. After I graduated, I got a job at the Adult and Community Education School helping people in the community to understand English and to start their new lives in the new land. My younger brother went to a community college; his English was better after six months. He moved to California to live near his brother-in-law. He continued his education and got his master's degree in chemistry three years ago. He was an engineer in chemistry in Cambodia. My father had sent him to Paris to study for the doctorate. Now he works as a research associate for a company in California.

In November 1982, someone told me about a job. I was afraid that I couldn't do it, but luckily I tried and got hired and started work there in November 1982. I tried my best to learn how to work in this country. In October 1983, I got a second job as a teacher's aide.

My daugher went to high school and continued on to college. She just finished last year. She got a job as a staff accountant in a nonprofit organization in town.

My older brother moved back to be near me. He says he has lost everyone, so he came to live near me, his only sister left.

You know, women in our traditional culture, especially the educated women, we had to learn to be brave and to make decisions. When I was a teacher, I couldn't even drive a car, no woman could, I had to be dropped off by a chauffeur and then be picked up. Then we went to the jungle and had to find food to eat and ways to survive. The Khmer Rouge brought Cambodia back to the time of prehistory. But we moved beyond.

That's my story.

NY JEWELL, 1980

In 1975, the Khmer Rouge Communist Party took over Phnom Penh. Me, my mom, my dad, my husband and my daughter, they kicked us out of the house. Just like everybody else, we left everything there at home. We had tried to get out before the revolution got so far. We had passports and

all, but then it was too late. They dropped bombs around the airport and we couldn't get away then. We tried to leave by going toward Battambang, to get to Thailand, but they were bombing and shelling everywhere around the city. So we were caught in the middle, listening to the explosions every night and every day.

We were stuck there. That night, we heard the bombs in Phnom Penh. My mom had taken everything—jewelry and clothes—and put them in the palace. We had been working for the king. My mom was raised by an aunt. That aunt was married to the king in the old time, so we were brought up in a palace, as dancers for the king. My mom was a dancer [Khmer classical dance], my aunt was, my grandmother was, and I was a dancer at the palace. That's several generations.

My mom thought that if we put all our stuff, our private jewelry and clothes and valuables in the palace where we used to live, that would be a safe place. They were dropping bombs really close by. So that meant when we left, we were really empty-handed. When I left the house that morning I was in pajamas because the guns were at my head. My mom had clothes on, my husband had clothes on, but my baby daughter was still in pajamas too. I had flip-flops on and we carried one teapot and a cup of rice in a bag. My dad really panicked and my mom was really stunned, like she didn't know what she was doing. She even forgot the number [combination] of the lock on the safe box that we had put some other things inside. She forgot that number! And the Pol Pot are saying, get out, get out, get out. My mom said, all right, I'm going. Then they turned around to another house and my husband asked her what was the number because we didn't want to carry the big box with us. She said she didn't know. She told us to get an axe or something to break it open and that safety box was so strong, we couldn't believe it. My husband took it down to the basement and finally they broke the lock. We had some jewelry and a little gold that we could take with us in there. But most of what we had was in the case at the palace.

My father—oh, there was one man, he used to work for my dad. He had a son with us, around three or four years old. My mom had kind of raised both of them. One day he just disappeared from our house. See now, I'm going back and forth. One day he just disappeared, several months before. We didn't know where he was and he left his son with us. My mom raised his son just like my daughter—took him to school and all. That day, when the Pol Pot came to tell us to get out of town, he had come back to get his son the night before. He came back in the night because he knew where our house was and who we were. He came, knocked at the door and came in. He was dressed as a Pol Pot—all black and guns and everything.

My father was so upset. He told my father and my husband that he was really glad we had taken good care of his son. He could see that he looked good and he appreciated it. But he said there was nothing he could do about what was going to happen to us. "I'm working for them because I knew one day the Khmer Rouge would take over. All I can do is to give you a tip. Don't tell anyone what your backgrounds are and what you do for a living. If you are a teacher or they know you have any education, they will kill you. The best thing to do is tell them you're a farmer or drive a taxicab or you stay home and take care of the children. Don't say you're a dancer in the palace or anything like that. They will kill you right away."

My old father had to shave his hair off to not let them know he was an official. He is half Chinese and half Cambodian, so he is very light-skinned. The palm of the hands, that is how they test you. They feel the palm of your hand. If your palm is rough and grumpy, they say okay, you probably work in the field or something. But if the palm of your hand is very soft and mushy, they keep you to one side and you know they will kill you. Finally he took his son back. I told him, you can have your son and whatever you left in the house that's yours. Not because I was trying to be friendly, but because we were scared because he had a gun, he could kill us, plus he knew our backgrounds. But he just came and told us how to survive—to do what they tell us. If they say go left, go left, go right, go right. Be careful, don't say anything about our education or the politics in the palace. Anyway, he took his son and my father went down the basement, shaved his hair off and put on really old clothes. My husband changed his clothes and we all practiced what we would say. I was just a housewife; my mom was just my mom who helped raise my daughter. No maids—we had two maids, but we let them go back to their homes. But then we were stuck because everybody could only move in the direction they said, one direction. You could not go where you wanted or go back to your house after you left. My maids couldn't go back to their houses, so they went with us. We took the jewelry we had in that safety box, some clothes, flip-flops, no regular shoes at all, and we left. My husband had a motorcycle and he took that along. He left the car because they wouldn't let you take a car. They wanted everyone to walk—several thousand on the road. They had one direction along the Mekong for people from one section of the city to go and another section to go toward Battambang. My father insisted we go along the Mekong because that's where my father's relatives lived. He had an uncle he thought was close by so we wouldn't have to struggle walking for so long. So we started off and when we got out we saw the dead bodies.

All the houses in Phnom Penh were left open when people left. You could go and get anything you needed to help survive. The man who had

come told us not to take anything heavy because we'd be going to walk a long way. "You're not going to ride in a Mercedes or even on a motorcycle. You're going to walk on your bare feet. Make sure you have some rice and something to eat—some dry food." So when we went past an open store, we'd just grab a can of food or something like that. We didn't get anything to be pretty—that time was past and not going to be anymore. We walked along the Mekong with many, many people. As we walked along, we'd see a store open with perhaps some canned food or rice. We had no knives, nothing to cut the fish if we could catch them. Finally, we got a knife from someone's house. We had no plates; we ate the food with banana leaves. Along the Mekong a lot of bananas grow. We just cut the leaves with the knife. We cooked—we got a pot that someone left—we got that and cooked the rice. We grabbed some salt from someone's house along the way and so we ate the rice with the salt. If we got fish, we ate it, if not, no. The canned food we tried to save till we were really desperate for food to eat. In that time the communists, they set up every five or six kilometers, a place that had rice and food and all that. It made people rush to get there to get something to eat. But then they would kick us out at nighttime—say we had to get out. So you had to go farther to where you were supposed to go.

We saw people burning money to cook food. The money had no value anymore, gold no value, diamonds no value. For the Khmer Rouge the value was asking, "Can you offer me a cup of water? Can you offer me some rice?" If they gave it to you, they gave it to you. If they had none, "Sorry, I don't have any." The people [in the villages], like I said, Phnom Penh was the last spot the communists took over. So the countryside had already been brainwashed. They already knew the system of the communists. We were like prisoners of the Pol Pot. They treated us badly. But they had their rules. For example, if we saw some food on the table and we asked them, they would have to offer us something to eat. That was the rule because the communists made everyone equal. You have one cup of rice, I have one cup of rice. So they have to listen to that rule, otherwise they would disappear also. Later, of course, they would hide when they ate so they wouldn't have to share. When we went through the villages along the Mekong, in each village we had to ask for something to eat, even water. We saw people die, we saw a woman give birth on the street, we saw a man holding a whole bag of money—several million riels of money—holding it in a white flour bag—and he had a heart attack and died holding that bag of money. We saw how people were really crazy about the money. We couldn't find anything else to cook the rice, but money we could burn to cook the rice to eat.

My mom didn't talk much, didn't each much. It was like her mind was

gone. We felt like we were dragging her along like a sick person. It was hard, we were leading her along. My daughter sat on the motorcycle and we pushed it along. We got to the point we had no energy left to push the motorcycle because it was so big and heavy. We took the wheels off and made a cart—put the wheels on, built it up and tied it all together with banana strings and whatever. My husband and father had the idea. We put my daughter and my mom in so we could pull them along that way. I still had my pajamas on. We finally asked some women for some clothes for me to wear. They gave me a sarong to wrap around me and a long-sleeved blouse because I was red all over from the sun. She said, "Poor thing, I'll give you a long-sleeved blouse." Thank God.

We had to cross the river to my father's side where his relatives' village was. We had to go in a boat. The day before that, four boats had been sunk. Pol Pot didn't care, they put as many people as they want in the boat to get rid of them. They wanted us dead or out of there. They hadn't sent us to my father's village, it just happened that we tried to get in the right section to go that way—the right place at the right time. I think that the Pol Pot knew that at least there was something for people to drink along the Mekong River, that's why they used that road out of Phnom Penh. Others they sent along another route toward Battambang; that's where the rice is. So they had two separate routes to send people. There was no choice.

Well, we got in the boat and we prayed. There were three boats going back and forth all day, all night long. We could have died because there were so many people in the boat. They put people on the bottom of the boat, in the middle and on the top. They put people everywhere. When I saw the first boat go in the morning, I saw people with their legs hanging over in the water because it was so full. They didn't care. The bottom [gunwale] was five inches from the water, it was so full. They still kept going, going, going. We prayed and finally we got to land. We walked to my father's village and stayed there. But like I said, the village people had all been brainwashed. They couldn't help you. They said, "Well, I'm your aunt, I'm your uncle, here's rice and food to eat and clothes to wear." They said, "You just came from Phnom Penh, that's it." They didn't want to say we were prisoners, but they couldn't help us. You just have to do like everyone else does. I catch fish, you have to catch fish, everything evenly. You know my background—I came from Pnhom Penh and we used to live in the palace, so we didn't even know how to hold a fishhook. We didn't know how to fish, to get an axe to cut the wood to burn. My father said, uncle, you've got to help us, otherwise we cannot survive. And he said, if we help you, the whole family will be killed. And when he talked about the whole family in that village, my father's family was a big family. They

would kill more than just us five people. So we stayed there only about four months. They gave us five kernels of corn, five pieces of corn a day, and we put a lot of vegetables, whatever leaves we found, and we cooked that. My mother could not walk; I could not walk because we were so weak from having nothing to eat. So then my father's uncle came and said we had to get out because he could not stand to see us like that. "If you don't leave, we're going to kill you rather than watch you die from starvation. We don't want to see that, so we will kill you." My father had to make the decision that we had to leave that night. By the way, my father's uncle was like a leader in that village, so he got us a letter for us to leave the village because to move from one village to another you had to have a letter [of authorization]. We had permission to leave for whatever reason. Now we decided we had to go back to wherever my mother had come from. When you're starving, no food, you get grumpy, you're sick. We had arguments a lot, a lot. But we had to walk back. My father said he didn't think he could survive, that it was too far. My husband said we should walk toward Thailand in case we could escape.

At that time they still had the train that went up that side toward Battambang. That was on the side to go to Thailand. So we wanted to get on that train. We walked several months, went across the Mekong, and back to Phnom Penh again to get to the place we could get on the train. The train was still running back and forth out of the city in 1975. The communists were still arranging how people would go where they wanted them—like several thousand to the Battambang side, several thousand here and there on the Mekong side. They were still arranging, so we could go and it wasn't really so bad. But how to struggle from one place to another? What if we met a soldier? What were we going to say? What were we going to do? How were we going to get something to eat? What we did was move only in the daytime, not at night. At night we just found someplace to sleep and in the daytime we just moved along with other people who didn't have an assigned place to go yet. We got to the train and we got on—it was like pigs. People went to the bathroom, everything. You had to sit with sick people, people crazy because they lost their homes. They lost their minds. I'm not saying my mom lost her mind, but she didn't talk. We just had to carry her, pull her along. We got the train and went to the Battambang side. We got out and now they're asking us, testing us again. "Where did you come from? What were you doing before?" They felt my father's hand, they felt my husband's. They were never so strict with women, but they were really strict with men. My father and my husband both said they drove taxicabs and then when the season changed, they would come back to their wives and do all the corn and sell it in the

34

market. That was our story and we kept repeating that same story. They said, "Okay, you don't look too bad, but everything you have, you have to leave here." That's not the rule of course, but you know people, they try to survive also. Remember the gold we had? My mom had sewn some gold into the seams of her skirt, so she put that in. She had sewn some gold and jewels, a couple of diamonds, into the waistband of her skirt. They weren't set yet, only stones. She put all that in there. Some of the women of the Khmer Rouge, they liked gold, because you know, they were still women and they liked gold. They would exchange it for food or rice or medication, whatever was needed.

Now we get off the train, we get on a truck and we go to the city of Battambang. But they wouldn't let us stay in the city, they wanted us in the countryside — the fields. They put us in trucks, like army trucks, and said, okay, these fifteen trucks go to this village so and so, #1, #2, #3, whatever. We were praying, we knew the farther and deeper you go, the sickness was worse. The mosquitoes bite something fierce and you get sick and there's no medication. The people who live there deep in the mountains, they're like Indians in this country. They chew the bark of the tree for medicine. They don't believe in medication like we did in the city. They don't believe in schools or in wearing shoes because God made the earth for bare feet. The women just wear a little tank top and a skirt, like the traditional wrapping. No jewelry, no nothing. Some of them wear a little bit of silver. They speak very differently. It's the same language, but a different dialect in the high mountains, the north and the south. So we kept back, every time they'd write the name and say "Okay, you go to that truck," we tried to stay away to get a high number. They started from the deep, deep side of the mountain, then came closer and closer to the city. Finally, we got between Battambang city and the deep mountain, kind of in the middle.

While we were on the truck going to that village — it's so funny. I had never seen rice growing. I never saw it before. I knew rice, but not how it grows. I'm talking to my mom, saying it's no wonder these people are so poor, look, they cannot even cut the grass. The grass grows all the way to your chest. My mom said I had better not ever say that again. "That's rice," she told me, and she told me how it grows. "You're going to learn all about it, but don't ever repeat that again." I couldn't imagine how these people were so lazy. And me, so dumb, doesn't even know what rice looks like. Or what leeches look like.

We got off the truck and started looking for water to drink. In my country it rains a lot and there are always lots of puddles and ponds. I had a little bucket and went to get water from a small pond. I put my feet in

the pond and the leeches—swoosh. They came to me and I didn't know what leeches are. They came to me and I thought, boy, what a lot of fish, I'll never starve again. I picked up a bucket of water with the leeches in it and went to show my mom. I said, mom, you're not going to starve anymore. I told her not to worry, we're not going to starve. I put my foot in and the fish came to me and I caught them like that. No hook or anything. When we were on my father's side, they taught us to put the hook on, the fish on the hook. It was so different here, the fish came to my bucket. My mother was crying and saying, "Oh, you poor thing, I hope you survive." She told me they weren't fish, they were leeches—they suck your blood and they make you sick. They stick on your feet, they don't come off and you have to grab them and—ugh! So I got them out and started to boil the water. We knew one thing. My father liked tea because the Chinese, they drink a lot of tea, so we always boiled the water. Some people got sick because they didn't drink boiled water. We always drank boiled water. Plus when you boil the water, all the dirt goes down to the bottom.

Now we get to the village and at that time I was about twenty-two or twenty-three years old. I had clothes then. I had flip-flops. Someone looked at me and asked why did I wear those. Three words, and I couldn't figure out what they were saying. I speak the same language, but the tone is so different, so strong. I couldn't understand. They asked if they could have the shoes. That's the rule of the Khmer Rouge—if someone asks, you have to give it to them because they don't have anything, that's why they ask. I said no, I'm not going to give them to you, this is the only pair I have. I started an argument with that old lady. They took me to the councillor or whatever and said, "This lady asked her if she could have her shoes and she said no. Maybe she has another pair of shoes in her pack. She doesn't want to give them to us." My mom told me to give them the flip-flops, give them to them, give them to them. So I gave them the flip-flops and I never wore shoes again for three and a half years.

The next day they had a big meeting. They always had meetings—at night, every single night. We would go to work at five in the morning and come home when the sun set. Then eat, have maybe an hour to shower or whatever, then go to a meeting and sit until midnight. It was like brainwashing, telling you about the communist rules, the sexual life, no rape and so on. One thing about the communists—that particular thing—I liked. There were no whores, no rape. Women were safe. No man would dare touch a woman. You could walk through the jungle by yourself, even at nighttime. If you said, "I want to go pick up some wood by myself," you could walk there alone, no problem. Men would pass by you, look at you like a board. They were not interested in you. They were really strict about

that. If a man touched a woman, or raped her, they would really punish him badly. They cut off pieces of his flesh day by day. Everyone was scared, but women were safe.

The problem was they divided us up. The men went in one section to work, the women to another. A woman like me, twenty-something, they called us frontline workers. I had to work really hard, digging the ground to make roads. My mom, she's old now, but then she could still work in the fields. I had my daughter though, very small, three or four years old. My mom wanted to watch her and another child. They said my mom sang beautifully, so she could sing and read some stories to the children. She could survive in that job. The Khmer Rouge wanted to raise all the small children and brainwash them. My mom was supposed to sing songs and read books and say whatever they taught her, and she was to teach the kids then. For example, if the Khmer Rouge say you have to kill your mom, you have to kill her. You, when you grow up, you don't have to think, well, I owe my mom my life or I owe my parents something because they brought me here. No. They don't believe that. This is what you should believe— they had sex together, they enjoyed life together and then they had you. You don't owe them. If they do wrong, kill them. That's the communists.

My mom stayed home then and watched all those little children, including my daughter. My husband, they sent him way out of the village. You know Battambang is famous for bamboo. They put my husband to work on the bamboo side, cutting. Me, I worked frontline work because of my age. A whole year we didn't see each other. I just worked in the fields, rice fields. And when it wasn't raining, we built roads. They didn't have any equipment, anything electric or anything. I worked like that all day. They didn't give you any food; that's how they punished you. So we worked in the fields night and day with no food to eat. My father was there less than a year and then he passed away. He wasn't killed; he just had a terrible reaction to a bee sting. When he came home he was all swollen. He came home around six o'clock in the evening. We had no medicine. In that village there was one man who knew about herbal medicines, from the trees, the old-fashioned way. I went to him—around two o'clock my father's fever had gotten really high. He kept saying he wanted to take a bath. I said, "No, your fever is too high." I went to this old man's house and he said he was too tired. "I can't come to see your father. Tell him to hold on until morning." I told the man my father's fever was like two hundred degrees, please come, take a look and see if you have something to bring his fever down. He was too tired to walk; he needed his sleep. So when I got back, I told my mom the man wouldn't come. I was crying. My mom said maybe it's time we cannot have my father anymore. My

37

mom tried to boil some water with whatever medicine we had that she knew about. I held my father on my lap. He looked at me and I looked at him. I held my arms on his chest. He couldn't speak, his lungs were so swollen. He passed away on my lap.

My father died after a year there and I was still working on that farm. I was always stuck all over with leeches because everywhere I went, I was in water, in the rice fields and everywhere, they come. And I got a very high fever. I got sick, really, really sick. I don't know if it was from the leeches or whatever. But there was one really big one once, about ten inches long. I was in the water a long time and I got out and there was this thing wrapped around my ankle like a rope. I screamed and everyone laughed and they pulled it off. But I got sick.

My husband stayed back because my father passed away. I told them then, I don't have a husband or a father. If I get sick again, who's going to take care of my child? My mom cannot take care of her by herself because she was also watching all the other kids. They sent my husband to work close by then. Not to stay home, but to work close by. That doesn't mean he could rush home any minute, but a couple hours away to walk home.

Somehow then, they decided to send us—me, my husband, my mom and my daughter—to work fishing. Near Battambang there is a big river and a lake called Tonle Sap. We would be working there now. They shipped us there because I was sick so much. I wasn't as useful anymore and my mom was too old, so they said you go there and you're going to die there. But somehow we survived. My husband learned so quick. He learned to fish and I learned how to clean the fish and cut it up and make whatever they wanted me to make. Somehow we survived.

Then the Vietnamese invaded and took over. They said we could go back to whatever village we came from. We said yes! We had to get out from that area by the lake, get on the road to where we came from and then we could go home. But we decided to walk towards Thailand so we could leave Cambodia. We walked to the city of Battambang and then we started toward the border. We stayed a bit in Battambang and we knew there were a lot of Vietnamese soldiers there and a lot of guns and a lot of bombs and a lot of landmines. I had a few pieces of gold left. There were a lot of people all mixed up all over the place at that time. You could walk anywhere you wanted, go anywhere, but at night, you had to stay still. Some people exchanged their gold then. People in Battambang, they knew how to do business, buying and selling things at the border, so they knew how to get there. But they wanted some money—gold—to show you. My mom had something left, so we gave it to a man so he would take us. At that time

I was pregnant with another baby, my son. So I still had morning sickness. We had to walk at nighttime and the Vietnamese soldiers, they knew when you walked at nighttime in that direction, you're going to escape and they didn't want to let you go. They'd put you in jail again for wanting to get out of the country. We had to hide from the Vietnamese soldiers and hide from the Pol Pot also. Two enemies to watch out for. We walked at night. But before we left Battambang, we cooked a lot of rice and dried it to make it really dry, so we wouldn't have to cook along the way. We just put it in our mouths and sucked on it. We put some salt in it already to give it a little flavor. We had some fish and dried that too. We had that, so we didn't need a lot of food to go. That made it easier than the first time, plus we had some experience of walking. I still had morning sickness.

We gave the man some gold, so we walked to the border and got to Khao-I-Dang camp in Thailand. It took us four and a half months from Battambang to Khao-I-Dang camp!

I was there for one year and in the camp I developed a dance troupe. I met a film producer, a Swiss man. He was in Thailand and saw our troupe and met us. I taught a lot of children and my mom helped with costumes and dances. They were all new people; there were no old dancers from the palace there then, just me and my mom. Only one man, a dancer, he's in the movie [an hourlong documentary called "Dance of Tears," about the Khmer Classical Dance Troupe which the Swiss producer filmed in the United States]. He passed away after coming to the U.S.A.; he was in a car accident. He was a dancer at the palace before. So we did it together with our bare hands. We trained them all—the musicians too. My mom taught them too. Some of them knew some instruments from before, but not our music, our dance. We put them all together and performed outside in the field. We trained every day in the camp. A lot of dust, so horrible because it's so dry in Khao-I-Dang camp. It's really hot. No trees in that camp, just out in the field. But we struggled and then we met that producer and he said he would go back to the U.S. and get a sponsor and do all the paperwork for the whole troupe and get us to the U.S., which he did in 1980.

We developed the troupe here and performed. It was difficult. The church, I don't remember the name, we didn't take a bus or anything because the instruments were so big and so heavy. We struggled a lot—all these men, they carried those instruments, I think it must have been about a mile, from our apartment to that church, every afternoon until we really developed the troupe. I'm really glad to have him do the movie because— well, we still have a troupe, but it's not like before. Before, we were on welfare at first and could stay home and have more time to practice. The group stayed together. Now, people have jobs, some even have two jobs,

39

they work day and night. So it's not that easy to practice and stay together. We only perform at the temple and only on weekends now.

My mom still teaches, even me, at the Cambodian temple every Sunday afternoon at two o'clock. She is seventy-eight years old now. The program they have at the temple is they teach children the alphabet, starting at one o'clock and go through till five in the afternoon. At four, I start dancing instructions till five or sometimes five-thirty.

I've been divorced from my husband. He remarried and has a child. I remarried an American and have a child. My two other children live with my mom. My daughter is twenty-three and my son is thirteen. Now I have this little boy, he's five years old. My daughter is expecting. She married and is expecting. I'm going to be a grandmother! My daughter is married but they live in the apartment with my mom. She has arthritis. When she teaches, she usually stands up, she doesn't sit down or bend her knees anymore. She teaches more by telling than showing—I do more of showing that she tells me. The temple is beautiful. Hopefully they can buy that lot for sale next door and make more parking space. Every time we have a celebration, we have problems. The police give us problems because people park at people's houses, in driveways and they complain. You know, we don't owe any money to the bank or anything for that temple. We paid it all off. Two million dollars for that building and property. We do have a strong religion, our people.

My life is different now, I don't think I want to go back. For my children's sake, I want them to have an education. Right now Cambodia is not a safe place to live or have an education. There are still shootings. But I'd love to go see my hometown.

3

BOSNIA

Bosnia (with Herzegovina) is a roughly triangular-shaped territory with one point emptying into the Adriatic and bulging out between Serbia and Croatia. Bosnia's inhabitants are South Slavs like their neighbors, speak the same Serbo-Croatian language, but differ in that they are mostly Muslims, their ancestors having converted to Islam during centuries of Ottoman rule.

The first Yugoslavia, attempting to unite Balkan states already rooted in cultural, religious, political and economic divisions, came into existence after World War I and the dissolution of both the Austro-Hungarian and the Ottoman empires. During World War II Yugoslavia was invaded by the Nazis; Bosnia was incorporated into the Nazi satellite of the Independent State of Croatia, and most of Serbia was occupied by the Germans, with bloody civil war and interethnic violence following. Many Bosnian Muslims supported Croat fascists against the Serb-dominated Partisans.

After World War II, Tito (Josip Broz) succeeded in asserting his leadership of Yugoslavia and his own independent brand of communism; through careful balancing of ethnic considerations, repression and terror, he managed to subdue nationalist tendencies.

In 1991, after Yugoslavia's disintegration, war broke out between Croatia and Serbia. When the European Community recognized Croatia and Slovenia as independent states, Bosnia, rather than accept rule by Serbia or division between Croatia and Serbia, felt forced to apply for recognition as an independent state as well, angering Serbia. Nine months after war ignited in Croatia, Bosnia was drawn into the violence. Thousands fled then. The ancient Bosnian city of Mostar was destroyed, the siege of Sarajevo began in April 1992, and flight from Bosnia became nearly impossible for a time.

NIHADA J., 1993

Everything started in April 1992. Bosanski Šamac, the town we are from, was occupied in April 1992 by the Serbian Army. I was still working.

I was managing a department store and I was ordered to stay and continue my work. After two months, I was fired. The next day after I was fired, I was arrested and they took me to prison. They—the Serbian Army—took my car and the money I had with me and I was in prison for forty days. After forty days in prison, I was moved to a prison camp. I was there for five and a half months until they exchanged prisoners. I was exchanged 24 December 1992 in Dragalic for prisoners in Croatia, so I was free. I don't want to talk about that time in the prison camp.

When the Red Cross came to exchange prisoners, they had to have some explanation of why I was a prisoner. They said I had a radio or a radio station in my car. But my car didn't even have a radio at all, much less a special radio like they were talking about.

I didn't know anything about my children during that time. When I was in Croatia, after I was exchanged, then I somehow learned about my husband and my son and where they were. They were in Croatia, in Marija, a small village near Càrovac. We didn't know anything about my daughter because she was left behind. The three of them went from Šamac to Gradačac in Bosnia, and when the war started in Gradačac, my husband and son went to Croatia. My daughter, who was two, stayed with my brother and sister-in-law. We didn't know anything more about them. We knew they left Gradačac with my daughter, but we didn't know where they were.

They were in a village, Lušnica, in Bosnia, near Tuzla. I decided to go after my daughter. So I went to Zagreb and was looking for some transportation to get back to Bosnia to take my daughter out of Bosnia. I was waiting there, and finally, one day there was a bus going to Tuzla, so I went back to Bosnia. I was traveling three days from Zagreb to Tuzla. We were traveling through forests and on back roads, not on regular highways. I came to Srebrnica and had only a telephone number of one man I thought knew where she was. I arrived at four o'clock in the morning and I immediately called them. I told them my name and they knew I came to take my daughter. After fifteen minutes, a man came to take me to my daughter, because she was in the next village. At the time though, there was very deep snow on the ground and we didn't have any transportation. So we waited until morning and then we called some other men and they got word to my brother that I had come. So my brother brought me my daughter. It was hard for me to recognize her because I hadn't seen her for eleven months. She didn't recognize me. We stayed there for seven days waiting for transportation—a bus or anything to take us back to Croatia.

But then, on the border with Croatia, we had a problem. They didn't permit any more refugees into Croatia, so we stayed there at the border.

I finally had to pay someone two hundred fifty German marks just to get us into Croatia. Some people just smuggled us over the border.

When we got back to Croatia, we were put into one room about two by three meters—the four of us. It was a kind of a lodge with twenty or so people living there—with only one bathroom. We asked someone to transfer us somewhere where we would have better living conditions. In May 1993, they transferred us to an island in the Adriatic Sea called Korčula. The island was a resort area with a lot of private hotels taken over for refugees and run by the Croatian government. The hotels were full of refugees—Croatians from Croatia mostly. The Serbs had attacked Croatia by that time. Some woman wanted to do us a favor and put us there. The rest of the Muslims were in tents somewhere. She wanted to help us, but it was very bad.

At that time, you see, the Muslims and Croatians started war between them. It became very hard for a Muslim refugee from Bosnia in Croatia. In this hotel—it was almost the same as a camp—the rest of the refugees in this hotel were Croatians. We were the only Muslim family there, so we couldn't leave our room or go out for a walk. We were very scared. We were there four months and we just had to leave, to go somewhere else. One day we were out and someone grabbed my little girl and threw her into the sea. She almost drowned.

In the same town, there was another hotel with only Muslim refugees from Bosnia and someone set fire to it. So we had to leave. They made all sorts of other trouble for us. The director of the hotel, they told him we were Muslim and they were all Croatian, so he wanted to throw us out. The only choice was America.

On June 15, 1992, Stevan Todorović, who was known as "Steve," was supposed to execute me just because I was a Muslim woman. That did not happen because "Steve" was in a car accident on his way to Beograd, Serbia.

People who had been in prison camp were allowed to go as refugees to America, so I was one of those and the only choice was to go there. My husband was never in prison or a camp, only me, and that was a condition. So that was how we could go.

I had the first interview in Dubrovnik. After that I had two interviews in Split. All these procedures took three months. After that we came here. We came 17 September 1993. All four of us were together for the whole time after we found my daughter.

I had to take much more responsibility for us because of the war and having to leave than I would have before in Yugoslavia. Much, much more. It was not easy.

43

Compared with what we went through there, it's all right here. When we first came, it was very, very hard. No English, no money, no anything. Now it's a little better. Friends help us; they gave us some furniture. My husband cannot work. I got a job at night at McDonald's to have a little bit of money. But if I compare my life there before the war, it is not—I cannot compare it. We had a good life there. What we have now is nothing to compare.

I just hope the war will end and we will go back home. I think of going home even in five or ten years. I have two brothers and my sister in Bosnia. One brother was killed last year in May and two sisters are refugees in Germany. My mother and father died before the war.

I hope you never have to go through what we did.

Jasmina G., 1994

We lived in a town—a small town. So we knew each other. A lot of us were born there. We were brought up almost in the same way or a similar way. I don't know how much you know about the former Yugoslavia—I'm going to speak about Bosnia. I'm a Bosnian—a Bosnian Muslim. Where I belonged—that was Bosnia. We have strong feelings for that part of the former Yugoslavia. Most of us don't know how much we love a place while we live there, until we lose it.

That's the part of the country where various religions and cultures met. Muslims, Croats, Serbs and other peoples—Jewish, all lived there. There was a place near my town where there were thirty-six nationalities—even an Italian colony! We were used to living together. And when we realized that something was going to happen in our country—we weren't aware of that at first—maybe we didn't want to believe. We saw the war in Croatia, but we had the feeling of, Where did it come from? We are educated people in a way and we tried to be informed, to be well-informed. And we thought that the nucleus was in one part of the country, not ours, and that something was coming from there. It started like a small snowball which was getting bigger and bigger and rolling, you know. And running in front of it were all the people, families, buildings. But we didn't believe it would come to Bosnia because we couldn't believe—we really loved all people and we had a lot of friends of all nationalities and we have a lot of them now. But unfortunately, it did happen and the war broke out. Before the war broke out, we used to talk about what we saw. We were brought up to think with our heads. I remember from my childhood, my

44

parents taught us to use our own brain, not to follow just anybody, but to think, to use our brain. So we did not need a leader, any leader to tell us, we were thinking with our heads. And we were used to talking about what we thought. I am such a person, you know, I say what I think. I don't consider the consequences. Both of us are similar, really, my husband and me. We lived in an area where the government was of his nationality. We are a mixed marriage. My husband is a Serb. Although he is a Serb, he tried to be understanding, to speak as he thought. But it wasn't good for us. He had a good position in our town and we had lived there all our lives. In a small place like that, people know each other. We all lived together. And I told you, I didn't think of the consequences. We didn't plan anything. We just behaved as we used to behave. But there were people who were listening very carefully. I think they kept an eye especially on him because of his position.

I'm so confused, I can't explain this to myself even now. I look in the past and I look in the future and I don't know—when did it really start? The first step was that we were talking about what we were thinking. And we didn't care where we were, who we were talking to, we were speaking frankly. I don't know, really, I really don't know what caused our troubles—I think his attitude and that I'm a Muslim. In such situations you must determine your attitude, you cannot be neutral, in fact. Maybe you can, but if you are neutral, I think you live as a plant. We couldn't be plants, that's it. We suffered if our friends suffered—especially the Muslims. Their position was very difficult. We thought there was no reason to fight. Against who, really? We had no problems there. Nobody can tell us who were born and lived there that were problems among us. My thoughts go back, let's see, I can really remember forty years ago—I can be aware of that. And I can say that there were no problems, really. They were made, they are artificial, in fact. Somebody needed problems to make a new country. How many people would die was a thing of no importance for them. How many families would be destroyed? They did it, we say, Machiavellian. So we must determine, we must know where our place was. We wanted to say we wanted to live with all of them no matter what nationality, because we knew we could live together. And in our town there were some people—they were not an organization, not a political party, just some people—who wanted to say something for democracy. They wanted to say the same thing that we wanted to say and they organized peaceful walks in our town. They were really peaceful and were held on Sunday mornings. They were against the war, for the abolition of paramilitary forces, for a common life, that was the program. I can't remember all of the points, but those were the most important. My hus-

band was on a trip the first time they walked but I went. My sister went. We were citizens of that town, those who lived there and we felt it. There were maybe three thousand, maybe five thousand people, walking peacefully, saying nothing. But when my husband came back, he wanted to participate. The walks lasted one or two months. I can't remember if it was spring or autumn. I do remember the weather was fine. He insisted on going. I told him, there could be consequences for me, I know, I live in this area. But for you it will be worse, don't go, please. I asked him not to go. But he wanted to and I understood that. I wouldn't have understood if he didn't want to go. In fact, though I said don't go, if he had not gone, I would have been disappointed. So we went together. Most of the people walking were Muslims and Croats. There were a few Serbs. He was among them—maybe thirty. People were afraid. And they took our photos, made a film. One Sunday, during those walks, we put our signatures on a petition for life as it had been there, common life, both of us. There were four books with signatures, but we saw some people we knew, moving around us in the square to see who was there. Some more men taking photos and making a film "for TV," you know. We put our signatures and two of the books were stolen from the tables. The next thing that happened was we were bombed with teargas from the town hall. They threw teargas from the town hall. Some people were injured, we weren't. We weren't close to the town hall. The next day, on the air there was a radio broadcast that said people entered the town hall and ruined it. It wasn't touched! Really it wasn't. Those were lies. And then, those walks were forbidden. They were forbidden.

The next step was, I think, the Serbian government from our area organized a plebiscite. My husband was expected to go and vote in it. The plebiscite was for separating. They said they could not live with us, with others. They expected all the Serbs to come and vote. Most of them went. We saw it later, the results showed that most of them went. He didn't go, of course. They had their books. They knew who voted for the plebiscite and who didn't.

The next step was the referendum from Sarajevo, from the Bosnian government. It was a vote for Bosnia and for common life in Bosnia. And we went for the referendum. They knew that too. They were going around walking, the way they do when they want to see. And we voted for it. My husband was working at that time. If you didn't speak with hate about others, you were suspect. You had to express your feelings in public, as much hate as you could show, to show you were loyal to them. That's the truth. And people started to speak like that. My husband didn't. He continued speaking what he thought. And he felt that things around him were

changing. He was expected not to speak to Muslims, not to stand next to them, not to continue friendships. It was a horrible state. And for me—one minute in our lives, we didn't think we could do it. We didn't want to. How could we change our behavior like that? Can you imagine that? We could not.

I'll tell you how I felt something was about to happen. I worked in a hospital, a secretary. My children were grown up. I had plenty of time, so I used to start early to walk to work, to have time to get there early, have my coffee before I start, have a rest and not to be upset. And we always enjoyed—we had coffee together in our staffroom. All of a sudden, I felt when I entered the staffroom—I used to say hello, good morning to everybody—I felt that the conversation stopped. Most of the people were Serbs in my staffroom. There were Muslims and a few Croats. I used to sit here, as I'm sitting now. A few Muslims sat there, a few others, also Muslims, sat there. All of the others, the Serbs, were in one corner. Others told me too, they felt when they entered, the conversation stopped. There was a silence. They didn't want to speak in front of us. The topic was changed, I felt it. I didn't want to complain, and not to my husband. I thought it was like a disease, it will stop. They will see, we were living together. I was one of the employees there longest. We used to work together all those years. And we did quite well. I was good to everyone, there was no reason, and I expected they would see they were wrong. I expected they would remember how we lived. We had a lot of trips, had parties, spoke about our children—sad when they were ill and happy when they graduated. You know. That stopped all at once. They were prepared, they knew what was going to happen. They gave them weapons, you know. No one offered my husband a weapon, fortunately. He would not have taken it. We felt isolated.

I loved my work. But they started to fire first the Muslims. That was the first step, and then I was called into the office and the supervisor told me I would work only—he didn't know for how long—until the first Serb could come to take my place. They did not have skilled professionals at all levels. And he called me in—face to face. He wanted to tell me—to apologize in a way. He told me if he were one of those who prepared this, he wouldn't do it this way. "You know I don't want to fire people. But I must do it, I have to do it." I know he had to do it, but he could have re-signed. I wanted to help him, he was aware what he was doing was wrong. It wasn't fair and it wasn't human. But he did not want to lose his job. He liked being in charge. I knew him. He came from the country, from the village, and it was a grand thing for him to be there. I know, I told him. But very soon, all the Muslims were fired. And then things got worse and

worse. I even felt that—I forgot to tell you. That's some of the problem, I forget. I don't know the chronology anymore—when what happened. My husband helped the Muslims in his workplace. They were sent home at first; they were not fired. But they had to come every Friday or whatever to put their signature on personnel records. They had to come. On the first or last day of the month, whatever. They weren't fired, but the man at the door would not let them in. How could they put their signature if he wouldn't let them in? They were standing in front of the door. Many of them were my husband's school friends, his schoolmates. It didn't matter if they were. They used to call him to come out and take them in, and he did it. There were people who watched that, they knew he was helping them. He was protecting them and they knew that.

In those days, there was no electricity, there was no food. Even if you had money, there was no food to buy. They delivered food, the Red Cross delivered food in our town. Only to them. Not to others, not to other people, other nationalities. And they didn't give food to my husband, they wanted to punish him. It started then really.

I forgot to tell you. My son-in-law did not want to participate in this war. He is also a child of a mixed marriage. His mother is Croat, his father is Serb. And he married our daughter, also from a mixed marriage. And we were hiding him, so he wouldn't be mobilized. We were mad from fear. They used to come with weapons to take young men from home. He was not sleeping at home. We were afraid of the doorbell; we were afraid of the telephone, of everybody who was knocking at the door. He didn't sleep; he moved every night. His mother was mad from fear and his father. One evening, he took the last plane and a bag. One of his friends decided to leave and fortunately he did too. The next day, he couldn't believe it. He went by the last plane to Belgrade. That day in Belgrade, the government forbade the people from our area to leave the former Yugoslavia. They needed them to fight. Fortunately he left. My daughter left to join him a few months after her husband got out. They are a long way away. I haven't seen them for three years. My son had left earlier. He had gone abroad to another country to study. All those children from my family—my sister's, all my nephews, my friends' children—left, most of them. And that caused problems too. But I think the point was our political attitude, you know. They knew it and I think even if they wanted to kill those people, we would rather die with them than to betray what we believed, to shut friends out, to turn our backs. We were isolated, full of fear. And we continued like that. We did it as we used to do it, we only continued our friendships. Because, you know the friend in need is a friend in deed. We were scared, but there were others more scared.

48

Then an article appeared in the newspaper. It said some people, Muslim, Croats and Serbs, who were as my husband was, with certain positions, the local government asked them to resign—to resign in public. And in that article they mentioned me, they said he married a corrupt woman. That was his fault. He was guilty. After that, some people from the town hall went to his workplace to tell them that if they don't resign, they know how to make them resign. Of course, he resigned. He didn't stop work—he only resigned from that position. But in fact, nobody worked at that time because the roads were cut and people were fighting. He felt he was a sign, a symbol, do you know what I mean to say? Some people did not want to be with him because if they were with him, they would be guilty too. He felt it, but he pretended he didn't. He didn't suffer for that. He was sure inside he was doing right. But he began to think what would be the next step. He was called rude names. You've heard of *Ustashas* [extreme nationalist collaborators of the Nazis]? And we were called by telephone, day and night. They would threaten us that they would come and kill us. We never knew who it was, but it was organized. They called him rude names, me too. I didn't want him to answer the telephone because I think it was worse for him. I used to take the telephone. For example, a rural voice, a man, dead drunk, with a rural voice, uneducated, told me he will come and we will meet. When I asked who it was, he said one of his friends. I asked his name but he said, no, he will see me. "We will meet. I will come." Women called too, you won't believe, they were even worse. When they are evil, they are worse. And one day, he came home very pale. I asked him what happened, why he was so pale. He said a man with a gun asked him what was he waiting for—what was he waiting for. Why didn't he leave?

One day, a man called him and told him that there was a demand for him, to forbid him to leave the area. And it really was so. They said it was the trade union, but in fact, it was not the trade union. Somebody was behind that, you know, they always find people to do what they want. And as a rule, all those people who do it, they were so ill, this was hard time. They are, most of them, without education, with complexes—lazy, most of them.

We felt as in a ghetto there all the time. Every morning, we were very frightened. We expected somebody to come kill us. When I entered our flat, for example—we had a big flat and I loved my home. We furnished it with love, really. We had—we really lived nicely, as a family. My home was full of joy. We used to sing together. Suddenly, everything stopped. We were alone, the two of us. We felt as in a ghetto—it was a ghetto for us. After that article in the newspaper—at that time, I worked, but we had

49

a vacation because there was no electricity. I didn't leave my house for fifteen days. My closest relatives came to see why, I was so sad. I locked the door. We had a chain, two locks. I was in the room farthest from the front door, lying in bed, and listening and waiting. And after twelve days, I decided to face it, to see people in the street again. I had to because I was to start to work again after the vacation. I put on my clothes—I liked to dress well, to have clean hair. They hated that, you know. Can you believe? It was not against me, but generally. It's unbelievable. And I went to work. I decided to take a firm approach, to be strong. And you won't believe, some people did not want to greet me or even to see me. They pretended they didn't see me. Suddenly, I saw in their eyes understanding. They were on our side, you could see. Some of them even wanted to say something to show how absurd. A few of my colleagues came later to my home to say they were sorry. They knew we were not guilty, and they didn't have the courage to show it in public. And I told them I didn't want them to—I know you will be punished and you won't help us. But it meant a lot to me, I appreciated it. For example, one woman, I worked with her only two years. She used to bring a piece of smoked meat from her home in the countryside. She just came up next to my purse and slipped it in.

Finally, we went into hiding and we were illegally in another town for a year, not quite a year. We were helped by some friends. Then we heard about this opportunity to come as refugees of a mixed marriage. And we did it. The IOM organization [International Organization for Migration]. We went straight to them and told them our story. We weren't shot, I wasn't raped. We weren't in the region where there were battles. But in fact, there was no place for us, no place for us to stay.

There are things I have not told you. You must forgive me, I cannot. Maybe someday I can talk about them. I can't now. One day, maybe.

Now I feel more stable, I think. I didn't tell you after we left the town, I lost my period, all at once. I felt very badly, I got a very high temperature. I think I was really under stress. I didn't go to the doctor. I didn't have insurance of course. I didn't think there was any reason to go. But I was really, really sick. I couldn't walk, I couldn't stand on my feet. I fainted. I was afraid to take the bus. My husband was holding me like a child. I lost my period, I had high temperature for a few days, there was no reason. In fact, I think it was stress. There were days when I wanted to be dead. I thought all my problems would be solved then. There was no sense in some days. I even, sometimes, I wasn't even aware that I had children. I wasn't able to laugh. My husband—we really have a good marriage. I worked one week in the morning, one week in the afternoon. When I worked in the afternoon, he used to come to meet me and we used to walk. We are used

50

to walking. We had an organized life. I had some outside interests. I lost that too. My life changed completely. When one goes through all this, one changes. I feel I am not the same person. Nothing is too dramatic in my story, but I am not the same person. We are not the same persons we were before. My husband is different. I see the way he walks. He is not the same. He is also another person, a different person. Me too.

Now I work in a shop. The other day, there was a lady customer. I was feeling good—I do feel better now after I started work—we've only been here four months. I have someone to share my thoughts, someone to joke with, to talk to, and they are very kind to me. It's a good opportunity to meet various characters. Some of the customers are very kind, some are rude, but that's people's natures. Everywhere it's the same. But I like it, really. I feel at home there. The other day, a young lady came in. She told me she was short of time. She had a flight that evening and she wanted to buy some clothes. And she went from one thing to another like a butterfly. Without a care. Joyful and carefree. In one moment my good mood disappeared. I didn't tell her. I felt I used to be what she was that day. I felt that I lost joy in life. I haven't felt it for a long time. I'm happy we are all alive. I know we are alive—we lost all we had, but I don't care about that really. I don't care. Those are only things. I can't wear a hundred blouses. I like beautiful blouses, but I can have two or three. I never had a hundred anyway. I don't care. I don't want pity. I'm not sorry in the material sense. But I lost joy in life. Joy. Something inside is gone. I feel like I am old, a hundred years. There were a lot of changes.

We used to gather in my husband's mother's yard. My son-in-law's parents, my nephew and his wife, us, my husband's sister and his niece and then his nephew with his wife. His nephew is also a mixed marriage—his mother is a Muslim, his father a Serb. His wife is a Muslim. And all of us, we shared our troubles and thoughts. We all were planning where to go and we all left. All left. All the people I mentioned, all left.

4

ETHIOPIA

Ethiopia is the oldest independent country in Africa and one of the poorest. After World War II, the Emperor Haile Selassie returned from exile to reclaim his country from the Italian occupiers, hoping to bring it out of its isolation and to unify its many regions and ethnic groups. Discontent spread at his policies, at deteriorating economic and political conditions and at perceived mishandling of drought and food aid. Mutinies in the military, civilian demonstrations and strikes escalated while regions far from the capital organized to fight for their independence. Haile Selassie was deposed in 1974 by a leftist group led by Mengistu Haile Mariam, who began destroying opposition through mass arrests, executions and terror. Mengistu's leftist government, in turn, was challenged by ethnic and regional factions, many of which held even stronger communist philosophies. Rebel fighting and civil violence continued for seventeen years both among these factions and against Mengistu himself as Ethiopians fled.

SEBLE M., 1989

I was born in southern Ethiopia in 1958. My father was an orthodox priest and my mother was a housewife. I grew up and went through elementary school there in the Sidamo region, and I started high school in Addis. But I married in 1975 when I was just over sixteen, before I finished high school. I suppose you could say it was an arranged marriage—our fathers knew each other very well and wanted it, but if it was arranged, it was happily arranged. We really liked each other.

In 1974 the revolution came and schools were closed. That was before I finished high school. The older students in the upper grades all went out to the fields and the countryside to teach the villagers to organize in political organizations, but also just to read and write. You have to understand that Ethiopia was like feudalism up until about seventeen years ago.

People out in the countryside didn't know how to read or write. I didn't have any quarrel with the new government. I didn't argue with them, but most students simply argued all the time for the sake of arguing, not against the government, but arguing for the sake of arguing about what kind of place Ethiopia would be.

Once the revolutionary government was in place they called meetings all the time. We had to go to endless meetings. My father owned a lot of land—a coffee plantation and so on. He had given us, his children, some land as gifts. But the government took that coffee plantation and any extra houses—our family had some houses we owned but weren't living in—the government took all those and the plantation to redistribute to people who had no land.

My husband worked in road construction then. The schools were closed, so I couldn't go to school and I stayed home with my new son. He was only a year or so old then. But in Addis, they suspected any educated person who had owned land must be against the government and we really thought they were going to kidnap me and kill me. My husband was frightened for me and he came from his roadbuilding site one day and put me in a sack in a cart and took me out into the countryside. We left my son with my mother in Addis. I was not living with my mother, but with my two sisters then, while my husband was on these road construction projects. They did get my eleven-year-old sister and put her in what they called a zone jail and tortured her for information about me. She didn't know where I was, but she stayed there for two months. She was never really quite right mentally after she got out. She just died in Kenya last year. My father took my younger brother up to the north to be with his uncles, but they found him and put him in jail. We haven't known all this time, fourteen years, whether he is alive or dead. We've never heard.

But somehow, something happened and they found me and put me in jail. They suspected me of being an EPRP [Ethiopian People's Revolutionary Party] member, the opposition party. It's very complicated. They were both leftist parties, but it was like Stalin killing all the Bolsheviks, just like that. I was seven months pregnant with my second baby when they put me in jail. It was not built as a jail, it was just an agricultural warehouse. There were sacks of corn in it, but they were rotting and there were lots of insects that used to come crawling out and all over me. There were only two of us in that jail, a man and me. They put me there to torture me, but I told them right away that I knew someone high up in government and they became less sure. So they would come at midnight, or two in the morning and just frighten me terribly. They told me what they would do to me, that they would rape me and torture me. They showed me pictures

of what they had done to other people and said they'd do that to me. My mother brought a mattress for me to sleep on, but they said that was not allowed and took it away. I slept on the ground and eventually I got a kidney infection. I bled a lot.

I had told my mother that she and my husband should not come to the jail to visit, because they would be put in jail too. But my mother would come sometimes and I told her to tell my doctor in Addis about the kidneys and the bleeding. She did and he wrote a letter to the zone jail and a local doctor came to visit me.

After two months, they gave me permission to go to Addis to have the baby. I was not yet in labor, but it was time. They really expected me to come back and be in jail again! A woman who was an officer in the grassroots cadre had an execution order for me; she could have come and found me and killed me any time, any place. But she didn't. In fact, eventually she and her friends were put out and she lost her power. I don't know whatever became of that piece of paper.

In 1978 I came back to a town near Addis. My husband's brother lived there and by that time things were a little more settled and we felt safer. We applied for land to build a house. They didn't know in that region about what had gone on before in Addis with me or my family. So when we applied just like anyone else for a piece of land where we could build a house, we got it and built the house and started a new life there. My two sisters lived with me again and my husband was out on road projects. After that I took a typing course that lasted a year in Addis and then I got a job for the Ethiopian Air Force at the air base near where we were living.

But before that, in 1981, my husband was working for a private company building roads, but he was called by the government to work as transportation maintenance manager in Addis. He didn't want to work for the government, but he had no choice. He had to go to Addis and take the job and after six or seven months at that job, one day he was taken to jail. That was before I was working at the air base. We didn't know why he had been taken.

I went the 45 kilometers into Addis looking for him. There had been no answer when I called his phone in his office. I called his friends; no one knew anything. I finally got a phone call—bring his clothes and food to the jail. So I went into Addis again, but he wasn't there in the jail they told me. They took the clothes and food and said they would take them to him and told me to wait. But they wouldn't answer any of my questions; they gave no reason he was there. I called all his friends and brothers to see if they could find out anything. I waited ten or twenty days—nothing. We finally found out he was in the jail where they put big political prisoners. That

didn't make sense. He was not active in any political party or any-
thing.

After two months they moved him and I didn't know where. They
wouldn't take the food I brought for him anymore. For six months, I would
just go around, every day, to every jail and ask if he was in there. One friend
of the family in the defense ministry found out where he was, but he didn't
tell me because it was the torture place. He asked, on his own without tell-
ing me, if he had finished torture or not. Some other people in the ministry
were helping him with food.

After six months of that—six months of torture it turned out—he was
put into another prison. I finally knew where he was and could get food
to him. After a year, he was sentenced to another jail that was much better
and I could see him there and talk to him. I wasn't working then. The fam-
ily supported me that whole time. When we could get the money together,
I would go and visit him.

I found a piece of paper in his office, just lying there, and I remember
that my impression was it said something that he had no political beliefs.
We think he wasn't political enough. But I kept going to the prosecutor and
to the jail and to everyone. The prosecutor told me he didn't have my hus-
band on his list, go to the minister, so I would go. They finally just got tired
of me, I think.

One day I went home after talking to all these people again, and at four
P.M. they called from the jail. I was really frightened because everyone
knew that was the time of day they called to tell people that someone had
died in jail. But they told me to come get him, that he could go home. After
two years he came home.

When he got home he said he wouldn't go back to work for the govern-
ment. They gave him a small paper that said something about we're sorry
about you being in jail, you are released. But he wouldn't go back to that
job. He just stayed home but they wouldn't give him the release papers he
needed to find another job. So I got a job then for the Ethiopian Air Force
and we sold our car and he stayed home. He would do short-term jobs,
things that lasted just a few weeks, but otherwise he stayed home. I was the
one out working then. He was getting depressed and so was I. We began
to think about leaving. He was able to get a visa to go to Kenya alone while
I stayed with the children. You couldn't get a visa if you were a skilled
technician, so he just said he was a driver. We had decided he would stay
there and not come back. That was in 1986. I left in 1989, legally with a
visa for a visit to Kenya as well. The chief of staff of the Ethiopian Air Force
helped me get the proper papers for that. He was one of the twelve generals
killed in the failed coup attempt—I was very upset to hear that. I had to

give a bond that I would bring the children back and that we would forfeit that money bond if we didn't come back after the visit. My husband had brought the paper about being in jail, so in Kenya he applied for asylum to resettle in the United States.

In March of 1989 we came to the U.S. and a week later I started work in hotel housekeeping. My husband was upset that I was doing that kind of work, but I didn't care. I said it would only be for a while. I would get something better. When the refugee worker was talking to us, she said we could go on welfare. My husband asked what that was and she said payment from the government when you're not working. He said no, you may call us refugees—it's true we had to leave and come without anything, but we are not helpless. We can work and we will work and we will get the things we need. We will make things better.

Both my husband and I are taking courses now. He is not going to do road construction anymore. He is learning to repair computers. Me too. Sometimes it's hard, but it's okay.

People ask me if I want to go back. Well, of course, but I won't. I hurt a lot, there's a whole generation that hurts. If we go back, my children would hurt the same way about leaving here. I can't do that. You know, when you go to visit and stay with someone, a relative, your grandmother, you follow rules of that house. I ran away from Ethiopia to a warm place, a place where people help, three thousand miles away. I feel comfortable. So I have to take the bad with the good. If there is trouble with crime and drugs in the United States, if the people who helped me are facing problems, I have to help too.

5

HAITI

Haiti may be the poorest country in the western hemisphere. In 1957, François Duvalier was elected president-for-life following a period of political turmoil. His rule was marked by political tension, severe repression of the opposition, economic stagnation and random violence. Soon after he came to power, middle and upper class Haitians began fleeing by legally emigrating to the United States. After 1971, periods of terror alternated with periods of eased tension under his son, Jean Claude Duvalier, but economic and political conditions continued to decline, violence increased and public discontent mounted. Finally, poorer, less educated Haitians began fleeing as the situation deteriorated, at first legally, and then by any means possible when the demand for immigration visas resulted in a waiting period of years. After a military coup deposed elected president Jean Bertrand Aristide, Haitians fled renewed violence. Many were picked up at sea and taken to Guantánamo where their future is uncertain. Haitians who flee their country today are collectively considered economic refugees, ineligible for political asylum, except in individual demonstrable cases.

MARIECLAIRE M., 1989

I was born in Haiti in 1962 and I came to the United States in 1989.

My mother had eight children, but one boy and one girl died. Then my father died. I started high school when I was fourteen, but I left to learn French accounting. I had a baby and after that I couldn't find a job anywhere as an accountant. Things were really bad in Haiti and I knew I had to go. I went to the [U.S.] embassy and applied for a visitor's visa, but I had to wait for a year. My mother had those six children and she was supposed to pay for school, food and rent—and no one in Haiti can find a job.

I knew I had to go so I could send money back to her. I was the second oldest girl.

After a year I got the visa and I bought a ticket for Miami. I left my baby with my mother. I only had a visitor's visa, but I just stayed longer. I stayed five months in Miami and then I came here. I got papers to work and the first job I got was doing hotel housekeeping. That was a hard job, I did it for a year and a month. You got paid $5.20 an hour for doing fifteen rooms a day. You had to do it quickly and I learned to be very quick. I could do twenty or thirty, so I got paid more. But one day I hurt my ankle and they took me to the hospital because I was swelling and cramped. It wasn't broken, but it hurt so much that I couldn't push the cart anymore, so I had to quit. I finally got a part-time job doing clerical work.

You know, it's really hard. I don't have a husband, I don't have a boyfriend. My child is not here. I'm here just to earn money and send it back to my mother. Everything is so bad in Haiti now. There's nothing anyone can do. My sister just came two weeks ago. I asked her to come and help. But she really doesn't know how to do much. Some refugee workers got me a job cleaning and cooking for Mr. G. just two hours a day, but I asked him if she could do it instead, so he is letting her work four hours a day now. She likes it here and wants to learn English and get a better job. She has three children, fifteen, eleven, and four years old, and she really misses them. They're with my mother too,

I'm working now in the hospital, doing housekeeping from two P.M. to ten-thirty P.M. It's a lot easier than the hotel, and my sister and I live together. We cook Haitian food, chicken and fish and rice and beans. Sometimes we make hamburgers too. It's a lot harder for women who don't have husbands. It's hard to ask for help from other Haitians here. If you ask for help, if you ask a man, he wants you to be his mistress. Haitian people in the community are always gossiping. If a Haitian gentleman gives you a ride to work or does you a favor, they start saying he is your boyfriend. I really am not close to Haitian people here. Now my sister is here and we live in the same room.

For a while it looked like it was going to get better in Haiti with Aristide, that maybe there would be more work and maybe better pay. It's not better for my family, because they're not in Port-au-Prince, but out in the countryside. Now, things are really, really bad—like in the old days. I'm afraid to go back now. They will kill me. All I can do is pray God and keep walking.

Haiti is my country, but life is better here. I like a lot of things about being here: more work, better pay, I can go to school, go to church, do what I like. But I don't like the weather! I want to go back to visit and see my

family. They can't leave, now things are too unsettled. What else can I do? I'm the one who speaks English and could leave, so I did. I had to leave. The president, Duvalier, didn't want people to leave Haiti then, he didn't want others to know the conditions of the country. If you weren't working in Haiti, you couldn't get a visa. But nobody was working, so you had to go to a travel agent and get working papers and you could pay up to twenty-five hundred dollars for them through the travel agent. Then you could apply for the visa.

Haiti has always been under the heel of America. What America has wanted is what Haiti and Duvalier did. But the people of Haiti didn't really understand that. Now with Aristide, he wants the conditions to change in Haiti, but America doesn't really agree with Aristide's plan. He is asking for more work in the country and more salary. Duvalier abused the people a lot, now we have found a president who loves the people, but the Duvalierists are making trouble, asking why are you making America frightened?

6

AFGHANISTAN

In December 1979, Soviet troops invaded and occupied Afghanistan. The strategically located nation shares a border with the former Soviet Union and is home to a fiercely independent Muslim population. The Afghans fought back with guerrilla tactics suited to their rugged mountains and deserts and their largely self-governing villages. Their strategy was so successful that Soviet troops applied increasingly destructive military actions to put down resistance and committed more and more troops, from 85,000 in 1979 to nearly 115,000 troops in 1984. In the increasing devastation, the Soviets adopted a scorched-earth policy when any territory had to be abandoned to the guerrillas. An estimated 40 percent of the population was killed or fled in the fighting. Though Soviet troops pulled out of Afghanistan after ten years, Mujahadeen Muslim factions have continued sporadic fighting for political control.

HAMIDA S., 1981

You know, I have been here for a long time. If I told you my story years ago it would be different from telling you now.

We fled as a family from our country, Afghanistan—it was exactly the fourth of July, 1981. So this fourth of July it will be eleven years—eleven years since we left Afghanistan.

The Russians, the communists, you know, they took over the country in 1979. We were there for a couple years after that. Then we realized that our lives, the children's lives, all were in danger and also there was no future for us. So many tragedies had happened in my parental family—my brothers were in the jail and two were killed. So we were afraid—if my husband, my children or myself would have to go to the jail. In that time, if anybody went to the jail, they would never get out, never get out. So

actually, we decided within a month to leave everything and just get out.

We lived in Kabul. I worked for the Ministry of Education and my husband worked for the Ministry of Interior. Both of us had careers, a house, property and a life—four healthy, happy children. So we just saved our lives and our children's lives. We stayed until the fourth of July, 1981 and then we went to the neighboring country, Pakistan.

This is a long story. First we took a plane from Kabul to Kandahar. That was July 2. Then from Kandahar—in Kandahar we hid in a village and we were escorted by Mujahadeen, the freedom fighters from my province. I am from the south, from Kandahar, but I was born and raised in Kabul. So they helped us. They helped us and they were with us. We went to their home and after a couple of hours, they said, "We cannot take you six, parents and four kids, at one time. You have to divide in two groups— the mother go with two children and the father with another two children." It was just terrible. I mean, if your life is in danger, you will accept everything, but otherwise how can you leave your children with somebody you don't know? Or how can a husband leave a wife with someone you never knew, or a wife leave her husband and children? Anyway, I went with one of my daughters in a big huge truck with two freedom fighters and after four or five hours, they took us to another village which was very close to the border, the border with Pakistan. You cannot believe it! That village was destroyed completely, completely destroyed. All the people—there were around two hundred people in that village—they dug holes and put straw on top and they lived there. That's all. Under the soaring hot summer July weather. And my daughter and I, we stayed there for two days and two nights and there was no news about my other three children and my husband. Every minute Soviet helicopters and tanks, with some Afghans too, came and passed the village. We didn't know what would happen in the next minutes or next hours. So the third day my husband and my three children came. A village woman, oh my God, she was so nice to me. She came to me and said, "Oh my God, I have a good news for you. The truck came and your husband and three children are here." And later these people told us we had to travel ten or fifteen miles from this village to the border by motorcycle and that should be one by one. Not all of us, not the whole family. So it took us one day, the whole day. We started at ten in the morning and it took until six in the evening. So of course I said, okay, take my husband and my son first because I didn't want soldiers to recognize my husband. He was working in the Ministry of Interior. So they took him and my son, and then one of my daughters and the next one and the next one. I was the last one. Around five-thirty that man came back

and said, "We cannot take you tonight." My four children and my husband were already in another country! I accepted and said okay, I will stay here. I don't know how it worked; maybe my husband told him that you have to bring my wife here because we want to be together. I think he gave him more money or something. After half an hour, another man came and said, "Okay, I will take you to your family."

So it was exactly six o'clock, six P.M. the fourth of July 1981, that I passed the border. I looked behind me at all the mountains and all the land and everything, just left behind and that will be an unforgettable moment in my life. Very, very sad.

Then we went to Pakistan and actually, the real struggle started there. We were in Pakistan for eight months as refugees. We were not in the camp. We transferred a little money by a friend to Pakistan. When we got the money, we rented a house. But there was no furniture, no beds, no pots and pans, nothing. So we got a house and we all sat on the floor and said, we got a house, so what are we going to do with it? A friend helped us. He brought a truck and he brought cushions, pillows and cups and this and that. We lived like that for eight months. How frustrating it is for humans that they lose their identity all of a sudden. We were in another country; nobody knew us—who we were, where we came from. We just lost everything, like we were completely different people. Our past was just like a movie and we were not real. Not like real life—all our past was like a movie, especially when we waited for our refugee status. That was the hardest moment.

We went to the refugee office in Islamabad, Pakistan, and we filled out the forms. There was a U.N. refugee office, but we went to the United States Refugee Office in Islamabad, Pakistan. It was run by the government and the voluntary agency. We came through USCC, the United States Catholic Conference.

So we came and we settled down in Tampa, Florida. I had been a student at Florida State University a long time ago and one of my former roommates became our sponsor. She rented an apartment—we were so lucky that we had her, really. Right from the airport, we went to that apartment. But it was very frustrating that we didn't have money, no jobs and we didn't know what to do. But we were lucky we had education, both of us. We received our educations in this country, the United States. I came before as a student and also my husband came as a student. But still, it was very, very difficult. First we put the children in schools and then, every day, from eight o'clock in the morning to four o'clock in the evening, my husband and I went different places and filled out hundreds and hundreds of job applications. We made our résumés and distributed them everywhere.

We decided no matter what kind of job it is, we would take it. We would rather work, any kind of work, than go on welfare. As a family, we never went on welfare, never. My husband's first job, with all his master's degree and experience and good English, was just like a cleaning man or something. I worked in a daycare center. But we knew that would be temporary because we were still jobseekers and we were ambitious and had a good hope for our children's future and our future.

But the struggle never ended. We moved from Tampa, Florida, to West Palm Beach because of employment. That employment lasted only for six months and after that—in the first stage it was just like honeymoon, but at the second stage, the real struggle started—emotional, financial, adjustment, children at school, the difference between our values, the community and society values. Still I didn't give up. But my husband always had problems with employment. He was never satisfied with the situation and that made him so unhappy, very unhappy. Because of that we decided to move again. We moved to here in September 1983.

All refugees go through different adjustment stages. I had some emotional problems. I mean, the loss of my family, my country, my identity, the loss of my early experiences and starting again from zero. But I succeeded. I never gave up my hope for a better life. So finally, I got a job with the public school system—it was a temporary part-time job. But you cannot believe! I worked so hard and whatever they said, I said yes because I wanted to keep my job. But my hard work was honored and I finally got a full-time job with benefits and still I am working at the same place. I like my job. I like my job because my field is education and this is an educational environment.

My kids are doing very well. Three of them graduated from universities. And one graduated from high school. But my husband was still unhappy and finally he decided to go back to my country, Afghanistan, in August 1990, when the Soviets left. This is the second year that we live in separation. It's very difficult for me to make my decision—either I should live like this or just go for my divorce. When he left here, he could not accept the reality, the changes. So he said he has a hard time here, he couldn't cope with all the problems. For a refugee family it's not only one problem, there are several problems, hundreds and hundreds of problems—family conflict, employment conflict, adjustment and acceptance. For some of the refugees it's difficult to cope and go from one stage to another stage. Some stay at the first stage, acceptance; they cannot accept what happened to them and they are still struggling and live unhappy and unproductive.

I don't want to hear from my husband—he left all the troubles and problems for me and he didn't support me. I know he went through emo-

tional things—I had problems too. I thought we came together and we will live together here and share the problems. He was not cooperative at all. He thought he had problems but he forgot about my problems and also the children's growth and living in this country. I paid a lot of attention to my children to make them able to make their future. I worked so hard, no matter what, daytime, nighttime, I tried to control my emotional problems, so I'm okay now. He, my husband, writes once in a while to the kids and he wrote in the beginning to me, but I didn't answer because I am very, very angry. I hadn't planned like this.

I still have two brothers in Afghanistan, but my other three brothers fled Afghanistan and lived in Pakistan for a while. I became their sponsor and now they live in California—also my mother and my sister. I was under tremendous pressure because when I left I didn't say goodbye to my parents. That was very, very painful. So finally my mother came to Pakistan and I tried to bring her here at least to see her. She's okay now, she lives in California and I'm very happy for her because she went through a very difficult time. She lost three children—three young children—my sister and my brothers. My brothers were killed in the jail and my sister died because there was no room in the hospital—there were hospitals, but no doctors or anything. She had kidney problems and she died within twenty-four hours and that was very painful for all of us. My father, he was alive when I fled and later I heard that he died. He died, that was painful for me too, when I heard my father died and my sister died. It's very, very painful, very painful.

I am an American citizen now. My children and I became American citizens in 1987. So four of my children and myself are citizens. I don't think I will go back or even my children, because we feel at home here. I think I belong to this society now. I lost that eleven years' experience from that society, so there is a big gap between that experience and this experience now. I think I missed eleven years. If I go there, I will be like a stranger again. So I feel at home here, this is my home.

7

GERMANY

Sometimes a war or revolution produces successive waves of refugees, those fleeing chaos or oppressive circumstances at the beginning and others fleeing the consequences at the end. Germany before and after World War II is such a case.

As Hitler began to consolidate his power in the 1930s and Nazi policies toward Jews became reality, German Jews, fearing for their lives and futures, fled the country. American immigration policy, tightened in the 1920s to a system of quotas, made no special provision for such refugees. These German Jews, though generally recognized as refugees, were admitted under the German immigrant quota.

At the end of the war, other Germans from the former German eastern territories of Pomerania and East Prussia themselves became refugees. A great number fled westward from January to March 1945 in front of Soviet forces advancing toward Berlin. Others were expelled from these territories after the May 1945 surrender, when the Potsdam Agreement was implemented to "transfer" them from lands now awarded to the Soviet Union and Poland. The occupying powers took no responsibility for these refugees who were technically within the borders of their own country; they became the responsibility of the emerging German governments. Many refugees who fled from the Soviet advance resettled in the British Occupation Zone, subsequently part of West Germany. Some others fled at the same time but remained in the Soviet Occupation Zone, which subsequently became East Germany.

SOPHIE L., 1936

I grew up in a very political family of the left. My parents were bitterly opposed to the Kaiser in the First World War and really believed that when the "Revolution of 1918" occurred, they would live in a social-democratic state. They demonstrated and when the Independent Social Democratic

Party was dissolved, my parents thought that the political future of Germany would be very bleak.

I was born in Berlin, as were my sisters, but my parents were not native Berliners. So I grew up in an atmosphere of great cynicism about the government. My parents thought the republic had betrayed its ideals, that the fact that assassins of the right wing got away almost scot-free convinced them that the right wing was really in charge. I grew up with this and I grew up listening to political talk.

My father died in 1931 when I was ten, by which time my sisters were already seventeen and twenty. He had told them quite consistently that they should leave Germany, that there was nothing good to be hoped for in the future. I took all that stuff in, but it didn't mean much to me then.

I started learning English in school when I was ten. Then came Latin, then French. By that time it was Nazi time. The Nazis started when I was twelve and a half. I remember the day very distinctly. I came home, it was in January, dark, and my mother greeted me with a very peculiar expression on her face. She asked if I had heard. She told me Hitler had been appointed chancellor and she was very gloomy.

School was exceedingly unpleasant almost immediately. I was the only Jewish girl in my class. It was a very small class because I was in the academic school, which meant everyone was upper or upper middle class. The only thing I can say for that is that I didn't get beaten up because that would have been unladylike for this school. But I was isolated instantly. There was no more socializing, no more walking together. It was finished—fast.

On the first of April 1933, the infamous boycott of Jewish stores took place. There was some kind of meeting of all the Jewish girls in this high school and we all decided none of us would go to school that day. I came home and announced this to my mother and she said no, that I should go to school tomorrow because I had to learn to deal with this and not be afraid. Very interesting advice at age 12! Well, I begged and pleaded and carried on—absolutely terrible. She finally told me what she was going to do that day. She was going to spend the day walking into Jewish stores. Well, I went to school and as I walked into the classroom, the other girls broke into an anti–Semitic song and I ran out of the classroom with tears running down my cheeks. The teacher came and asked what had happened. I told her. She was very nice and said the only thing she could do was tell them they can't do that. So I walked back in with her and she did tell them they were absolutely not to do that again and they didn't ever.

Well, soon it came out in the paper that we were not just to stand up when the teacher came in, but to give the Nazi salute. The same article said

that Jews were exempted because they would besmirch the German salute. So I immediately clipped it and took it to school and did not raise my arm. The teacher didn't say anything, but at recess the girls came and surrounded me and said I had to give the Nazi salute and I said no. I brought out the clipping, feeling very triumphant, but they didn't care what the paper said—I was receiving the benefit of a German education and must give the salute. I said no. So upstairs we went to the teacher, a different teacher, and they told what happened. Now, these used to be my girlfriends. He said no, she doesn't have to raise her arm. First of all, it's the regulations and second, how would you feel if you were in a country that was against you, would you want to give their salute? That was the end of that. This was very early, but what bothered me was that I was the only one in the school who resisted.

By this time we were hiding people a great deal. I was sworn to secrecy and my mother said if I came to the breakfast table and saw a stranger, to just make polite conversation. These were people persecuted by the Gestapo who had to sleep in different houses every night and people on their way out.

I was very proud because I became a courier. We had a good friend whose husband was in the French Consulate and they smuggled mail out in the diplomatic pouch, which of course was illegal. And I got to carry the mail back and forth.

School became less and less agreeable and less and less useful because the instruction had deteriorated. Not English so much, but history and German, which was supposed to be literature, but became nationalist propaganda. We had to take race theory too. The science teacher, who was a Social Democrat, had to teach it. I remember two things. Once he showed slides the Nazis had put together of racial "types." Everyone has seen those, they're terrible. The other thing, though, was he put a spotlight on the blackboard and we were supposed to have the types examined in that spotlight. Well, of course, I was the only Jewish girl in the class. So I had to get in the spotlight. But I was blonde and blue-eyed and my nose turned up at the end. Well, the whole thing just dribbled away. We never had that again.

We went on with our lives. My mother tried to keep a balance between teaching me resistance, thinking politically, and protecting me, which was really impossible, I think. By this time I had found a group of Jewish kids and we took instructions from a rabbi and I became confirmed. My mother, of course, was not only an atheist, but her father had been a rabbi and she absolutely hated organized religion, particularly synagogues. When I told her I wanted to be confirmed she said, "Fine." She even said

she would come to synagogue and buy me a dress and some champagne to celebrate. I became very religious and went to synagogue every Friday night and every Saturday and of course fell in love with the very young and handsome rabbi. It was a very distorted adolescence because I had absolutely no normal boy-girl anything. But I did have dancing lessons. There was a pathetic attempt for Jews to replicate their former social lives among themselves. Terrible in a way, totally segregated and unreal. There was a Jewish Cultural Association—a tremendous social thing because all of these people were unemployed. First-rate lectures, concerts, operas, you name it. But all Jews.

I was sent out of the country in summer vacation, as my mother put it, to get some fresh air. In 1934 I went to Denmark to some of our relatives who had fled and were running a farm and a guesthouse. It's funny, because neither of them had done anything like that before. He had been a Social Democratic representative in the *Reichstag*. But they had this place and it was mostly refugees staying there. It was there I had my first brush with a person who had been in a concentration camp. He was a dentist from Hamburg and was a gardener there. He was clearly very damaged psychologically. He showed my cousin and me some scars and told us what had happened to him. It was one of those seminal experiences.

Nothing violent happened to us in Germany. My mother had gotten a blackmail letter. She was hiding people, which was illegal, sending stuff abroad, which was illegal, sending stuff in the diplomatic pouch, which was illegal. I was in bed one day, sick. I was being moved around the apartment all the time because we always were having people stay and I didn't have a room of my own anymore. So I went into her room and my girlfriend was visiting and she asked for a brush to brush something off her shoe. I said there was one in the bottom drawer of the nightstand. We found this letter there and I thought it was odd. It was open, so I read it. It said if you don't deposit so much money in such and such a post office box, we will give the following information to the Gestapo. Well, we were frantic! My sister came home—she was in Berlin then—we showed it to her, and the three of us sat there appalled. Mother came home and we showed her the letter. She simply asked since when we read each other's mail. I asked what she had done. She said you don't respond to blackmail. If she'd sent the money, it didn't mean anything. He could ask for more and could still have given us up. She just did nothing. She did consult her brother-in-law, who was a professor of law. He advised her to take the letter to the police since blackmail was against the law! He still wanted to believe in the rule of law. She told him he was crazy.

My mother had no sense that the situation under the Nazis was going

to go away or things would be better. Jews had not yet begun to be rounded up the way they were later. There were individuals beaten up, terror, killings, but organized deportations had not begun.

At the end of summer 1935, Mother informed me that we were going to emigrate to the United States. I was very pleased and had absolutely no sense of leaving my homeland, nothing. We even had relatives in the States.

We didn't have much money after my father died, but we were comfortable. My father had this total pessimism about Germany. We had lived on his very good salary and had absolutely no savings. The inflation had wiped out what they had had before, and he said we're not doing this again. We'll have a good life, have a beautiful apartment, buy art, travel and enjoy life. Well, that was all very well, except he died leaving a wife and three young daughters. There was a private bank which my uncle had begun; Father was a partner. They proceeded to pay my mother some sort of pension every month. That's what we lived on then. We did move into a smaller apartment, but we were okay. So it turned out the reason my mother made the decision to emigrate when she did was that the partners of the bank, all Jews, told her they would really like her to get out. I think it was because they knew she was doing all kinds of illegal stuff; they didn't like it and it scared them. They informed her that my father had illegally put five thousand dollars in a bank in Holland—five thousand dollars was a lot of money at that time—and that she would have that when she came to the U.S. So that was part of the decision-making. Five thousand dollars seemed like an incredible fortune to me. We could live on that a couple of years. My sisters could work. My oldest sister was at the University of Berlin. April 1933, they told her not to come back. So Mother sent her to Switzerland. People could send their kids out of the country with German money for a while longer then. She became the first woman veterinarian graduate in Switzerland. My other sister had spent a great deal of time in France and England already, and was fluent in French and English and knew English stenography. She went back and forth and got good jobs as a trilingual secretary, even in Berlin. She left for the United States a year before Mother and me.

My mother had been helping other people get rid of stuff before they emigrated. She was most unsentimental. She'd ask if you needed that where you were going, take it; if not, get rid of it. Well, now it became our turn. We had a sale and I became very uncomfortable. I couldn't stay. When people came, I found it very upsetting. I was too stupid and too young to understand how upsetting this must have been for my mother. I left the house and when I came back at night, all that stuff was got rid

of. We did bring some things with us to the States. You could still do that in '36. What you couldn't do was carry out money. So when the packers came, a Gestapo man watched them so that they wouldn't pack anything illegal. We took the train to Frankfurt and then to Paris to visit my uncle before boarding the ship. On the way to Paris, that very day, the Nazis occupied the Rhineland.

We spent the week in Paris, then went to Cherbourg and boarded the ship. I thought life was absolutely wonderful. Mother had given me some money one day, since we couldn't take it along, and told me to buy myself some things. I bought silk stockings, a new evening gown for the boat—a lovely wardrobe because Mother said we wouldn't have any money in America and I'd better get it then. I thought this was going to be the most wonderful thing in the world. I wanted to get out of Germany and to go to America! What did I know about America? Hollywood, wealth, everybody had cars. I had read all of Fenimore Cooper in German and Upton Sinclair. The only regrets I had about leaving were about people. I was not distressed. I realized in retrospect that I was indeed distressed. Now I know; it just comes sometimes. I am very sorry I had no better understanding of my mother's distress. She died when I was 29. I am sorry I couldn't relate to her more in terms of what she must have suffered. But it wasn't in me then.

We went to my uncle and aunt in New York. I finished high school in a year and a half—four years of English, American history, civics, economics, hygiene and gym—and graduated with honors. I learned about race in that high school too. I thought racism only happened in Mississippi and Alabama. But the black girls were totally segregated, not by law, but they just were apart. I tried to sit with them in the cafeteria. They were polite, but it went nowhere. When I tried to get on the same subway car with them—they all got on one car—one of the white girls said, "Don't ride with the tribe." I was stunned.

New York was refugee world. We called ourselves refugees. We were refugees. Most of the refugees in New York were Jews, but there were others, Catholics and Protestants. I kept going to synagogue. Mother worked for an organization called Self Help, which the refugees themselves started. I gave free English lessons. Most of the women knew more English than their husbands because they had gone to different schools in Germany where English was taught. The women became household help, babysitters, seamstresses, because they all had these skills presumably. The men, if they were lawyers or doctors or businessmen, were much worse off in certain ways. The women, a lot of them, really kept the families together.

But I used to say I didn't want to be a refugee. I wanted to be an

70

immigrant. I felt I would never become an American in New York—that I would remain in the refugee world forever if I stayed. I was connected to it and had feelings about it, but I thought I had to get out. I also think I thought it was time to leave home. I was eighteen or nineteen, that's when you're supposed to go away.

I wrote to a cousin who had fought with the Lincoln Brigade in Spain and asked if I could come see him in San Francisco. I had some idea of becoming a photographer. He said yes and that started my independent adult life.

Elsa W., 1945

I was twelve years old when we had to leave. My mother, my two sisters and me. We walked the ten kilometers to Kolberg. It was terrible. No one had any food by then, everyone was hungry, the little children were crying. And I was so dumb. I just wanted to go home. I told that to one of the sailors I saw there in the Kolberg port and he laughed at me like I was crazy. He said, "Look, you and your family get on the next boat out of here you can. Kolberg won't hold out five days more." I ran back to where my mother was. My father was a post office employee in Kolberg and we were able to go there to him and to sleep in the cellar of the post office. He was too old to be in the army. I told my mother what the sailor had said and we all agreed we would get out as soon as we could. A whole group of small boats came to get people out before the Russians came. My mother took a look at the one we were supposed to get on and said no, we can't go on that, it's too small, it will sink. The boat was one that dropped depth charges on submarines, I found out later. I didn't know it then. We got on it all right, one of the last boats out. We were on that boat with nothing to eat for eight days until we got to Swinemünde. My father didn't get on the boat. The men stayed to fight. He was captured—they all were. He was sent to Siberia and died. None of those men came back, not one.

In Swinemünde we were put in what was called a KZ, a concentration camp for Jews before. We were there six months and there was a serious outbreak of typhus and dysentery. If you had relatives or friends somewhere you could get out quicker. We finally could go to Schleswig-Holstein in the British Zone where we had friends. We went on a train, if you could call it that. It was a freight train and there were cows and pigs in with people. We would stop and they would unload dead bodies, both

people and animals. We would go on for a while and then there would be an air raid. The war was not over yet and the Russians bombed everything. We would stop. Sometimes we would back up. Finally we got there, to Ratzeburg.

When we first came we had nothing, no belongings, no food, no job, no home. We were nothing.

The four of us were put in one room in a farmer's house. From then on it was nothing but work. I had no "teenage" life. No singing, no dancing, no movies, no friends, no school. We all just worked in the house, or in the garden, or in the stable, morning and night. Things weren't always nice for us refugees. We had no worth, we were nobodies and they didn't like us. We didn't pay any rent and we got our food and little pocket money, but we had to work, work hard, from morning, all day and half the night. If you didn't work and keep busy all the time, they could just send you away. Where would you go? They could just get rid of you. There wasn't anything to buy and we only had a little bit of pocket money, enough to buy soap or a comb maybe.

After two years of that, I had a chance to go to school. I learned to be a secretary. I moved to the "big city," Lübeck, and I went to work as a secretary. There were no apartments available then; we lived where we worked. We used to say we worked from six in the morning until ten at night because we were there all day and night.

I met my husband then. That was such a strange and unsure time. People didn't know what was going to happen. Some said we would go back. Some said the Americans would push the Russians back. No one wanted to get married, and if they did, no one wanted to have a baby. But we got married anyway and moved to Cologne. He still lives there. That was a very hard time, and we're divorced now, and I try not to think about those times.

I have to laugh at myself. I was listening to the news about Genscher [Hans-Dietrich Genscher, former German foreign minister]. I was thinking, okay, good, Genscher is trying to do something for the people in the East. But he'd better be careful to do something for *us* too. No, I live here in Lübeck now. I'm doing very well. This is home and I won't go back and I don't want to—at least not to live. But I have some free time now, so I work for the Pommerische Landsmannschaft [an organization of Pomeranians in the west devoted to cultural and educational pursuits] so that we don't lose our heritage.

HELGA B., 1945

We were lucky on our refugee flight. It took us over four weeks. We left the twenty-fourth of February 1945 and finally got to our final destination near Hamburg the twenty-sixth of March.

I was a young woman then, just engaged to my now-husband. He had been wounded, lost a leg at the Russian front, and was recuperating in the military hospital near our village when the Russians came. My father and three brothers were in the army and there were just the three of us, my mother, my ten-year-old sister and me, living at home then. We knew the Russians were near. Our farm was one kilometer from the village itself. We could see the village burning, could see tanks and hear the shelling. We heard screams and cries from the village people and saw the animals fleeing in our direction. Everybody screamed at us to leave, that the Russians were in the village. We took just what we thought was most necessary; it was dark and we just grabbed things and ran. We harnessed the horses and began our flight. We had seen many refugees from farther east fleeing in the weeks before, past our farm, but we could not believe the Russians would come. We were on the road about eight days when we heard that the Russians had retreated and the German soldiers had retaken our village. So we went back. I remember seeing beautiful embroidered linen that the Russians had taken from people and ripped up and just thrown in the mud. What animals would do this?

Two weeks later, we had to leave again, but this time we knew that we had taken some of the wrong things the first time, things that were not as necessary as other things we should take. Still, I insisted on taking some of my lovely hats in a wicker trunk, can you imagine?

We had official orders to evacuate this time and German troops still protected the roads west and the Red Cross fed us along the way with soup and bread. We thought we were safe, but we hadn't counted on Russian air raids and artillery. There were five families that made up our group, about twenty-eight or so persons, with eight horses and four wagons. My mother had taken an elderly couple in our wagon. The old farmer was very worried about the horses, I remember. My future father-in-law, who was the group leader, had a large farm wagon and he had to take two other families with him. My fiancé, who was visiting his parents, on a short leave from the hospital, came with us. He had lost his leg and could not ride a horse or walk, so he straddled the beam of a cart. When the Russian planes came to bomb and strafe us on the road, he just had to roll off on the ground and slide under the cart.

After we left the village, we had to go west to cross the Oder River.

Everything was bombed and the roads were bad. Our group split up. My mother went northwest by a shortcut, but my sister and I stayed with my fiancé and his family and we went southeast the longer way. My mother's group met Russian soldiers, and they were taken back. I did not see her again for ten years.

Everything was in ruins. Houses were burned, animals were dead everywhere, there was no place to sleep except on the road by our wagons. The Russians bombed us and strafed us constantly. There was never any rest. When we finally got to the Oder, we did not know how we were going to get across. We heard the ferry was damaged and we could hear tanks and artillery in the distance. So we went back to the highway which crossed a bridge over the river. It was under constant air raids and so many people were killed. Many others lost their horses and all their belongings. But we got across and were so happy then. We found a house where the very nice people who owned it let us rest there for two days. They even let us sleep in a bedroom and we were able to wash and change our clothes. The horses could rest too, but not for long. The danger was always there and we fled again.

We traveled then through Vorpommern, pretty much along the coast. We stopped at farms along the way, sleeping in cow stalls and sheep sheds or wherever we could find some warmth.

On the twenty-fourth of March we arrived at Ratzeburg and got our final orders to go to the town where we would be quartered. When we got there, the families were split up and we were assigned to the farm of the H—s and were received very friendly. They had a big farmhouse, and my sister and I shared the bedroom of the young woman apprentice home economics teacher who was living with the family.

After two weeks, we had to register our horses for the war effort and my future father-in-law was inducted into the home guard. On the first of May 1945, the English took the town after some fighting and the war was over for us.

My fiancé and I couldn't marry at first because he had no trade or money then. He learned to sharpen knives and tools from another refugee and he rigged up an old bicycle to run the sharpening wheel and I pedaled it. He couldn't do it with only one leg. So he sharpened knives and scissors and we travelled to the villages or they brought tools to us. But we were together that way and I used to sing as I pedaled and he worked and I was happy. We married in 1946.

But the old people suffered a lot. My father-in-law only wanted to go back home. He saw no sense in building anything new. He died in 1963 and my mother-in-law in 1969.

74

We got a loan and built a little house and my husband learned to be a mechanic and we made a life here. The house that we built and the ones other refugees built are now just garden sheds or stalls for goats, but they were very important to us then — our own house, no matter how small. We were very lucky. I was with my fiancé and his family and they took care of me.

BRIGITTE L., 1945

I was born in Stettin and went to school there. I was in school in 1943 when the air raids got much heavier and the schools were evacuated. Our school, it was a middle school, went to the country and I lived there. That was a wonderful, beautiful summer. Then my mother came from Stettin — my small cousin from Berlin was living with us then because Berlin was under such attacks that mothers with small children were allowed to leave the city. She came to live with my mother in Stettin. My father had been drafted. He was in the army in Holland at an airfield in Amsterdam.

Every morning we listened to the radio and heard how Stettin was bombed. My sister, who was working on a farm in Hinterpommern, left with a trek and was overtaken by Russians. She got away and walked along the coast all the way. She knew we were somewhere in the area and she got to Swinemünde and then got a train to where we were, terribly exhausted. She had left in March and got to us in the middle of April. She was in a terrible state. I can remember, there was a long line of Russian prisoners passing in front of the house where we lived then. My mother was looking out the window and turned around and said to me, "Look Brigitte, Russians." When my sister heard "Russians," she jumped out of bed and to the door and wanted to run away. Then she wanted to leave. The Russians were moving closer all the time. My mother didn't want to go because our father was away. But there was a terrible air raid, the twenty-eighth or twenty-ninth of April, and that finally made my mother say, okay, we would go. But we couldn't take anything with us. We just had to leave everything. We were given a ride in a truck, my mother, my sister and I. We got through Vorpommern by way of Rostock, Lübeck and a tiny town where we spent the night.

We wanted to go to Denmark, but the Danes had closed the border. There were simply too many refugees and they couldn't let in anymore, so we stayed in Flensburg. We got a room in a large apartment and then there was an air raid in Flensburg, the last one, and our room was the only one

that was damaged and we had to move out! Then we went to another part of the city and got another room. What happened was that we were at a Red Cross station and everyone was always telling about where they had come from and how awful it was and what we lost and all. One of the doctors that my sister told she had fled from the Russians in Hinterpommern—he knew where that was and he arranged for us to get a room. We really had luck there.

You know, our landlady said to us, "What! You don't have a washcloth and a toothbrush? You always take such things with you when you go on a trip!" That made us very sad and I couldn't understand it. They simply didn't know how it is when you have to leave everything behind.

We had no belongings. None of us smoked and whenever we got a cigarette, we traded it for anything possible. Once we got two small blankets, plaid, those small blue and white plaid blankets the army had. Someone gave them to my mother. There was a sewing room in the refugee center and you could sew things there. My mother made my sister and me a blouse and skirt each from those blankets. But how were we supposed to wash them? There were no washing machines then so we had to spend the whole of one day in bed so that our outfits could be washed and dried. Thank God it was summer—the summer of '45 was nice and hot. Ja, now we can laugh about it, otherwise we'd all be lost in the past. We can't change anything that happened.

At that time there were the four occupation zones. We were in the British Occupation Zone and in the first months you were not allowed to write letters out. There wasn't anything to write with anyway. We couldn't cook in our room and had to go out to the refugee center to eat and that's where we met all the other refugees from the different towns and areas. I remember that one young woman got to know an Englishman. He wanted to marry her and her mother always talked about her daughter was going to go to England. I don't know anymore how it happened, but in any case, we gave this Englishman a note to take with him when he was going to Wilhelmshafen. My mother's sister lived in Wilhelmshafen, so my mother wrote our address on this note so that someone in the big extended family would know where we were. One day the doorbell rang and I opened the door and my father stood there! That was August 1945—really fast. I said, "Papa." Ja, my father. He had been in a POW camp. The German civilians were outside and the prisoners inside. My father had the same idea—to get one of the civilians to get a letter to Wilhelmshafen for him. So he had written my aunt there to tell her where he was in the hope that maybe we would also be in touch with her. We had already written so he found us very

quickly. We were all very happy but my father had no job. He had worked in a big paper mill in Stettin and there was such a factory in Flensburg but they didn't have any jobs. He worked for a while cutting trees in the forest, but he didn't like that.

Then the refugees began pulling together more and they started making a big card file at the refugee center—somewhere where each one could register where he came from, where he lived and where he was now. My father helped build that up as well as the organization of people from our area in Flensburg. And so out of that came the opportunity for my father to work for the city government. So we were finally out of the big emergency. Then in 1951 or '52, we got an apartment in Flensburg.

I was seventeen when we first came as refugees and I knew there was a lot of tension between my parents. We lived in two rooms in an attic at first—in one room were two field beds, one for my sister and one for me, and in the other two beds for my parents. It was all squeezed and the rain came through the roof. It wasn't very nice at all. My father couldn't understand that we hadn't planned better and brought more with us, and my mother couldn't understand that. Because he was a soldier, he must have known how it was when you had to pick up and go and not take anything with you. My sister really didn't talk much—the flight had affected her greatly. So it wasn't very nice at all there.

My father thought a lot about our house in Stettin and about what we had lost in Pommern and my mother would talk about missing the city, because she was, after all, a Stettiner. I'm a Stettiner myself. But then later, after we got the apartment things got a bit better. There was peace and quiet at home again. We had been a happy family before and finally it was more like that. My sister got a job then and I wanted to become a gym teacher, but there was no money. In the '40s money was very tight.

I must say though, that it took a long time until we were integrated in Flensburg. The Flensburgers are for themselves—all the Shleswig-Holsteiners are. When you're finally in, then it's very nice. Partly it was because my father was at the refugee office and had helped so many refugees get apartments and other things. People started to say, "Oh yes, Herr L.—, of course."

I moved in 1953 to Konstanz and I married there and we moved to Mannheim and lived there for thirty-four years. Now I live here.

Ja, that terrible flight is a bit forgotten now. In 1987 I went back to Stettin for the first time. I've been there twice since then. I think I'd like to move back there. I find the city still beautiful. Maybe I'm looking at it through half-closed eyes, but I tell you honestly, we've got a lot of houses here in the west that aren't beautiful anymore. Maybe I'm only looking at

what is still beautiful in Stettin. There is still something good there and I appreciate that. When I'm there for a few days I think, this is where I should be. Maybe I'm just naïve, but I do like to go there when I can.

LOTTE L., 1945

Mother was with us, we four daughters and a grandchild. We headed west before the war was over because we had three contacts in the west — something not everyone could say. We had a cousin in Hesse, one who had been evacuated to Düsseldorf and the in-laws of my older sister in Ostfriesland.

We fled but were overtaken by the Russians — that was in March 1945. We had two wagons. My grandmother was part of the trek too, and we had two Poles with us. It's always been a wonder to me that all of us and our wagons and our four horses got back to our house safely. Today I can understand that the Polish woman said "Take my two boys with you," because she didn't want her sons to have to go into the military.

Father was wounded on the Russian front maybe two days later. He came back on one of the first transports — there were fifty percent killed of those captured — and so, in December, the family was all together again. I was twenty-two.

Then we came west again. That was very difficult — by way of Thuringen, illegally over the border. Then Hannover, Ostfriesland to the in-laws of my sister. Jobs were absolutely not to be thought of. The father of one of our relatives in Düsseldorf worked for the city government and he made it possible for part of the family to go to Düsseldorf.

I was a farmer's daughter and my father worked for a farmer in the west until 1951. Then he was able to buy a small piece of land which he worked for twelve years. In 1946 it was very, very difficult. My father, to go from being the owner of his own farm, to being a farm laborer for another farmer, that was very, very difficult. But as I said, this piece of land was offered for sale. One of our acquaintances knew it was for sale and he wanted to get my father out of that situation and he helped us. People believed then, after they saw how he could manage, that he had been a farm owner.

In 1946 I went to Hesse to the rectory of a pastor who was a relative. In November of 1946 I began studies to become a nurse and I worked as a nurse until 1983. I had a lovely little apartment. I was raised as a farmer's daughter, I had training in agricultural things. That's what I expected to

do. But then an uncle offered this opportunity and I took it. I don't think that would have happened to me in Pommern where I lived.

Our village was a tiny farm village with seven farmers. We had forty-five hectares, not all that large. We had some animals and some farm laborers. They were Poles, a couple of them must have been prisoners of war. They came from near Bramberg and they were also agricultural workers. I can't say anymore how they came to be with us, but in any case, there was a widow with nine children. It was 1940 when they came. My father did what he could for them, sometimes the impossible. They weren't supposed to have pigs, weren't supposed to have a garden. My father let them do that, but he wasn't supposed to.

You know, we were treated fairly well by people in the west. That was because of our relatives and friends. That was already a big step forward—to know someone. It wasn't so hard for us as it was for others.

You know, the people in the west were so taken up by what they had lived through that they never even considered what the people in the east, who had to flee, had gone through. That was partly why the integration was so difficult.

The *Lastenausgleich* [the "burden-sharing" legislation which provided compensation to refugees and expellees from the east]—there has been only this one example of such a thing in history in the whole world. Every person was given a payment. It depended on how large one's holding was, how many animals one had, tools. But it helped. And I became a nurse.

Monika M., 1945

I was only six when we left. We were living in Sopot, near Danzig. My father was in the army and he had always told my mother that if it got bad, with air raids or attacks, to get out. So in early May 1945, before the war ended, after the Red Army occupied Sopot, my mother and I left with a mass transport. All my relations on my mother's side stayed and I guess you could say they became Polish. They learned the language and got Polish citizenship. In the late '60s we visited the family in Poland. But we had communications problems because only the older generation was able to speak German anymore. My relations on my father's side left. But only my father and we stayed in the DDR [the former Deutsche Demokratische Republik, or East Germany]. The others, his two sisters and brother, went to the west in the '50s. We've had no contact with them either. When my father died, I wrote them and they replied, but did not say that it would

7 9

be nice if we met or anything like that, or that they'd come to the cemetery. Maybe they were afraid that we poor folks from the DDR would suddenly descend on them and want something. Oh well, they're all over seventy now. I suppose they're too old to travel. I'm sure my cousins—I don't even know how many I have—don't care at all.

I only have the vaguest memories of leaving Danzig. I think I remember getting on a boat out of the port, but I don't recall much about that. We did get on a transport, a train made up of freight cars for all of us who were leaving. There were maybe forty or fifty people in ours. Everybody had his own little place and you put your backpack down. No one had any real luggage; there wasn't time to organize or pack, really. And we all had on layers and layers of clothes. I looked like a very fat child I had so many layers of clothes on. Well, you couldn't carry everything, so how much you wore made room in the backpack for something else. We were on the way for three weeks and during that time I didn't wash or change my clothes or take anything off. Not just me, everyone. When we finally got to the camp and I took off my clothes, I was covered with some kind of boils—all over. Red sores everywhere.

We were there in that camp for some time. I'm not sure for how long. There was a three week quarantine for everyone then so they could watch for typhus and measles and other contagious diseases.

Then we were sent to a different kind of place, not a quarantine camp. It had been a camp for forced laborers from Eastern Europe during the Nazi time. It was attached to a former hotel on top of a mountain, well, a hill really, in the Harz mountains. My mother was working for the Russians in a barracks kitchen at the bottom of the mountain and she was able to get some food for me at midday every day from what soup or whatever they had in the kitchen. I would walk down the mountain everyday at noon and wait for her and she would come with a bucket of soup and some bread maybe and sit next to me while I ate, and then she would go back to work and I would climb back up the path to the top of the mountain. That was most of what I ate every day during that time.

We located my father through the Red Cross. He was out of the army then and he didn't want to go back to Danzig, so he went looking for a place for us to live and for him to work. You know, we were resettlers (*Um-siedler*). I never thought of myself as a refugee. No one called us that. We were, all of us in the east, resettlers. We got no help from the government like they did in the west. We weren't any different from anybody else in the DDR. No one there knew where we came from. We simply had to find jobs and places to live. I guess that's partly why, now after reunification, we in the east don't really have a notion of what a refugee is—it's a term

we never used and I think a whole generation has let it drop from our vocabulary. *Asylanten* [those given asylum for political reasons] are something else.

My children never had the feeling that their "resettled" grandparents had any special status. There never was a "resettler" mentality in the family. Everyone felt like a normal citizen in the early DDR society. The only time it came up was when there was a discussion about the old days and then it was expressed more in terms of social problems in Sopot. The "problems" of the resettlers in my family, at least, were only recollections of the past.

Anyway, my father found a place for us and a job in a town near Schwerin, so we went there.

It's really very funny. I always told my husband and my children about this town, how beautiful it was, with a big park and lovely houses. I told them that for years. So finally, we went to see it again. Well! It was a tiny village, not even a town, one main street and one street crossing it leading to the railroad station. That was it. The houses were ugly, they certainly weren't the lovely houses I remembered. And the park! It was three trees on a small patch of grass. My family thought I was crazy. "This is the beautiful town you talked about?" Well, in my memory it was different. I was a small child, the war was over, I was with my mother and father and had some food—not much—but I had other children to play with and it was wonderful.

There were some bad times of course, the food situation was very bad. Our children don't really know what it's like to be really hungry for a long time. We used everything. We gathered wild mushrooms and wild sorrel in the woods and ate it like spinach. We used everything—the water the potatoes were cooked in became soup that night or the next day. I still think of that time when I eat rutabagas. But now I cook them with cream and butter and it's different. The coffee was *ersatz kaffee* [coffee substitute], made mostly from acorns. We used to use it to cook other things in. There was so little fat. At school we did get one meal a day at noon and that came from things sent by the Swedish Red Cross. That was my main meal during that time too. Our children get hungry for something, but if it's not there, they can get something else. We had oranges and bananas only at Christmas time here in the DDR for years. So if they were hungry for an orange, they couldn't have it if it wasn't Christmas, but they could have something else. They never really went hungry.

8

SOMALIA

Somalia, jutting out into the Indian Ocean and the Gulf of Aden, is at Africa's easternmost "horn." It comprises only one ethnic group with one principal language, but many family clans and lineages.

Like other African nations, Somalia endured a colonial experience, divided into British Somaliland and the Trust Territory of Somalia under Italian administration (Italian Somaliland). After 1960, the newly independent Somali Republic boasted a parliamentary government, rich in democratic socialist intentions but poor in fertile land and natural resources. Pastoral nomadism, like Islam, is central to the cultural and economic life of the country.

In October 1969, a group of army officers, led by Major General Muhammad Siad Barre, took power, seizing key installations in the capital city of Mogadishu. Under Siad Barre corruption was rampant and public institutions were abused and weakened; different interpretations of socialist government developed between north and south and among clans and lineages. Siad Barre was toppled in January 1991. The resultant civil war has seen clans and lineages turn against each other and the destruction of Somalia's army, police force, civil service, banking systems and schools and hospitals. Somalis began to flee the anarchy, factionalism and violence of marauding gunmen in 1990.

CHAMSA S., 1993

I'm from Somalia. I lived in Mogadishu and then we went to Nairobi [Kenya] because of the war. We were in danger because of the fighting. I came with my sister, but she is still in a refugee camp in Kenya now.

I'm thirteen now. I was twelve when I left Somalia. That was in 1993. I was in the refugee camp—Utange, near Mombasa, for five months. It was bad there because people did bad things. We got there by car, truck actually—my brother, my sister and her husband and children. My aunt

was already there and we met in Utange and then we stayed together and came to the United States. We're going to stay in the United States. I like it here. I like my school, middle school. I like playing and the people and my friends. There is one other Somalian in my class, a girl. I have many friends—we talk on the telephone a lot. I talk to them in English. I speak English only since I came to the United States, not before. When I finish middle school, I will go to high school. Then I want to be a doctor.

Somalia is a good place. I would like to go back. Maybe when I'm twenty-two, maybe the war will be over and I will go back. Maybe I will be a doctor by then and go back.

My three brothers are here. They are my brothers because of my mother and my aunt. They are what you call my cousins. I have ten brothers and sisters.

Nothing really bad happened to me in Mogadishu or in the refugee camp, but it was not good there. But here, in school, I fought with a girl. She was a Hispanic girl. I was sharpening pencils and she asked me for one. I gave it to her and she threw it at me. I asked her, "Why did you throw that pencil?" She said, "Because you are stupid," she said. Then we went into another class and she stuck me with another pencil. Then we fought. We had to go to the office. Another girl, a black girl, I had a fight with her too. We were playing ball and she threw the ball three times at my back. I asked her why she hit me. She said she didn't know. It was a basketball.

I was at my aunt's house in Mogadishu and we had to run away to Bardera. The family was split up. I was with my cousins but my aunt was in Bardera. She ran away and when we came to find her, she was not there, so we went to a village where the rebels could not find us. There was no food, no anything. So we had to collect water and find wood and things.

First, when we came from Mogadishu, we went to Bardera, then to the village. But we came back to Bardera because of the rebels. We wanted to leave then. It took seven days of travel because we were hiding from the rebels. No water, no food. Finally, we hid in trucks under sacks of maize or beans or something. If they had found us they would beat us or put us in prison.

I was afraid because I heard that the Kenyans came with knives and took young girls away. But I always stayed with my aunt and uncle. If you don't know Swahili language and you go to the market [in Kenya], they ask you for I.D. If you don't have an I.D., they send you directly back to the border. So you must hide or learn Swahili. So I learned Swahili very fast.

I have a Spanish girlfriend here and every night I talk to her on the telephone in Spanish—not the same girl I had a fight with. This one is my friend.

Luul A., 1993

I was born in Bardera, Somalia. I lived there with my mother, my father and my brothers and sisters. Altogether we were about thirty-two people. My father had four wives. We lived there peacefully and in joy. Our family was very well-known — respected, religious people. We never killed, looted or attacked anyone.

We had gotten our independence in 1960. I really went crazy at the time. I was so happy when the Europeans left my country, especially my town, Bardera. The civilian government was installed and we enjoyed a democratic elected government for a short time from 1960 to 1969. Then in 1969, October 21, the military overthrew the civilian government. They abolished all political parties. They put the canton in an emergency mode. There were *guulwadayaal*, which means the vanguards. The *guulwadayaal* abused the rest of the people, threatened them, and the military did whatever they liked, campaign after campaign. First there were the self-help projects, then civil wars, then war with Ethiopia, war within Somalia, clan after clan. Somalian money went up; there was economic crisis, social crisis, no schools. From 1987 to 1990 there were civil wars in the north of Somalia, then in Mogadishu, then in Bardera, then the whole country.

It was a Friday in February 1991 — the armed forces arrived in Bardera city. Later the United Somalia Congress [USC] forces attacked the Siad Barre forces. Then the USC turned back and the Siad Barre [forces] came and looted all the shops, all the properties. It was Aideed's and Siad's forces that looted Bardera town. They destroyed houses, burned everything, attacked civilians, raped women and threatened to kill people. Let me give you one example: they attacked us, our house. We were rich. Rich in Somalia means we had jobs, farms and also we had trucks. We used to be in business and they knew we had money kept in our house. They attacked two times. One time they attacked outside our house, but luckily we had some guards — they defended us. Again, another night, they attacked us. They came inside our house and everywhere there were bullets flying. I cried. I said "Help, help, help. Oh God, Allah, help me, help me." Everybody was hiding in their own houses, nobody could help me. I had my son and we went under the bed. I thought that night was the end of my life. I prayed and prayed. Luckily a neighbor came and defended us and they turned back. It was that day I decided to leave the country.

Before that day, every night, I heard women crying. Everyone knows that they raped women. There's no police, no courts, no government. I can't sleep when I hear women crying. They raped my sister. She was thirty-two years old and had two daughters. They went into her house,

looted her property, and raped five women. Soldiers! In the morning when I visited her house I saw her lying on the bed. I thought she was going to die. Her eyes had become white. Her two daughters were crying. I didn't cry. I just said, "God, Allah, help us." Even in Kenya, when I arrived there, the police, they do the same. They are bad, bad people. They do bad things. We thought at first, the Kenyans are like our brothers. But they are animals, wild animals. They asked for bribes, they raped women. All the beautiful Somali girls they raped—and today they have ugly children of Kenyan soldiers.

During my journey from Bardera to Kenya, first I stopped at Eelwak, a small town on the border of Kenya. Then another town, then Nairobi, then Mombasa, then the United States of America.

I left all my property, all my things, all my clothes, all pictures of my husband who died that I wanted to give to my children—I left them there. I left other important things. My family—my mother, my old father, my brothers, my sisters, my nieces, my nephews, my aunts, my relatives, my friends—I left my beloved land, Somalia—my beloved native town, Bardera. I dream every night of the river at the head of Bardera town—the trees, the farms, the animals. I was so happy there. I grew up there; I know everything around that area. I left my neighbors. I don't know today if they are alive or if they are dead. I don't have any news because there are no telephones, no post offices. There is no institution in all of Somalia. The unity of Somalia collapsed. Today we are fighting in clans—Clan A, Clan B, Clan C. It's very difficult to ever unite the people again as they were during the time of independence.

When I was in Bardera and the United Somalia Congress and the clan of Siad Barre were fighting there, the rebels used to say we are the Mujahadeen. The USC said we are fighting against the evil Siad Barre, and Siad Barre was saying to the people you are fighting against the hyenas from Mogadishu. Actually, they are both evil and hyenas. What they say is true because what they did justified who they are. Most of the Bardera area, the people who lived there, are farmers. They are poor people; they are peaceful people. They are not warlords. When the rebels arrived, they looted the farm products—the maize, the fruits, the money, everything. It is the people of Bardera who are dying every day, thousands and thousands like flies. Oh my God, I am lucky I left in time. My son was in the U.S.A. and he used to call me every week. I called him and he sent me money to leave. He helped me and my children who were stuck in Mogadishu. All of us, we came together in Nairobi because nobody could stay in Bardera any longer. They beat and slapped my son and they kicked me when I tried to help him. We cried. We couldn't do anything. They told my son, if you

start talking or moving, we will kill you. They took all our money, all our property.

When I arrived at the bus station in Bardera, near the bridge, then they looted the rest of the money we had and we became poor from that day—refugees who do not have anything. We walked and walked and walked—about forty kilometers, hiding from tree to tree. There were landmines all over. Someone guided us and we paid him the little we had. I had only one thermos and one cup. I am sick; I am diabetic. I can't drink tea with sugar, so I have to get hot water and tea to survive. I didn't have any food. I cried and asked why God was punishing us? What have I done to the world? But it was not only me. It was all Somalian women, men, children, elderly people who suffered. Nobody can picture. Nobody can imagine so much. . . .

Finally we got a ride. We asked him to give us a ride and that we would pay him when we reached Eelwak. We would give him his money when we reached there. And then I went to Nairobi. When we went from Eelwak to Nairobi, we hid under sacks of grain and rice. The Kenyan soldiers, unless you pay them bribes, they won't let you go into Kenya. They don't recognize us as refugees. They don't recognize that we don't have a home anymore. They don't recognize that we fled a civil war. They never welcomed us. They looked at us like enemies. We hid and hid and hid and then we arrived in Nairobi. When I woke up in the morning and saw the sky in Nairobi, I was still thinking I was in Bardera. But the noises of the cars, the faces of the people, the buildings, the food—everything was different. I knew this was not Bardera.

After a while, my children joined me and we went to Mombasa. We entered the refugee camp, Utange. There also, we had big problems. We had to pay a bribe. The children had to stay close to home, otherwise the Kenyan police would take them and arrest them and deport them to the border where the civil war was going on. Girls, they have to sell their bodies to protect themselves. No organization, no human rights, no other groups can help them.

In 1993 I arrived first at JFK Airport and then my son was waiting at National Airport in Washington, D.C. I cannot remember the time. I didn't know where I was, the plane was so big. I thought it would not be able to fly. There were about five hundred people! They treated us well while we were in flight. They gave us nice food. A doctor, a medical doctor, woke us up. He treated all the elderly people. We landed. We arrived in Washington. But now I live here. They gave us food stamps and financial assistance. I got Medicaid. I went to the hospital and they treated my diabetes. They gave us medicine. Today, I am healthy and I am well. I like the United States. I visited Washington again on Christmas Eve. I liked

the Christmas trees. I went around the White House. I saw lights and different people, different faces. I enjoy it here. I feel peace now. But still my heart is there and I dream every day of Bardera—a city of death. But I hope it will be a city of prosperity and life.

My daughter is still missing. She is in Kenya with her three children and my son-in-law. I hope they will join us one day. I would like my children to go to school, to finish the university, then I hope everything will be okay.

HADIYA M., 1992

I didn't experience the civil war directly—not like women who were there, who have seen their husbands, children, fathers and brothers murdered in front of them. It's a horror story when you meet with someone who came from Somalia and speak with them—with people who tell you what happened. That they're living is God's will. They should not be living and be here, if they tell you what they've been through.

It was not like that for me. But when the civil war started, for example, one of my sisters had nine children. Her husband was from a different clan than ours. The husband could not go with her, to accompany her, to help her with the children. It was not safe for him, so she fled with the nine children. She doesn't have a penny. After one month of the civil war, I was waiting to hear what happened to my family. I got a call from Mandera [refugee camp in Kenya] on the border of Somalia and Kenya. She said, "I'm here by myself with the children." She doesn't have a penny; she doesn't have anything. Her husband first tried to come with her, but he couldn't. Some people were looking for him to kill him—from our own clan! So he had to go back to where his clan is. Stories like this are what bring me in personally.

Myself, I did not come here as a refugee. I came here first as a diplomat. But losing that in a short period of time, while my country was falling apart, I was falling apart here too. When you are a diplomat in another country, usually you don't go into the details of what is in that country. For example, what are the day-to-day activities of a regular American person. That's not something that I was involved in. I never knew anything about such things—the job hunting, babysitting problems, the local rules and regulations from traffic to tax filing. I had to go out to look for a job. It was only me, my children and my husband struggling. How we can get a job. First of all, making up a résumé! Looking for a job.

Learning to mix and the ways to integrate ourselves into this system and society. That was very difficult for us. Plus the constant calls, collect calls from refugee camps! Letters and Red Cross messages! My loved ones are in distress and I don't have anything to give them, because practically I myself am a refugee. I cannot maintain myself and my children. It has been a very difficult time. In that way, I was affected. In two different ways; one is myself, being a "refugee" in a different country. Then my family, thinking I can help them when I can't. In this distress, so the feeling is very painful, one of helplessness.

My sister in Kenya is still in Utange refugee camp. Last night, coincidentally, at five A.M. Sunday morning, I got a call. The brutality of the Kenyan police is also another problem. What happened is that Sunday morning, the police just came into the camp and burned all the houses. They did not let the people collect all their belongings. Then I got another call. It's continuous pain. In Utange, this is the third time that the houses were burned. When they called yesterday, I said nothing is new about that. Why do they call? The reason they call is to tell us about their difficult situation—they lost everything again. The third time.

I tried to get a job. I didn't know the job hunt was so difficult. I thought everything would be fine—I'll pursue the American dream and all those things. It was very tough to find a job. But there was not time to wait around and look for a suitable job. My intention was to take anything. I didn't have any specific skills that I could use immediately, except that I had a degree. I learned one thing—that even if you have a degree, you lack a lot of other skills. Finally, I landed this clerical job, which I am still doing. And the reason I'm still doing it is I have to reinvent my career. I am taking classes and building my résumé and computer skills and learning business language and things like that. It was a hard new learning experience. You know, learning the American culture, the American work environment is not working at the Embassy, where you are surrounded by your people, always discussing events back home. In that way, a career in the embassy is a fake profession.

So I'm just staying in this learning process. It's taking me long, but I have a lot of things to learn. I'm still in the search.

My children are all going to public schools. They're doing okay. The oldest one is on the honor roll. The events—the civil war shook all of us, but we adapted and everybody's working—moving ahead and doing the best we can. Life is not easy for us, but there's light on the other side of the tunnel.

I cannot go back. The civil war—violence is still there. You cannot be safe in your house. There is no order, no police, and no government. So

anybody can just come in and do whatever they want. There's no security. But personally, actually, I have been thinking about going back. To go to Kenya and cross the border and see my father, who's eighty years old. Again, the means—how can I? The ticket alone costs two thousand dollars, so it's not easy. But I wish I could do it. It's a risk; your car could hit a land-mine. It's not a safe area. It's a war zone. But my hometown, as far as I know, there's no war going on at this time.

My brothers and sisters—you would call them half-brothers and half-sisters—were in the capital city when the civil war started. But originally we are not from the capital city. What happened is, my father was still liv-ing in our hometown, so my brothers and sisters, as soon as Mogadishu was chaos and killing, within the first two weeks, they left. Some of them walked from the capital city to our hometown, near Kenya, walked for days, but they managed to come. Most of them crossed the border to Kenya because by that time our hometown was not safe. The war was spreading so quickly. So currently, some of them made it to Canada, some of them are in Holland, some in Italy, some are here in the United States. My other sister, she has a lot of children, that's why I talk about her often. She's older than me. She's still in Kenya with her children, trying to make it out. My father went back to Somalia from Kenya. I wanted to bring him here, to sponsor him. But he said he was an old person. It's hard for people like him. He said it's time for him to stick around there, so he went back. My mother is in Canada. She was here visiting us when the civil war started. Since I was not able to support her, she emigrated to Canada. She's been there for three years; I haven't seen her for two and a half years. Even though we are able to talk on the phone, because I don't have the proper papers, I cannot go to Canada. She doesn't have the papers to come back here either. A lot of Somali refugees are in Canada. Ninety percent of them are women and children. Some of them are there with their husbands, but most of the men cannot even adjust to a foreign country and they feel it's degrading what they have to do. Most of the refugees there are women and children. The reason is that men have a tough time making the transition between two lives. All this inhumane violence that humans commit, the victims are the women and children. Unfortunately, the men are still talk-ing about politics and negotiation and peace, and the women and children are not at the tables. They are somewhere trying to survive. They pay the high price and they really should be considered. Their opinions should be learned from.

No one wants to be a refugee. Especially women, who have to move from one home to another. When you see what they are going through at international airports, at international borders, it's very tough and very

sad. This is not a decision that I made—to change my home to here. I didn't have anything to do with making it or creating it. For other women too, they are the victims again and again and again.

Being a woman and leaving your husband behind somewhere—I know a woman in Canada. She was in Canada with a sick child when the civil war started. Her husband was on one of the boats that sank along the Mombasa coast. He had the other three children with him, very young children. Fortunately the children survived, but the husband died trying to save the children.

I hope that anyone who is displaced will get some mercy. But the best thing is for everybody to be where they would like to be and not have to start life all over again in a different country.

9

HUNGARY

When Imre Nagy became premier of Hungary in July 1953, his announced plans were correctly interpreted by Soviet neighbors as a rejection of policies in place since the Communists had seized power in 1949. Expelled from government and the Communist Party in 1955, Nagy continued leading popular pressure for change. In 1956 Budapest students staged a peaceful march which turned violent when the government responded with armed force. Resistance continued until Nagy was brought back, purged the Stalinists from his government, had Soviet forces withdrawn from Budapest and announced Hungary's neutrality and withdrawal from the Warsaw Pact. Before his request for United Nations protection could be taken up, the Soviets re-entered Hungary in force on November 4. Armed resistance and a general strike continued for two weeks. The resistance became known as the Hungarian Freedom Fighters and their flight from Hungary grew as the Soviets consolidated their power and installed and supported a sympathetic government.

MARTA G., 1956

We left Hungary in 1956, December 6, Saint Nicholas Day. I was married before and I had two kids, and my husband was married before and he had two kids. Three years before that we had married each other and to have all the four with us was not easy because we did not have enough accommodation. Half the kids were at my mother's and half were with his former wife. So now we gathered all of them together and left Hungary.

We had lived in Budapest and we left everything behind. To make it even more interesting, we picked up another woman who had just come out of jail, a friend of my husband's, and she had three small kids. So altogether, with my mother, we were twelve. We just closed the door and

everybody had about one change of underwear and one day of food and one six-ounce bottle of whiskey in case we met any Russians, to bribe them. That was the way we left.

We had made an arrangement to go through the border with a Hungarian military person. So we went to the place we agreed on and that military person didn't show up. So by late afternoon the farmer we were staying with became very nervous; everybody knew we didn't belong to that village. He arranged another way of going through with a former border worker. The kids were packed into a one-horse carriage and they had to put their heads down, while we were walking in the ditch next to the road. Wet! By the time we arrived we were soaked, but that was nothing. When we finally arrived, it was close to midnight. I was immediately asked to come help translate for another group that had already come through because no one was there who could talk German. So I went and then we found out that the military person [who was supposed to take us] took another group instead of ours because they had paid more. And that was the group. They went a different way from the way we went and the Russians found out and started to shoot. That particular family, a man, a woman and three kids—the baby was in her mother's arms and the two kids, one in the back of her father and one in the front—because they had to run and to hide, the father was not able to carry them both plus whatever packages they had. So they gave one of the kids, the small boy, because the bigger one didn't want to leave the father, to another man to watch out for. I was asked to translate because at ten or eleven o'clock, they still had not found him. As far as I know—ten or fifteen days away from there—they still hadn't found the little boy. He was about two years old, not even able to tell his name. So that was the first thing that hit us. We lost our wonderful way of crossing the border, but what if that had happened to us. Look what we gained!

It was a must that we leave. First of all, my poor husband had been arrested before. My father was also arrested before for political reasons. Both of them were exonerated in 1989, when the new government declared them innocent. But that didn't change what happened to them or to all of us. We had to leave because they were looking for my husband. He was an engineer and the one who opened the doors [of the small arms factory where he worked] for the freedom fighters to get weapons. I'm sure he would have been arrested again. Unfortunately, my father decided at the time not to come with us. Well, it's a long story. At the time he was arrested, he was beaten so badly that both of his kidneys stopped functioning. Mother was forty-two at the time we left Hungary and Father was fifty-three. He was in bed and he blessed us and said we had to take Mama

because if the family was arrested, what could she do? So we left him in Hungary, that was the sad part.

Well. We walked to the Austrian border and crossed. Finally we had to carry all the kids' stuff and the kids. It was very difficult. We walked toward Penhagen. Within fifteen days we were up in Denmark. We were very lucky. We lost all our address books, but my father had a former business connection with Denmark and we were able to go there and we stayed there two and a half years. After that my husband was asked to take a job through the Academy of Sciences here in America, and that's what brought us over. That was much easier than many other people's lives, but still, we have no way to describe how many difficulties there were.

Eisenstadt [in Austria] was the biggest refugee camp. It had been occupied by the Russians after the war and just a few months after they left, it was opened to take the Hungarian refugees. It was in terrible condition. Even the doorknobs were taken away. Even the doorknobs! When we were put in a room in that camp, the first thing I did was order the family to clean it. We immediately started to work to clean that room, to make it comfortable, to cover up that box and make a table out of it. This became an example for the others. I sometimes felt a little ashamed of doing that because other people might think I was doing it for the show. I did it for our sakes, for our own health, in order not to be depressed. My husband's daughter had just married two years before we left Hungary and she had a six-month-old baby we were not able to take with us at that time. So it was the hardest thing to comfort her — to leave a six-month-old behind and not know when they would see each other again was very hard. But again, if you just think about that story I just told about the child who was lost on the trip, ours was not with us, but at least it was not lost. Whenever we got to the point we thought was the worst, we got something better to show we are still not in the worst shape. Others were much worse off. That's my view always of life. I always feel, everything, if you just twist it a little bit, then you can see there is another corner which is a little bit better and then try to use that better corner. I tried to give that sense to the family and cheer everybody up a little, even in the worst situations.

When we left, that was the most beautiful journey I ever had in my life, that journey to Denmark. At every station we stopped there were people waiting for us. From Austria all the way to Denmark, nighttime, daytime — it was about thirty-some hours — we went on and at each station they were waiting. They offered something to drink, chocolate for the children. We arrived in Denmark with more food than we had ever seen in the last years. These were just Austrians and Germans, waiting for the Hungarian refugees. They knew there were Hungarian refugees coming,

passing through. As a matter of fact, when we crossed the canal [at the border], the officers invited us to the dining room and they gave us a dinner. There were many of us who had never seen such a thing before—there was an ice carving! They gave us everything. It was a glorious welcome for the Hungarian freedom fighters.

We had fifty in our group; twenty-five went to the big island and we went to Copenhagen. It was very hard at first not knowing a word of Danish. Who knows Danish? But they were very helpful and my husband, being an engineer and with his connections to a factory there, he started to work right away. I started as a technical secretary, not knowing a word of Danish, and my husband as an engineer with his German and his technical knowledge. But there were lots and lots of problems with many of the refugees. In a way, we were fortunate and in a way we were better off. Like the lawyers, they were just lost. Regardless of their education, what can they do as lawyers in another country? Or the doctors? Being the best doctor, without a license, what can he do? Pharmacists? As an émigré, the most fortunate one is the one who is plain. Their desires are plain and they just want to work for food. And everywhere you can find work for simple people. The worst off were those whose education could not be transferred. That was the most difficult.

I was not yet thirty years old when I left Hungary and I already had a grandbaby. I was not born in Budapest, but I lived in Budapest almost all my life, during the war too. After the war, first of all, I married in the last days of December, two days later, the Russians closed around Budapest and the siege began. Budapest fell, as you know, and the war was over. My first baby was born in February 1946 and the second, in May 1947— fifteen months' difference. I was in a very weak condition and three months later, my husband was arrested. A year and half after that, everything we had was confiscated. My husband spent five years in prison. First there was a one-year sentence, then they increased it to two and half years and then another two and a half years, in a concentration camp. These were Hungarians who did this. In the beginning we tried to sell what we could, then when everything was confiscated, we had nothing to sell. I filed petitions; I objected that what my husband was accused of had nothing to do with me or my children. I married him and then the war was over and in between we were in the bunker and he did nothing and neither did I. So finally, they gave me a job which was about thirty miles from Budapest. So each day from five o'clock, I had to go to work. And for the five years I kept the children by myself. When a man is in prison, the situation changes so much. When the man is in prison for that long, most of the time, the marriage is broken. For me, there was three years' marriage and

five years' divorce. What a different person I became and what a different person he became in those five years in prison. So when he came out, he went back to his parents and I stayed with the children. He remarried about three months later. I remarried too, in 1953, to a man who also suffered misfortune. In his case, his wife left him while he was in prison. So that's how we got the four children. And we were very happy to leave the country for many reasons, political reasons and family reasons. We started a new life and finally for the first time, we all slept in one place, all of us, not divided up as we had been. I married in 1953 and my adopted daughter married the next year, so that's how I became a grandmother so soon.

Just think about that, having my husband in jail for five years. Plus my father was absolutely unable to work because both of his kidneys did not function. And everything was taken away from us. And Hungary itself was in very, very bad shape. I have a horrible story about my daughter. She was about three months old when her father was arrested. The big boy was eighteen months old. I got a job and then I was fired when it came out my husband was arrested. But the good and the bad are parallel in my life. The two kids were listed for the soup kitchen. So I would take home the food which had been given for the two kids. We were three people and this was only one meal for two children, not three meals for the day. And my poor daughter had the tendency to eat what I gave her and then to throw up. But we had no other food! I could do nothing else; I fed her again with the same food. She never threw up again. I always wonder about how many things in life we don't dare to do and how useful it might be if there is great pressure to do it. She never threw up again. But whenever I think about that, that was probably the most horrible thing I have ever done in my life to any of the kids.

We had a very hard time with the children adjusting to a new country. What is interesting—Denmark was easier because they were smaller then. But that two and a half years' difference made it absolutely difficult here in America. They had become teenagers during that time. They didn't make friendships as easily as when they were little. Like a baby, a baby makes friends within a minute. A little older, it may take an hour. For the elderly, they probably cannot make any more friends. It's so sad.

My husband was offered a job in the United States through the Academy of Sciences, and it was a big decision because we always thought that from Denmark we could walk home. From here we cannot swim home. So it was a very big decision. But at that time, two and a half years after, we knew there was no hope for the freedom fighters. The Russians would not give up, and as you see, it's been thirty-five years until they finally went back and God knows what will happen still.

I have not been back to Hungary and I won't go now. Why not? Because that nine or ten years, the war itself and after the war, what I saw, I don't want to see again. I shine my memory into my childhood. My mother went back about twenty, twenty-five years after and she came back and she said to us, "There is no face in Hungary." We didn't understand, what did she mean by "no face?" She said everybody has such a bitter mark, such an unhappy mark in their faces. She could not recognize her own people. I don't know, I don't want to go back. My children are here. My family is here. We traveled once across the border. My father came after us in 1960. He lived here, although he was very sick, until 1972. We had the whole family here. The little baby came the year before my father, by himself. He was six years old. He was six years old and he came by himself. As a matter of fact he graduated and went into the armed forces and he's working now and he is very happy and has one baby daughter.

When we got to America, my husband got the job immediately, but I was told, through an agency—I probably chose the wrong one—they told me I was too old for a job. I was almost thirty! He said I was too old and he told me, "You think all the Europeans coming over here can get jobs." He said that under no circumstances was I going to get an office job because my English was still very poor and I hadn't finished the university in my profession. Someone suggested I learn to be a manicurist. So I did that for one year, but after that I said if I had to wash one more head of hair or clean one more dirty nail, I'd kill myself. I went to work for an insurance company, starting at a very low salary, and within a year I more than doubled my salary. I was very happy there, but then we were involved in an accident and I had to leave my job. In the meantime, my husband became head engineer of his company and he didn't let me work. And that's how I became involved in voluntary work with the Hungarians and I guess I work much more than I ever would have worked for money.

We came here because the spa was very good for arthritis. My husband had arthritis very bad, and diabetes, so we used to come, and after about two years, in 1968, we bought the house here. He died ten years ago on February 2.

My story is much too long. How we got the church started here is another story. First of all, the Hungarians had a house in the city where the refugees used to gather. That house was sold. You know, when you start to feel comfortable in your new home and your brother, a refugee, arrives, you give them everything, but you don't want trouble. That's exactly what happened. They had the house and the house was neat and nice, and we, the poor refugees poured in, and we were trouble. Everyone had problems. Certainly we brought trouble to them. So what did they do? They

decided to sell it. It's the same as a wealthy family here in America giving everything to the child until they reach the age of completing high school. Then they kick them out and say stand on your own feet. That's exactly what they did to us. Now you are here, you have everything, stand on your own feet. And they sold the house from under us. That's what happened; we had no house anymore.

I started the first Hungarian Ball in 1966 to get money to buy a new house. I was very successful; I got twelve hundred people. I'm still amazed. We had the first six thousand dollars and were so thrilled, thinking about buying a house for our own Hungarian freedom fighters. But then the others [the older Hungarian immigrants] said that wasn't nice because they had helped us and now we wanted to be by ourselves. They asked why not join together and make a cultural center for all of us—and we fell for that. Well, long story, finally we were alone again. Then we started to get very cautious. If we didn't have enough money, how would we run the house? Then the economy changed. And we were becoming divided. The intellectuals had their group. The white collars, they had their group. They didn't want to have a club life together. What kind of a club could we have? Monday to the high class, Tuesday to the low class? What? So we realized it just wouldn't work. We hadn't had enough time to grind ourselves together. We had lots of political differences, which were not our fault exactly, but the fault of circumstances. We had the before–Nazis, the Nazis, the after–Nazis, the Communists, the—aach! And everybody is just a little bit burned by the others. We couldn't cook any food which could be eaten by everybody. Always somebody doesn't like the spice.

So we just collected the money and waited and waited. We still wanted to have cultural center though. Then one day, I was called by the Little Sisters of the Poor. I went and they asked me to take care of having a Hungarian funeral for an elderly Hungarian lady who came to America about fifteen years before. She spoke French and the superior of that order there was French, so the woman never had to learn English. She ran the sewing shop by herself and lived that way for many years. Two years before, they changed superiors and the new one did not speak French, so the last two years of her life that lady did not speak to anyone, but she smiled, always smiled. We did not know about her, but we looked on the mailing list that the old organization had given us and she was on the list and was getting our paper. I will never forget, in that home, just like in a hospital, you had a bed, a chair, and next to it a little desk kind of thing and then a little wardrobe outside the room, that's all. Half of that wardrobe was filled with our newspapers. That was her connection with the Hungarian world. She never wrote to us or asked for anything. We had the

funeral service at noontime, but nobody attended. Just me and the priest. I will never forget that welfare casket—the empty church, I, the only "relative," the funeral director and the priest, who was very embarrassed. When we went to the cemetery, I had some flowers, but they drove way back to the end of the cemetery and I ran to the office and asked where the burial site was. They said when the weather was better, they'd put her in because she was a welfare case. They said there would be no stone anyway because welfare cases don't have stones, just a little marker, and they didn't know when.

Going home, I said to myself, that woman, God knows who she was, but she spoke French so she must have been an educated person. She was fifteen years here and now we bring her nowhere. You find better situations for dogs here. So from that time on, I had in my mind that we must do something for those who just drop out from us like nobodies.

We bought the acreage here, not by the Hungarian freedom fighters, but by Hungarians who got together to form a corporation, and we bought 180 acres. And in the middle of this land, there was a 660-square-foot family cemetery that could not be sold separately or excavated; it was protected by law. And that was the minute I realized, this is where we will build our Hungarian stronghold. This will be the place because what we build should not be sold. You know, one generation puts everything together, they work to get something, and the next, because difficulty comes, they just throw it out. When my husband signed for the loan, I had only one request, that we had to have the acreage around that little cemetery for the future Hungarian family cemetery. And that's how we started to build our chapel instead of a cultural center. Our chapel is very unique. It's not denominational because we have all kinds of denominations. So each minister will come to celebrate weddings, christenings or burials. The lower part is the crypt. People buy a place or we give it away because they have nobody to bury them, like that woman. The upper part was created by donation. We put in the ceiling the coats of arms of the seventy-two counties of Great Hungary from the year 1000. We put up the coats of arms because people who are living now in the United States were born as Hungarians over there, just at the turn of the century. At that time, there was still a larger Hungary than after the Second World War, when we lost two-thirds of our land. And on one side we have portraits of the founding fathers from about A.D. 960. We've already buried more than sixty people—some are from Paris, some from London, some from California.

10

VIETNAM

Under French colonial rule from 1858 and occupied by Japan during World War II, fiercely nationalistic Vietnam chafed under both dominions. After the war, the French returned to confront a growing movement for independence. Negotiations on a new relationship with the French broke down when the Viet Minh, a coalition of nationalistic groups led by the Indochinese Communist Party, attacked the French in Hanoi and war began. In 1954, a cease-fire agreement provided for the division of the country into a communist North Vietnam and a noncommunist South Vietnam at the 17th parallel. The French withdrew.

North and South Vietnam rebuilt along mutually antagonistic ideological lines. South Vietnam's President Ngo Dinh Diem requested American military assistance in 1961 against the growing insurgency of the communist North Vietnamese. What started as a program of military advisers increased to include U.S. military installations and then troops to protect and defend those installations. By spring of 1969, U.S. military strength reached 543,000 troops.

After U.S. military forces began a phased withdrawal in favor of "Vietnamization" of the war, communist forces began a major offensive in 1975 and the subsequent military collapse of South Vietnamese forces and fall of Saigon in April of 1975 caused many anticommunists, especially those connected to the South Vietnamese government or its American ally, to flee for their lives and safety. Others came in later waves—Amerasian children of Vietnamese mothers and American GI fathers and South Vietnamese Army Officers who had been detained in "reeducation camps."

N. THIEN LY, 1975

I was born and grew up in Cambodia. My parents were Vietnamese who went to Cambodia to work. I was certainly brought up as a Vietna-

mese. My father died when I was eleven years old, but the family remained in Cambodia until I was nineteen. At nineteen, I came back to Saigon with my family and lived there eleven years until 1975. There was some adjustment coming back to Vietnam. The two cultures were different. The war was more intense in Vietnam; living conditions were more difficult. But I was brought up Vietnamese and always knew I had a home to go to—an ancestral home in South Vietnam, in the province of my father.

Within a few years, with hard work, I had a stable job, earning a good salary, and I had completed a college degree for teaching French language to high school students. I was a schoolteacher in Vietnam working with the French Cultural Alliance.

My coming to the United States was owing to my sister. My older sister was secretary to the U.S. defense attaché. Her supervisor was an official in the unit organizing the evacuation of Vietnamese related to American GIs and those Vietnamese who worked for Americans. My sister obtained a visa for herself, but said she wouldn't leave without her relatives—my mother, my younger sister, my older brother and his wife and children, and me. We left on 28 April 1975, practically two days before Vietnam fell—well, the morning of the twenty-ninth. We were taken by U.S. helicopter to the U.S. navy base at Subic Bay. We stayed there for two weeks and then were taken to Guam for one week. We were processed and sent to Fort Chaffee, Arkansas. Our family stayed for two months and then left—me, my older sister, mother, younger sister and a nephew. We were sponsored by an American we had known in Vietnam. He worked as a contractor to the military—a civilian systems analyst. We went from there to Annapolis, stayed there for six months and then moved here. My brother was a doctor and he stayed at Fort Chaffee for a while to be a doctor for the refugees coming in.

I had studied English in high school—the way of the old system—reading, translating old text books, with practice at the Vietnamese-American Association. We would meet with other students and teachers for an opportunity to practice speaking English. My acquiring English was through French association—it seemed to me that transferring from French to English was easier for me than for most of my compatriots.

My first job was as a babysitter to two children—to replace a teenager! My second job was with the locating program of the Refugee Task Force. A systems analyst for the State Department needed someone who knew the names of refugees coming in. Reports from the camps were very disorganized, names had been mixed up. The systems analyst lived in the same town where my family was and he read in the newspaper that my sponsor had somebody with education; he came to the home and spoke

100

with me. I volunteered to help sort it out. In return, the systems analyst assisted me to obtain a job with the locating program. It was a temporary telephone operator position and it lasted six months. I was happy and felt very lucky to get the job. Sometimes I believe in fate and the convergence of all the things that happen. If I had not known Cambodian, Vietnamese, French, Chinese and English, I may not have gotten that job with the State Department! My volunteer task had been to sort out not only the Vietnamese last names in alphabetical order, but also to classify or discriminate other ethnic names, Cambodian, Chinese, Laotian, Thai, Filipino.

Actually my real second job I was fired from before I even started. I was supposed to be a chambermaid at a hotel, but my sponsor got me an appointment for an interview for a better job at a library. She called to postpone my hotel position and they fired me on the spot!

I had to commute every morning from Annapolis to Washington for the State Department job. I did that for six months. Then the program was transferred to the Red Cross. So my fourth job was as a "tableman." You know what a "tableman" is? A waitress—at the Naval Academy for midshipmen in Annapolis. I was there only about two weeks, though, when I found out about another job. A county program was looking for an outreach worker, a social work assistant.

My husband-to-be was a social worker for the Red Cross. We both went to apply for the job and he was hired first—as an eligibility worker. Then, two weeks later, I was hired. He lived close to the job and with me in Annapolis, he would drive to come get me and take me bck. We finally decided it would be easier if we just got married—more practical. We knew each other only from here. Both of us were looking for our lost loves from Vietnam. He had been engaged and I had been engaged to people in Vietnam and we didn't know what had happened to them. We had dated for less than a year and then we married. For a while I thought I would always remain single out of mourning. I was lonely, isolated and afraid. I believe it was the shock that most refugees experience when they first arrive in a new country. I worked for the State Department at that time, with the toll free line, and many people called from all over the U.S.; their anxiety, loneliness, sadness reflected very much my own feelings. Reacting against my fear of isolation, I felt the urge of founding a family, having a child, setting root in this new land with a family of my own. I believe my husband and I married too quickly. We both realized our mistake soon after, although we're doing very well now after many years. We married in 1976, then grew apart, but I was determined to go my way. I went back to school against my husband's wishes, but I was very pleased with my achievement. I came home more conciliatory and nicer. I believe part of me wanted to

behave like a Vietnamese wife, respectful and submissive. But somehow I felt we were growing apart. I wanted more—more days full of constructive activities. And I wanted a child. I was getting some pressure from the family. I was thirty years old. I wanted a child and he didn't, so we fought. He probably felt threatened with my eagerness for learning and my eagerness about the U.S. I now have a fourteen-year-old son—he'll be fifteen in October.

I felt liberated as an American woman. I was using more of my energy in a constructive way, using my skills and devoting my time to things I think are important. And the product has been my own benefit—part of my growth. My family has always had aims for higher education.

There is some competition between my husband and I, but we get along much better now. It was quite a threat to him when I went back to school. He had his own way of adjusting. He is intelligent and was brought up with different family values from mine. I define a framework. I'm more practical; everything does not have to be perfect. I like to be active, to meet other people, they enrich my life more. My husband is more a loner, a self-learner, an avid reader. Our house is a jungle of books and magazines—all types from entertainment to serious material, criminal law, psychiatry, etc.

I finished my MSW [master of social work degree] in 1987. I went four years in the evenings. I got a scholarship from HHS [Department of Health and Human Services] because they needed Asian social workers. I was already hired as an intake social worker by the county before I graduated. I worked four years for the county in outreach and in 1985 I moved into the mainstream, working as a social worker with all kinds of clients.

Owing to my work with immigrant clients I learned that my adjustment was not as hard for me as it was for others who came as refugees from Vietnam. But it was still a struggle. Because I didn't stay long in refugee camps or because the processing went rather quickly does not mean I had no problems. In the range of difficulties of adjusting to the refugee experience in coming to the U.S., on the woman's side, I see myself in the normal range. For example, I felt difficulties about going out to get a job. I was competent and eager. I would be able to do it—I would accept anything. I went out on so many job interviews—I was denied a job sixty times! But I felt each interview went well. I answered all the questions well and appropriately. I had a bachelor's degree in education. I could type without mistakes. I felt discriminated against as a foreigner. I remember one shock very clearly. I was very proud. I thought I would make the best appearance in my Vietnamese dress. It was my best dress and very elegant. So I presented myself at the Hilton for a job interview as a cashier in my Vietnamese dress. People were staring at me. They looked at me like I did

it for show; certainly their looks were no compliment. When I asked [about my appointment], I was told the position had been filled—although my sponsor had called and gotten the appointment. It was a very revealing shock. I see change in attitudes toward foreigners here now. People wear their own ethnic clothes all over and now people look at them with appreciation. But that was a revealing shock. I was so eager to be accepted. I was still in the stage of euphoria, a honeymoon—just to live in a free world.

There certainly is racial discrimination around, even in the office where I am now. There is always a quizzical look at an Asian social worker. I handle all clients now. Sometimes I've had people say to me "Go back to your own home, you Korean woman." About forty percent of my caseload is white, about forty percent black and a little over fifteen percent Hispanic. The Hispanic population is increasing.

Maybe the discrimination comes more often from men against a woman. The hostility directed at me is against me mostly as a woman. How can a man ask for services from a woman—and someone who looks quite different? I believe there is a general attitude against Asians here. I also think people are trying to combat that with open community programs between ethnic and minority groups. Different races, genders, gays, Jewish—our director has been encouraging discussion and questions about the different minority groups. In general, I'm successful at forming relationships, communicating with those who need our services. I have a good sense of what are universal needs and what cultural differences exist between different persons and groups and the uniqueness of each person.

Despite my many years in the U.S. now, I still think of myself very much as a Vietnamese person. This must be due to my perception of cultural differences between my American peers and me, gaps between my son and me! However, to the newly arrived Vietnamese in the U.S., the relatives still in Vietnam, the ones I knew there, I have changed—more American than Vietnamese. I recall the way we had to behave under an autocratic director at the school I worked in. In one correspondence to me, he said that he missed the social order of the old way, with allusions of racial segregation. My letter back was a sarcastic reply. He certainly had respect for me as a schoolteacher of his children. I was representative of the labor union—really only a formality. But I did make some change—we asked for a raise and got a compromise. I was timid at that time. He was the director. In my letter to him, I told him I am an American person. I'm learning more the democratic way and that things need to be changed.

I'm planning to go back to Vietnam—for how long I don't know. I'll be at retirement age, 55, in seven years. At that time, my son will have

finished a bachelor's degree. I would have accumulated my retirement benefits. I could go to Vietnam and be a volunteer social worker. I'm working on that goal little by little.

N. YEN TRAN, 1993

I am Yen Tran. I've lived here about seven months now; I came on October 21, 1993. I feel very good here. I felt bad in my country because before they changed governments in 1975, we lived in a republic; after 1975 the communists came. Before my country was divided into two sections, the north and the south. The south had a republican government, but now it is all communist. They are very bad. Almost all the military [officers] of the republican government had to go to what we called reeducation centers. They were not real reeducation centers, they were labor camps. My husband was a lieutenant in the South Vietnamese Army and he had to live in the reeducation camp for six years. Officers in the South Vietnamese Army were friends of the Americans and the communists said that America is an enemy.

I am a Catholic, so is my husband. While my husband was in the reeducation camp, we suffered for six years. Before 1975 I worked in the agriculture department—from 1973 to 1975. I worked in the office, answering the telephone, taking documents to ministers and from ministers to supervisors. After 1975 when the communists came—I had studied animal husbandry, about goats and chickens and cows and fish, everything—anyway, after six months of the communists, I and lots of my friends went to a farm far away from the city, where we worked very hard. I fed the animals and took care of the baby animals. I worked eight hours a day and four at night while my husband was in the labor camp. I thought that if I worked very good and very hard my husband would come back. So I worked hard, but—they had A,B,C,D—I always got a D. Six years and I never got an A, first because I am a Catholic and second because my husband is their enemy. I couldn't get A. It was a very sad time; I had no money for my son. I cried a lot. I thought about work a lot. I prayed.

After six years my husband came back from the camp. When he came back I felt happy and wasn't thinking about money anymore. I didn't think about how I could get money; I just felt happy. We were outside Saigon then. I sold fruit and juice and vegetables—artichokes. It was only me who could work. So I sold things to get cash. I did everything—one other woman and me. My husband was buying and selling things from the

trash—you know, the U.S. Army storage [depot] at Long Binh. There were people who dig in the storage and then other people buy the metal boxes and they make things from them. Anything from the army, medical boxes, tires—they get things and recycle them—everything. My husband bought from men at Long Binh, but he could never get enough money. Most people in Vietnam are very poor. In one day they can make only about one dollar. That is enough for food and rice, but not for anything else for yourself.

I had a big problem when I became pregnant with my second son. My husband could not get a regular job. He was thinking about the U.S. all the time; he wanted to go to the U.S. as soon as possible. He borrowed money from his sister and brother in Vietnam, about $1,000 in gold, to get to the beach and leave by boat. The communists caught him and said he liked America too much and put him back in reeducation camp. They did not like that he wanted to go to America and that he had not been convinced in the camp before. He was put back into camp for two years—terrible, terrible. I thought he would die in that camp. It was worse than the first prison. When I came to visit him in the camp, I saw him and I didn't believe he could be so thin—about thirty kilos, sixty pounds. He couldn't stand; two people held him up. I felt so sad inside. I thought maybe he would die.

I stayed in Saigon and sold things. I finally had a chance at a job. I helped make tires for cars at home. I stretched plastic strips and glued them on a sheet. I didn't make the whole tire. I stretched the strips, put the glue on, on a big plastic sheet. The boss in the company would take them and then press and cut them on a machine to make tires for bicycles and cars. They recycled everything—old nylon and old American tires. They make tires for bicycles from old tires, old American tires too.

I did anything to make money. I needed a little money to live. There was not enough for health [care]. My son is very thin because when he was young we did not have enough of anything. I think that's very bad. The little boy is eight years old, but he is very little too. When my husband came back from reeducation camp from 1981 to 1983, I was pregnant with the second boy. He was born February 1983. When my husband came back from the camp for the second time in 1985, I got pregnant with the third boy.

When my husband came back we started to raise chickens. I had studied about agriculture and I knew animals. I told my husband to come to the country. My husband's father had a house in the country not far from Saigon—about forty kilometers. We went there by bicycle. We did everything by bicycle. We carried hundred-pound sacks of yellow corn for the animals. Now when I think about it I can get afraid. Carrying things

like that can get too heavy. My husband could carry about two hundred pounds on the bicycle, but sometimes he would have an accident because the load was too heavy and the bicycle would fall.

We raised chickens, chickens hatched from eggs. We bought the baby chicks from a farm, bought a big box, one hundred baby chicks. Then we fed them yellow corn and vitamins and rice and things. My husband was very good at this job. After about three months we could take the chickens to the shop for people to buy. But in my family we didn't raise the chickens for meat, only for eggs. Every day we got between one hundred and one hundred fifty eggs from two hundred chickens. We sold the eggs near my home, not in Saigon. I did that, I did everything. I bought the chickens, the yellow corn and the rice. We were not rich then, but we had enough for food and to spend a little for the family. I saved a little money all the time. Compared with everybody else, we were happy. Everybody in my country, even in the countryside far from Saigon, people were poor. They can't even make a dollar a day. Children over fifteen years old cannot go to school. They finish elementary school and they have to work to help the family. Children can make fifty cents. With my family, I could make two or three dollars in one day—and I like chickens. If I compare us with everybody else, I feel good. In the city, the people, most people, even if you are a nurse in the hospital, you get about fifteen dollars a month. Very poor. The communists are rich though because of corruption. I have received letters from my sister and my husband's brother and sister who tell me that things are very bad there. I just wrote back a letter to my husband's sister that in the U.S. I feel very happy, thanks to God.

We had the chickens from 1986 to 1993—seven years. I continued to work up until one month before I came to the U.S. I stopped only one month before I came.

When I lived in Vietnam, the communists do not care about human rights. They don't see the South Vietnamese Army as friends. They say they are enemy. Why should my husband and my husband's friends need reeducation in prison? I don't know. If they wanted, we would work for my country to help develop it. We could help. We can work hard for my country, no problem. Why do they see us as enemy? We are Vietnamese, not American. Why are we enemy? The communists do not have human rights. In America I feel everything is good because people have human rights here, the poor, everybody. They can get work. In Vietnam there is no work, only corruption. If all the nations in the world helped my country there would be lots of money. But no, the communists take that money for private use. I feel that is injustice.

My husband had a high rank [in the South Vietnamese Army] and was

in the camp for more than three years. If you were in the camp for less than three years you couldn't come. My husband was in the camp for more than six years and the Americans had documents from before 1975, when the American army was in Vietnam. My husband's name was on a list because he was in the South Vietnamese Army and in the reeducation camp.

When my husband came from the camp, he had one year local control, but no citizen rights. My husband lived in the country for two years, but he told them his wife's house was in Saigon, I want to live with my wife. After my husband was in the camp [the second time], he used another name. They didn't know my husband was living there. He told them he lived in Saigon. Then my husband lived sometime in the country, sometime in Saigon. They didn't know. They always changed the people in the office.

We did have some problems with other documents. In Vietnam, there were lots of problems with documents. They were not good with the papers of people. I got married in 1975, but they didn't have the papers. I had nothing. When I was filling out all the papers to come here in 1989, we finally got a certificate of marriage, but it was too late. In 1986 I sent most of the information to Thailand with pictures and Thailand made documents for my family. I think I could have come to the U.S. earlier but I did not have enough information. But in Thailand they believed me, made my family documents, marriage certificate, papers about my husband in camp. The Thailand office for refugees did this—IOM [International Organization for Migration]. We had to pay the airfare. After we received the papers, I took them to the Comintern Department of Refugees so that we could leave.

I don't have relatives in Thailand, but I do here. My step-sister came here. She had children with an American father. She came with the Amerasian program.

I feel very good here. In the U.S. people have lots of human rights and justice and freedom. Now I have a big problem about the rent for the house. All refugees worry about rent for the house. Most people, refugees, worry about that. There is not enough money. I go to work; I get five dollars an hour. I get about seven hundred dollars a month and after I get the check, I pay the rent. Not only me, most refugees worry, I think. In the U.S. things are good, better than in Vietnam. I study English at the refugee center but my big boy says Mommy speaks wrong.

H. PHAN, 1993

I was born in Hanoi in 1932. I came to this country on the sixth of December 1993 from Vietnam. I lived in Saigon. Now the name is Ho Chi Minh City; they changed it.

Before 1975 I was a clerk in the government social services office. I was a social worker from 1964 through 1968. The social services office solved many problems for people—taking care of children, taking care of the older people, distributing money, medicine and food to the poor people. I know how to do social work and I know how to do the paperwork—documenting cases, filing, typing, doing vouchers and keeping track of things. I know how to do reports and work with a supervisor.

I was married and had only one daughter. She is twenty-three years old now. My husband was a major in ARVN, the South Vietnamese Army, before 1975. So after 1975, he was sent to a reeducation center because the communists forced all ARVN officers to reeducation. My husband was there for nine years, four months and ten days. There were many reeducation centers in Vietnam. For example, my husband went to North Vietnam and in the center they were considered prisoners of war and they had to work, to do forced labor. Sometimes they tried to brainwash these officers. Nine years, four months, and ten days! He was released in 1984, October.

While my husband was in the reeducation center I could not work anywhere because when I was young I only graduated from high school and after that I worked in government offices. So I made a small business to make a living for me and my daughter. She was only four years old. So I made a small business—I would buy some things—food, rice or something—and I bought fish and sugar. Then I would sell that in front of my house. If I did it in the market, I would have to pay much money in tax.

Before 1975 I lived in Da Lat. After 1975, when my husband went to the reeducation center, I moved to Saigon. In this time I was homeless and jobless and had no money. So I went to Saigon to do the small business there. They would not let me have any other job.

Don't you know, when my daughter was four years old, I took her to the school and they told me that if you are children of the old regime, before 1975, you cannot study there. I had a friend, so I got my daughter into school eventually and in 1989 when my daughter graduated from high school, she went to the medical university. She hoped she would be accepted. They told her she could not be accepted. All the wives and children of ARVN officers of the former regime, they could not attend *any* university. So my daughter had to go to a medical college and in 1992 she graduated

as a medical assistant, but they wouldn't give her a job. So we had to leave the country for my daughter to find a job. She came with me and my husband to the United States.

I went to visit my husband sometimes when he was in the reeducation center. I am very poor; I had to borrow money from friends and relatives to go. They still live in Saigon. They gave me money and food to go visit my husband. Life was difficult for him every day. They gave them a small bit of rice and they had to work outside very hard. Hard labor.

When he was released, I had to sponsor him. They told me that. Then he came home. Do you know in Vietnam we have a family card? When my husband was in reeducation center, they canceled my husband's name. So when he was released, I had to take the family card to the police to pay them and to guarantee that he was my husband. If there were any problems, I was responsible for him. When he came back I was still head of the family. In the family card my name was still first, then my daughter, and my husband's name on the third line.

After he came home he was—the police said he could do nothing for six months, not go anywhere, only stay home. Every week he had to go to the police station to report. He could move around the city later, but not leave the city.

The American government said that all the officers of the former regime, of ARVN, who were prisoners, if they were three years in the reeducation center, they could apply to go to the U.S. All the former officers were considered prisoners of war and they knew they could apply. If we didn't leave there, my daughter's future was bad because she couldn't find any job in any health station. They said I would have to pay them a certain amount of money to get a job. So my daughter said she would go to America, go anywhere. It took two years. My husband applied. I am a documented refugee [because of having fled North Vietnam and crossing the border to South Vietnam] and because my husband was nine years, four months and ten days in the reeducation center. We received a letter from the State Department that my husband's name was on the list to go. We had two years to wait. If he had been only two or three years in the reeducation center, he could not go here now. We might not be here.

The Americans lent us money to buy the plane tickets and now we must pay it back. My daughter had to sign the bill to pay back the plane tickets. Now in June, they sent a bill about the tickets and my daughter said, "Oh God, I don't have the money now. How can I pay it back?" "Don't worry, we'll share," I told her.

My daughter is studying English and she wants to go to college. The refugee family has eight months' welfare and food stamps and in July our

welfare will be finished, so we have to share a room with someone. We don't have much money, so we share a room for the three of us. I don't have a job yet. My husband has a job; he works at a warehouse.

When I came here, some Vietnamese were my neighbors. They helped me about heavy clothing, gave me some medicine for a cold. They were good to me.

My life was very difficult. It was miserable. Before 1975 my family had a house, a car. After 1975 I had only my two hands and no money.

When my husband came home and when he found a job finally, we shared many problems. From 1985 to 1987 he had no job. After that, he found a job. They told him to teach English at a private English school, not a public school, in Saigon. I learned English when I was a student in high school. We had to learn two languages in high school—English and French. But I forgot the French, too much has happened.

Do you know, when my husband went to the reeducation camp, I met many problems. How to feed my daughter—she was four or five years old. When my husband came home, he could not recognize her. I sacrificed my life too much. You know, I am very poor because I have no relatives. I have relatives who went to America before 1975. Now I have a brother and sister in California and New Jersey—my older sister, seventy-five years old, my brother, seventy years old in Maryland and an older brother, seventy-eight. They are too old and cannot help us much. My brother who is seventy years old has to work every day still. They did not sponsor us; we came by ourselves. When they interviewed me—when I applied in the application I had to state any relatives living in the U.S.A. I stated those and the chief officer at the interview, he said, "Do you need your brother to sponsor you?" I said, "No. You can send us anywhere in the U.S." The Traveller's Aid Association helped us and sent us here. They told my brother to meet us at the airport, to pick us up. They gave me mattresses and money to pay rent and we came to the social services department to apply for welfare and medicine. A documented refugee has eight months' welfare and medicine—after that none. We get food stamps and I and my husband get two hundred eighty-six dollars welfare every month. My daughter, because she is over eighteen years old, she gets one hundred sixty-two dollars each month. But we have to share a room—to pay rent of three hundred fifty dollars—and after everything we have only thirty-two dollars for bus fare to go study English. The people where we live just had a room in their apartment and the owner of my apartment is a man. One room is for the owner and one room for my family. We use the kitchen; electricity and telephone are free. I don't have to pay for them. I cook our food.

Do you know, in Vietnam, when the man was in the reeducation

center, some women, not me, had relatives to support them. Some have people in the U.S. to send money or food to Vietnam and they could live. Many, many women were happy. But because I had only me in the family, I didn't have any relatives — after 1975 they went to America — so I had only me. If I go in 1975, who would share the trouble with my husband in the reeducation center? I didn't have the money to go overseas then. Some people, they had relatives to sponsor them. At that time I didn't know where my relatives were living, where they were.

My husband has a temporary job. My daughter wants to have a job and I also would like to have a light job to help out. My daughter wants to learn in the college and now is preparing to take examinations in August. I don't know what will happen. No money. I want you to help me find a job.

In Vietnam, in the communist regime, do you know, some families have money to send there to pay taxes for them and they're very rich. We don't have relatives to support us. In Vietnam, if a family has relatives in U.S.A., they can leave because the relatives send money.

L. LANG, 1993

I came here about four and a half months ago from Saigon. I went to Bangkok, then to Amsterdam, then New York. I stayed overnight there and then came here with my family — my husband and six children. The oldest is thirty-four and the youngest twenty-two. I wanted freedom and for my children to go to school.

Before the government changed in Vietnam in 1975, I was a teacher of history and geography. The new government stopped my job at the school, so I became a businesswoman. I sold many things and I bought many things in the market. There were a lot of vendors — people who buy and sell. They couldn't get other jobs, so had to get money from that kind of business. I made wine too, but if they had found out, they would have put me in prison. I used to make wine at night. I could sell only to close friends in secret. It was very dangerous. I had twenty chickens and five pigs at one time too.

My husband was a soldier, an officer in the South Vietnamese Army, and he was put in prison — reeducation camp. He died there in 1987. I remarried in 1990. My second husband had also been in the army; he was a close friend of my first husband. He was also in reeducation camp, but a different one. My second husband had four children of his own and

together we had eight children, so now we have twelve! But six of them have families of their own in Vietnam and they stayed. I decided to leave such a long time ago—1975.

Before 1975 I had a big house, a car, many things in my house. When my husband was in prison, I had to buy food, clothes and medicine for him. If the government gave me a permit to visit him, I could—if not, no. The government did not always give you a permit. There were many offices and you had to wait a long time. If I made no mistakes, no problem, I might get a permit. I always had to pay the officials. Sometimes when I came home, I was sick.

My new husband didn't hope to go to America. We filled out the papers to go, but didn't know what would happen. My government finally sent a letter that we could go. We went from Da Nang to Saigon to go to the interview with the Americans. I don't know who it was, but finally they said we could go.

When we came here, I had a sponsor, my younger sister. She came to the U.S. in 1975. I have two younger brothers and one younger and one older sister here. My brother is a doctor here. He was a doctor in Vietnam. He studied here too to pass the examination. He has all Vietnamese patients.

My older sister has an American husband. He came to Vietnam in 1963 and my sister married him and in 1975 he and my sister left for America. My brother-in-law worked for CIA. He retired and he and his family live in Miami.

Every day I go to school to learn English. But I need money. Some days I go to work, so I'm absent from school. I pick crab meat. They call when a boat has brought the crabs in and I go. If there are no crabs, then I don't work. I work eight hours a day. They call and pick me up with a van. There are about twenty-five women. I like the work and I like the women—Lao, Cambodians, Chinese, black Americans. My manager is a white American.

I would like—I hope to learn English and go to college to study history. I don't know what to do, but I like history.

My husband is very old. He is retired, he doesn't work. My son works and my daughter goes to high school. One son went to New Mexico. He will have a good future there. There was a priest in Vietnam who is in New Mexico at a school and he invited my son to go to school there.

When I was a Vietnamese woman I had a hard life. Every day I work from 5 A.M. to 10 P.M. I was in business, working at the market. At home I had to be wife and mother. I had my children at home and my husband in the camp. We had many problems. The new government stopped my

job at the school, but my children went to school. They even passed the examination for the university, but they could not go because they were the children of a South Vietnamese soldier. After 1975, the new government gave jobs only to you if you had joined the revolution or were a member of the communist party. There were no jobs for you if you were part of the South Vietnamese Army. Their children could not get into the university. Even if the children were good students, they still could not get in. They would not accept children whose fathers or mothers worked for the old government. They punished us.

11

CUBA

In the 1950s, Cuba, 90 miles from the U.S. mainland, appeared prosperous, but not every Cuban benefited from that prosperity. Unease about the role of the United States in Cuba's economy combined with growing poverty and popular discontent over government corruption to produce an opposition finally led by Fidel Castro. His assumption of power was hopefully welcomed in Cuba and abroad as a means for a return to democratic government and an end to the graft and corruption of Batista's era.

Generally, no restrictions were placed on emigration immediately after the revolution. The first Cubans suspicious of projected Castro policies left in 1959. A larger exodus began in 1960 after the revolutionary government reforms and when Castro publicly declared himself a Marxist-Leninist and curtailed opposition political activity.

In 1980 the Mariel boatlift brought another wave of Cubans seeking refuge. A fluctuating hostility has marked relations between Castro's Cuba and the United States—the Cuban missile crisis and the abortive Bay of Pigs invasion are two examples—but in 1987 the United States and Cuba reinstated normal migration procedures despite a continuing U.S. trade embargo.

In 1994, thousands more began fleeing Cuba in makeshift rafts. Most were picked up by the U.S. Coast Guard and taken to Guantánamo. Almost all will be admitted to the U.S. as immigrants.

ELISA M., 1959

In 1959, when Castro first came into power, he called my husband through a secretary and asked him to come see him. My husband came home and told me about this and said he knew exactly what Castro wanted him for. "He is preparing a trip to the United States where he wants to ask for money for the new government," he said. "This being, I am totally certain, a communist takeover, I refuse to take any part in it. My going to the

United States with him, even if I did not say anything, is tantamount to my accepting him and I cannot do that." So he decided—he was a very decided person—he decided he was leaving the very next day. And, as a trial, to see if it was easy for him to leave, if he were a free agent or not, he left with only his briefcase for Miami and he found that he was detained at the airport. They tried to get in touch with Castro to see if he had been given permission to leave. They were not able to contact Fidel and instead they contacted someone, a Spaniard who was working with Fidel. I'm certain he did not know my husband. He had probably just arrived in Cuba recently and, at any rate, he said, yes, let him go. So my husband left that day and never came back. He realized, of course, that if he was not willing to work with Fidel, as he was not, and had openly criticized him more than once, he would probably be jailed, as his brother was later for five years, and his brother's wife.

Now, I joined him right away, of course. I went the same way, with nothing. We left everything we had behind, obviously. With a very little bit of money he had sent to the United States from whatever he had in the bank, we bought a flivver.

My youngest son was already in the States because he was in school here. The others were grown up. One of them married in Miami, but they were all grown up by then with their wives or sweethearts or whatever. So I joined him and we got into that flivver and went up to New York. We stayed in a room which was rented by someone we knew and there he started looking for work immediately. He typed very badly because, since he was young, somebody typed for him. So the next day he came in with this old typewriter and he had gone to the ten-cent store and gotten himself a book "How to Type," and the next thing I knew he was sitting in front of that contraption with a handkerchief across his eyes, blindman's buff style, learning to type. After three or four very arduous days, he started typing letters with two fingers. He had a simply extraordinary memory and he could remember the addresses of his friends. Those he didn't remember exactly, he ferretted out. At that point, Fidel was very much an unknown entity, and besides, unfortunately, many Latin Americans think that anybody who bothers the United States is welcome. They think it's fun. No one wanted to touch a well-known person like my husband, who was anti–Fidel, with a ten-foot pole. Everybody answered with effusive and charming letters but no one seemed to know of anything they could give him to do. So finally, some American he had known slightly from San Francisco, from the time he served there and the United Nations was born, this man said if he was willing to go to Mexico, they wanted to invest there in housing, would he like to take on that job? More than happily! He said

115

yes, and off we went in our flivver to Mexico. We were there about a year and a half. Our first worry was that things were getting worse in Cuba by the minute. It was now openly a communist takeover. There was no longer any attempt at camouflage. Our first concern was getting all of our children out. There were the three boys and one girl who was married. We started fishing them out. Two of them stayed in Miami and the third boy, who was very sickly since he was young—he is since deceased—he came to live with us in Mexico. And our youngest son was in the United States already in school.

And then I went back to Cuba—that was still in that first year—with a false passport. My mother had had a very bad stroke and my daughter had had her third Caesarian. So I came back for a few days. I had no problems with a false passport—a different name on mine. It might not have been so easy here. I just went back. I remember my mother's doctor telling me I had to leave because when they saw who I was, I wouldn't be allowed to leave. But I said how could I leave Mother like this? He asked what I was waiting for. I said I was waiting to see if I could get her a visa to get her out. He told me I would not be able to do that. Mother had had a total stroke. He said she was still relatively young and she might be that way five, ten or fifteen years. Long before that, he thought Fidel would be out and I would be back home. And she was there with people who would take care of her. Her brother was a doctor and was still there. So she was not abandoned. The rest of the family was there except me. So leave, he said, and I did leave and never went back.

Later my husband said—he was a wonderful father and all his children were chicks to him, and he wanted to have them all around him—he said he just wanted to see that little girl who was just born. We had built a house for my daughter in the garden of our house, just as my parents had done for me. So my husband said, "I know this is an extravagance, but I'm going to send them tickets just to come for Christmas." He thought of nothing else then. But when they arrived [in Mexico] my son-in-law said he could not go back either. He said there was no work and it was all going from bad to worse. So they stayed and lived with us and we had to get a slightly larger place in which to live. We were in Mexico for about a year and a half. I cannot say I was unhappy. First, I was with my husband, whom I loved very deeply. We were married fifty-seven years. And then, my children were all safe. You are very egotistical, I think, when your own chicks are all right and you're away from the danger. You do worry, of course. My husband worried more than I, I think, because he was very patriotic. I was living the day. I was seeing that people got fed and just felt the worries of every day.

116

Well, finally, there was nothing more to be done in Mexico on the project. The housing money had been spent and my husband advised them not to spend any more money unless they could get matching Mexican funds because investments were subject to nationalization if they were totally foreign. So he himself cut himself off. So he and I came here because this is where he had served for five years as ambassador.

So, we got a room and from there again, he started to look for work. He did get work as an expert on Latin American law. He was a lawyer and so whenever someone had something to do with Latin American law, they could consult him and he would charge them. So we decided to stay here.

I think our experience was atypical. I say atypical because we were lucky in having had friends. We weren't strangers here. And this I really want to say. I think that only in the United States of America would people have reacted the way they did with us. Because instead of, sort of—well, they knew us, but there you are, that's the end of it—everybody tried their best to help us in every way. To give you an example, Mrs. P. was a great friend. She had asked us to go to her country place and at the last moment I couldn't because I had gone to the doctor and he decided I had to have an operation. I called her secretary and said I was sorry we couldn't go, that I was going into the hospital to see what was the matter with me. I had the operation and eight days after, when we left, I wanted to know how we could pay for this. They said it had all been taken care of by Mrs. P. That just gives you an example. Of course, she was a very wealthy woman, but I don't know of anybody who would have been that generous, because she didn't have to be. You know? And that, I think is very much to be said for Americans. They are good friends. I don't think they are the type who think less of you because you don't have the position you had before. My experience here has been very positive.

Now, of course, my children. They're doing well. They were well educated and the two older sons are with international organizations. My youngest son, an economist, became an American citizen and married an American girl. So they are all on their feet, fortunately. I can only say I am very grateful for having been an exile in the United States of America, because had we been exiles in other places, I don't feel we would have had the same help and warmth that we encountered here. This, I think, would be true for most Cubans. I think that also, as to our people, we thought of ourselves as very lazy, perhaps we were—the sun may have made us lazy—but our people, when they came out, they realized that they had to work for a living, even those who had never done so before. And everybody is on their feet. To such an extent, for instance, that people who were forced to receive welfare and so on, the immense majority have paid it

back. When the first Cubans in Miami went to pay it back, they didn't know how to go about it—the people who were receiving the money. So they said they'd have to look in the books to see how to repay.

I say I am an exile because it was a voluntary thing. Some of the Cubans, a few, those who have been jailed or fear jail, you could say they are refugees, because they fear. Necessity made others leave. My husband having been ambassador here, we had, and I still have, non-resident diplomatic status, which they have been kind enough to renew.

I could go back. Any one of us who is out could go back, I think, without exception. Well, perhaps not those who have very actively done things against Fidel—they'd be clapped in jail. But it's not like an exodus, let us say, like a biblical exodus. In that sense, none of us are like that. Some of us are exiles by choice, which I think would categorize our particular case. We had chosen exile. We could have lived there very well probably, if my husband had accepted collaborating with Fidel. We could have been among the people who lack nothing. Even now that Russia has stopped sending them anything, Spain still does, Mexico still does. Obviously there's enough for only a small amount of people.

My experience is a happy experience. The unhappy thing is that my son died in Spain and my husband died two years ago and that, of course, has changed my life totally. I still live here in the same place because this little house is the closest thing to a nest; it has been our home in exile. Plus, it's easier for me to stay here. My oldest son, who has inherited many of his father's good qualities I think, also lives here and is a very nurturing sort of son. Takes very good care of me and I feel very protected by his presence. Son number three lives in the area. He's married and has four children. Of course he has more complications and obligations, but he is here for me too. Some of the grandchildren that we have brought up, well, all are in the eastern part of the United States and this is home to roost. Christmas time they all come here and so on. So this little house has become the nearest thing to a nest that one could have outside one's own country.

As I said, we went out without thinking of anything but the fact that my husband refused to collaborate. And there was no other thought at that moment, I guess. I left all my former life behind. My house was still standing. The servants were there. Finally, Fidel's people went there one day, they took everything over and sent the servants to live in a tiny place, Lord knows where. My brother-in-law, who stayed—he was, of course, a dissident—he was put in jail. His wife was put in jail because she had not informed on him. They finally got out after seven years through great effort. A very wealthy sister-in-law paid a hundred thousand dollars for his release

and that of her sister. Because Fidel *sold* prisoners. These people were very wealthy Cubans. He had a sugar cane plantation, but he had money outside of Cuba. Those people are all dead now, only their children are alive.

We left all—everything—our roots, our house, our belongings. We had a little house by the sea. We had a large farm. I was an only child, but my father decided he was too old to leave. People, when they are a certain age don't take the adventure of leaving easily. My mother was ill. Since then, of course, both of them have died. What has become of all their things I have no idea. They had a lovely house and in the garden of that house is where they built our house when we married. My father had an extraordinary library. He had three rooms full of books up to the ceiling and a wonderful collection of stamps he'd had since he was a little boy. I have no idea—the silver, the pictures, whatever—I have absolutely no idea what happened. When *we* left, the servants asked us if we wanted them to hide the silver, to put it down the well. I said, "Don't be silly, because if they come here, they're not going to think we ate with our hands." I would rather they gave it up than have any problems for any of them. "Don't bother." I said I wouldn't like my portrait to fall into their hands. My husband said he would not like his decorations to fall into their hands.

I think people should be more alert to what is happening in Latin America. Their governments were not ideal, neither was ours. My husband, for instance, was against the government of Batista because he thought he was too dictatorial. But I don't think anybody has been able to devise a government that is totally just for everyone. There doesn't seem to be a way of bridging the gap between the haves and the have-nots totally. I think here, they make good efforts at it. Now in a communist country, take Cuba as an example, everybody is a have-not, with the exception of the directly involved heads of government. They have everything. The other people are merely like the little slaves of that reigning clique. That's what has happened in every communist country in the world. But when you are enslaved by need or by fear, it's awfully hard to get rid of that government. You can get rid of other governments. In Latin America we've had a hundred and one revolutions and toppled one government and put in the next. It may be just as bad and we topple that one. But there is a degree of freedom. When you are in a situation like you are in Cuba, it's harder. For instance, if I have a visitor in Cuba, the *responsable*—every block has one *responsable*—the *responsable* has to know if I had a visitor. They come and find out who the visitor is and later they would come and say why was that person there so long? What did you talk about? In a very nice way, but she will be in on everything that you do. I recall an uncle of mine, his heart was very bad. He finally did leave, fortunately. He could

get the ration, I think it was a quarter of a chicken every two weeks or something. Anyway, my aunt bought a whole chicken on the black market. But what did she have to do? At night, when everyone was asleep, she went out into the back garden and dug a hole and put in the bones of that part of the chicken he had eaten without permission of the government. Because, putting it in the trash, they look at everything in your trash. I think it is not just because they are bothered by your eating chicken. I think it's because they want you to feel, as you do feel, totally oppressed and totally living in a glass house.

If my husband were alive, he would go back if Fidel fell and I would go back with him. If he wasn't able to go back, if he were alive, I would feel too sad to go back alone. However, reality asserts itself over what you wish or want. I feel myself now, like a tree planted with its roots here. However, I would cry my heart out, because I know my husband would have wanted to go back too. Not for one moment did he forget Cuba. Not for one moment did he stop seeing people, working, writing. In every possible way, helping, so I know he would have gone back to whatever.

Here, there was a group of Cubans who were very active at the beginning and we used to go to all the meetings, but that sort of died on the branch. Most of the activities are very much alive in Miami, where there are so very many of us. Just recently, though, I went to a group of people who very thoughtfully want Cuban Catholics to give our impressions of what we think the role of the Church should be, what we think it has been up to now, that type of thing. We're supposed to gather in little groups and I'll have eight people here. They give us themes to talk about. One of the things they gave us was very interesting—it consisted of a number of interviews in Cuba with Cuban dissidents who have been in and out of jail, and when I saw who had written it, I was very much amused, because it's the son of my cousin. He's with a human rights organization in New York. Some people think the Catholic Church has been too pliable in Cuba—the priests who stayed behind. I would say, if you stay behind in a communist takeover and you don't agree, either you're put in jail or you're killed or you leave. But if you stay behind and you want to continue to help the dying and to say Mass or whatever, you must make allowances. You must pact with the enemy or you can't stay because there is no other way to stay. If you're going to stay there and say you're a total enemy of the regime, you're not going to be there for twenty-four hours.

120

12

ARGENTINA

In 1976, General Jorge Rafael Videla carried out a successful coup against the government of Isabel Perón, the widow of Juan Perón, and was named president by the military junta. Argentina had endured a number of coups and the resultant military governments alternated with short-lived civilian governments since the coup that toppled Juan Perón in 1955. Although the 1976 coup was not Argentina's first, the military government resulting from it was probably the most repressive and violent Argentina has ever known. Tens of thousands of citizens were illegally detained and secretly held by the military in an attempt to crush all opposition, especially from the left.

ALICIA PARTNOY, 1979

I've told my story before, but not this way, of course. I came here in 1979, the end of 1979. One of the ways of surviving and keeping myself going was to tell the story of those who did not survive, and to do that, I, of course, had to talk about myself. Especially in this country, I would say, it's hard to relate to a collective tragedy and sometimes I'm fighting with this feeling of me being the only victim—of how I'm being perceived by people who listen. I try to tell them the other side, but to do it I have to dwell on my own experience.

I came from Argentina by Christmas 1979, after three years as a political prisoner. I spent five months of that time in a concentration camp, a secret detention place in my hometown in the south of Argentina. The place is called *Bahía Blanca* (White Bay)—it's a city in the south. We had had a military coup in 1976 and as a result of that, 30,000 people, mostly youngsters, were kidnapped by the military and taken to secret detention places—that's one per thousand of the population! We were tortured in those places and most of them were disappeared. We know now that they

were killed. We still say disappeared because their bodies were never returned to their families.

I was twenty-one years old when the time came for me. I had been active as a student, active in politics and against the coup for almost one year. So, in January 1977, they came to get me. I was at home with my child who was a year and a half and it was noontime when they came. There were many soldiers and several trucks, army trucks. I knew what was going to happen because I had been collecting just this kind of information and leafleting on this situation and that was completely forbidden. The constitution was not ruling the country. People could be arrested without any due process or anything. Some of my friends had disappeared already. They came for me; they took me to the secret detention place. It was called the Little School by the military; it was an old school of the army. They took my husband there too. We spent three and a half months there with our hands tied, blindfolded, lying on mattresses and beaten all the time. We couldn't talk to each other. We couldn't sit down. If our blindfolds were loose, we were beaten up. But the worst was that we never knew whether we were going to survive or not.

My husband was tortured with electricity. They used the 220 volt electric prod. They applied it to the most sensitive parts of your body. They were beaten up also. In my case, I was not badly beaten because—and I was not tortured with electricity—because the doctor who supervised the torture was not around and so they were being a little softer on women because they didn't want them to die on them before their time. But they had tortured women with electricity in that particular place. There was a woman there who was pregnant. She had been tortured on the way to the secret detention place. Eventually she gave birth and the baby is still disappeared—now it must be a teenager—and the woman and her husband are still disappeared. There were about 400 children who were disappeared in the detention place, either born in captivity or taken with their parents. Some of them were adopted by the torturers, like in the case of this child. I was told by the guards that one of the torturers had already bought clothing for this child.

My best friends were taken out of that place one night and killed in a mock confrontation with the army. They were put in a house with leaflets and were shot and then the army was shooting from inside the house and outside the house and they called the press and recorded this as a confrontation. That was my best friend from college and her boyfriend and a couple more friends, sixteen or seventeen years old.

Like I said, we were among the few survivors. But that was a small camp. The biggest one was the School of Mechanics of the navy, where

about 7,000 people were disappeared and eventually killed. So after that time, I was still disappeared, but taken to another location for a couple of months with no blindfolds but just in a cell. And then I was a prisoner, acknowledged as a political prisoner, and spent two and half years in a jail for women political prisoners—without ever having a trial, never saw a lawyer. But the accusations were very clear; it was because of my participation. And then you had the right—they call it the Right of Option—it was the right to remain in jail or to be expelled from the country. So you had to apply for the option to be expelled from the country and I applied to go to Spain. They said no. They had the right to deny it without any explanation, just on the ground that you were a danger to the national security. And so they denied it first, but then I applied to come to the United States. It was time of the Carter administration and the Carter administration had a strong policy on human rights in Argentina, so they gave us visas. My husband came first and a couple months after that I came. At the time I applied, the Organization of American States had visited Argentina on a monitoring mission, so it was good timing and they released some people at that time. So in that sense I was very, very lucky. Also, if some of us survived it was because there was a movement in the country that called international attention to the situation in Argentina. Especially the mothers, the mothers of the disappeared at the Plaza de Mayo—those women with their white scarves who marched across the street from the government house. They were the most visible, the most outstanding part of this protest.

Like I said, I came here. My daughter—we were reunited at the airport. My daughter had come—my big daughter who was four and a half by then—had come to visit us in jail. I was in a jail in the north, 400 miles from my hometown. My husband was 400 miles south. So she had to travel to visit us. With me, she couldn't touch me, there was a glass between and a speaker to speak through. So when we got together at the airport I could finally embrace her. I had some time with her and my family there. And then I was put on the plane and I had to come straight to the States. I couldn't get off. My parents got me the visa and brought the tickets, they made the suitcases and they shipped them. The U.S. consul came with me and walked me to the plane. I was taken to the airport by the military. I was under their custody. I was on a commercial flight—technically a prisoner until the plane arrived in the States. I couldn't get off. I could get out in the transit lounge in Brazil, but I couldn't go out because all my papers were in the hands of the captain; he had my documents. They gave me my passport and they gave all the visa papers to the captain, who forgot to give them to the immigration authorities in Miami! So in Miami I was questioned for hours at the airport and I kept saying I had a parole—I had

my passport with a parole visa stamp, but it was a very peculiar visa and not everybody knew it. There was a parole program called the Hemispheric 500, it was for about five hundred visas. So what happened was I was with my little girl and they interrogated me. I didn't know that I had a right to have an attorney, but the thing was that I kept saying—they said where are you coming from? I said I was in jail. They said were you active in politics? I kept denying it because I thought if I say yes, I would be sent back. So that's why, after I got together with my friends, because I wasn't allowed to call anyone or anything, I realized that, of course, how could I be a refugee if I wasn't active in politics? So they thought I was a criminal. I was saying that I was in jail but I didn't know why and the captain hadn't given them the whole envelope with the information. So after three or four hours, they made me lose my plane, my connection to Seattle.

You know, I'm working in a program going to the schools and working with newcomer kids to try to make them write testimonials. So I was reading the stories of the Vietnamese kids and the boat people and those who walked through Mexico, and this is just a little joke, the story of what happened to me. If you put it in perspective, it's just—you know, it's ironic. But I had—for a while, everything was almost paradise compared to the concentration camp. Even jail, for a while, wasn't that bad because I had been in the camp. For a while! It doesn't work for your whole life. It does give you a certain perspective. So I managed, and I managed because I had the child and I had to get there and people were waiting for me. I had a certain knowledge of English that let me move around. They finally gave me what they called a temporary visa and I had to go to immigration in Seattle. So I sent for my papers again and I got copies from the consulate.

I guess I thought I didn't suffer any permanent physical damage. They just broke my teeth. But some things you just don't know. See, last year, well in 1990, by the end, December of 1990, they amnestied the military and by that time they found a cancer, a tumor, malignant, small, very small, and they removed it. Then they did another cystoscopy and found another one. So I am under control for that. It's a bladder thing—very rare, very, very rare for women. They just found it by coincidence. I didn't have any symptoms or anything. I know there is an incidence of cancer higher in people who suffer persecution, political persecution. There are studies in Europe with former prisoners and the incidence is higher than normal. But it's so hard to grasp and to figure if you could or not have developed it then. I just choose to—I mean, for me it was like the last straw and again a reminder of the precariousness of life. For many years after I was released, I was here, I didn't know the next day what I was going to do. And this is a place where you plan your future for life. Ten years, twelve years—I

mean, your whole life you plan. You have a mortgage for thirty years on a home! So they would call me and ask me to give a lecture a year from now and I always said no, I'm going to be in Argentina. Somebody advised me, just say yes, you can always cancel. But it was very hard for me to plan. Everything was very precarious. And then this cancer was another reminder, although it's minor. I don't need to use it as a way of denouncing what happened. But I see it somehow as a metaphor for how the body reacts to such things. Although you think you mentally control the system, there may be damage you cannot even evaluate.

Of course a lot of rape and sexual harassment went on. For us, for me, it was a lot of molestation and sexual harrassment. Most of us were raped. But you know, they did other little things—the issue of the kids was one. They were torturing us with the situation of the kids. They kept telling me that I was not going to see my daughter. And in jail—the situation was not as bad, as I said—but they—for instance, men had what they called "contact visits." They could touch the kids, and we had a glass in between. The women's prison was the first one that had the glass. Men could send drawings to their children, but women couldn't although we did do it at Christmas. For us, they said they were escape plots. For men, they could send them. But they could beat up men in jail, suffer physically more. They were tortured in jail in ways we were not. I mean, we were tortured psychologically. Of course, we were starved, but not beaten up. When we were disappeared, we were at the mercy of the military. They didn't have to account for us. When we were in jail, they had international organizations checking. The Red Cross would come and visit. Occasionally the OAS, the Organization of American States, would be there too. So we called the women's jail the display window because somehow it looked better. But they had ways of torturing us, especially with the children. Our letters, when there was some hint that the family was coming to visit, they would find ways of punishing us and sending us to isolation and cutting visitation rights—that type of thing they did a lot. They would make the children and the families stand for hours outside waiting in line, not giving them water. They would search the kids, although we could not touch them. They could strip the parents and search the kids. We couldn't even touch them. It was humiliation and a way of making us feel bad in the hopes that we would tell our parents don't visit us anymore. Many of the parents decided that, because they couldn't bear to see their children and grandchildren suffer that way and they had not the ability to judge the importance for kids of seeing their parents, whatever the conditions were. They couldn't judge, but they had to answer all those questions from the kids when they returned home, so it was easier to just leave the matter aside and not have

125

the kids see the parent. It was very tough on our parents. My parents are still alive in Argentina. My brother committed suicide. My brother was twenty-five when he killed himself. I was still in exile when he killed himself, I couldn't go back. He was not in prison. When we were arrested, by that time, it triggered in him mental problems, and eventually. . . .

I was expelled to the United States, which was very ironic because for us the United States was one of the orchestrators of the coup that was the cause of so much suffering for all of us. In the case of Argentina, it was not as obvious as in Chile, because it was not the government, it was not the CIA, and in fact, the government was putting pressure on the Argentina government to release us—that was Carter. But the long-time policies of intervention in third world countries and this type of thing, and also the corporations based in the States and their economic interests, were reasons why we had the coup, and the coup was supported by these corporations. It's a long story, but I must say that I would never have chosen the United States as a place to come, not even as a tourist. I was not interested. But it was very good, and as a matter of fact, after I could return [to Argentina], I stayed here and I'm not bitter. I'm really learning every day something, and especially what I learned was that people can be very diverse. You shouldn't pass judgment on the whole population on the basis of the foreign policy of a country, although you can blame a large sector of the population for supporting it. There were many, many people who helped us when we came and helped us understand what the country was about, although they didn't always understand themselves and were struggling with it. The best people in this country struggle to understand what's wrong with it and that's true of a lot of societies.

Anyway, I came to Seattle, Washington, because there was a refugee program there that was supported by churches. There was no refugee program with help from the government for us; it was just private initiative. It was mostly the communities around the churches that helped us. They had done that in Seattle with refugees from Chile. So I came and was greeted by the press—the main newspapers—because ours was the first family reunited. And it was Christmas, it was a Christmas story for a lot of the papers and one of the most shocking things was my little daughter had picked up an American flag—those little American flags they put on top of hamburgers, you know—so she had picked it up somewhere and I didn't even notice that she had got it. So when we arrived into Seattle—I didn't notice—we were meeting with her father after many years. So next day there is a huge picture in the paper of this little hand giving this little American flag to the hand of her father. So I found—that was my first encounter with the American press and it was fascinating because that was

not the symbol of what we had gone through basically. But after that, because I spoke English—I had studied English for ten years because my mom had forced me to. I hated the language and she forced me to from when I was seven until I was seventeen and then she couldn't force me anymore. But mom is always right and it helped me a lot. So I became the speaker for the solidarity group we had there. Although my English—and I'm still struggling with it—wasn't good at all, but I had at least a working knowledge of it. So then I started to contact the press. We had interviews with me and other people from the Argentine refugee community. Most of us had come from jails after suffering torture and awful treatment at the hands of the military. So we had stories that the press was interested in. And then it was the time, for a while, it was still the Carter administration—and after that, when Reagan came, nothing happened anymore. So the timing for my release was very, very good.

We were admitted as refugees under a strange program. We were given permanent working permits and I was very lucky in that sense. I tell this story not only because other people did not survive and because I did. Until very recently, until a year ago, I still had hopes that justice would be served in the cases of the Argentine military who were responsible for this massacre. There were several attempts to do it, but finally, a year ago, they were all amnestied, pardoned. So that is one of the reasons. Another is to inform people here how they can produce change—or at least hear about what the influence of the U.S. can be on other countries and also around the world. But a third big reason is as a way of contrasting the situation with Central American refugees who were not even accepted as refugees here. They had gone through situations as hard as mine or even worse, if you can compare. I still don't think you can compare levels of torture or levels of suffering, but those stories are very, very—there are no words to describe what they have done to us—so I see myself as a bridge for others who have stories to tell also. That's the reason why, after I wrote this book of stories about life in the concentration camp [see note, page 149], I edited an anthology of writings by women in Central and South America. My next project is—it's been there a long time—I'm trying to work on it, but you also have to eat. But it's a project with a friend of mine—testimonies by Salvadorean women immigrants—how their lives are here, because it's not only they were not allowed to tell what they had gone through and their fear, but they had to live in fear of being sent back to the hell they had escaped from. That was not my case, that was not my case. I was really a refugee in a society that could provide for me. I was not in a refugee camp. I was, in that sense, I was very, very lucky. But then with time, you come to reflect. When I put together the anthology of women in exile, of course,

I started to reflect more and more what exile meant. I still—there is not one definition. I still think that everyone adopts the definition that better fits the state of mind and the state of soul. Also, it's funny because I'm making connections with—I'm finding it interesting that I'm making connections with my grandparents. My grandparents—I'm thinking of them right now as refugees. I started to think that my grandparents arrived into Argentina as refugees because they were escaping from the pogroms. But I always saw them—because I met them many years afterwards—I saw them as immigrants and that's probably the way people perceive me now. And I don't say anymore I am a refugee. I have a green card and I don't even say I'm an exile because there is no longer a dictatorship in Argentina. But I'm certainly not a—I don't know from where I belong. I don't know. Some days I feel lucky that I came. Other days I feel anxious because I don't know what's my place. I don't know where I fit.

I can go back. I could since 1984 when we had elections. Since that time, I cease to call myself an exile. It wasn't easy. My daughter, by that time, didn't want to return and my husband didn't want to return either. My second husband; I divorced my first husband. We separated after arriving in Seattle. We had spent three years separated. We couldn't even communicate jail to jail. It was a very traumatic experience. We had gotten together at a very young age. We had married at a very young age. We didn't have the energy to put into a relationship when we got together. So we separated. When you are fighting you are together because of that. You have that joint strength and you lean on each other. Once you've been somehow defeated, you have to have the energy to build yourself and to help build the other. That we didn't have. We were very, very young to know where that energy comes from. My second husband is also a former prisoner and he was also in the refugee community. He was—is still—a friend of my first husband. A year after, we moved here from Seattle.

I have gone back to Argentina several times. I go to visit. I went to testify for the trials. There were two lawsuits. I was part of the two lawsuits. One big trial against the generals who were in charge of the country and the other one, the people who were running the Little School concentration camp. So—but again, there were different stages of the process and finally it ended up at a point in which all the guilty ones were pardoned. They are walking the streets.

But I still have some hope that in other countries—what happened is that when Argentina achieved democracy and the lawsuits started, the trials gave a lot of hope. I had a more realistic analysis. I knew that it was not going to get too far, but the international community was looking at Argentina as an example. And after Argentina failed—now for instance,

ARGENTINA (Alicia Partnoy)

Chile is saying, well, see, Argentina can't do it, the pressure the military put is too strong, so we should give up, we shouldn't try to go forward with our case. I'm afraid that's going to happen in other Latin American countries too.

13

EL SALVADOR

A small number of wealthy landowners known as the "fourteen families" long ruled El Salvador in conjunction with the military. Toward the end of the 1970s, traditional Salvadoran political and social relationships unravelled and the nation fragmented into armed camps. Radical leftist groups increased their appeal and strength as general social discontent grew; eventually guerrilla warfare broke out.

Murder and executions by rightist vigilante death squads and repression by the Salvadoran armed forces took a terrible toll as violence escalated. In 1980, moderate civilians joined reform-minded military officers in a junta leading a provisional government, and scheduled elections for 1982.

Leftist opposition did not stop then, however, and attacks against civilians rose, provoking even more violent right-wing reprisals. A tentative measure of peace returned to El Salvador with the 1992 formal accords ending that country's long civil war.

ROSA G., 1987

I came to the United States on March 3, 1987. I went from Tucson, Arizona, to New York on the fourth of April. I came here for a number of reasons; first, because of the war in El Salvador between the Salvadoran army and government and the guerrillas. I was afraid for my life. I had become a member of the *Comadres*, the Committee of Mothers. We are family members of people who have been captured and imprisoned or disappeared since 1978.

My husband was a worker, a member of the sugar workers union, working in El Salvador. The owner of the factory is one of the members of the fourteen powerful families of El Salvador—all the owners are. The conditions of the workers were inhuman, the salaries were miserable, so the workers began to complain in the factory. They were asking for the basic

130

things, they wanted their rights and the owners said it was illegal, what they did. They went on strike and the government made it illegal to strike.

That was the first time I'd seen a general work stoppage. I went to see him at the factory. I didn't know that it was dangerous to do that. The first day I was threatened. I was talking to my husband through the fence and a sergeant from the national police threatened me. I had no idea what was going on. My husband was inside the gates and I was on the outside. I didn't understand what the sergeant was talking about. The authorities were there with machetes. A lot more people came running around. I didn't know, so I just stood there with my arms crossed and didn't do anything. I was so shocked, I didn't run. The sergeant asked me what I was doing there. I said I was doing nothing. He shouted at me to get out. I was just standing, not doing anything. I started arguing with him, saying I wasn't in his army, I wasn't a soldier. He said to get out. I said I wasn't afraid because I've not done anything—I'm in the street, not in the factory. He knocked me down then. "Why did you do that?" I shouted at him. I'd never seen anything like that. I couldn't understand. But more police and then soldiers came.

I went away with my sister and I was so mad I didn't care if I did die. I went to the place most of the workers lived. The workers hadn't come home Monday or Tuesday and everyone wanted to hear what had happened. All the women were crying and shouting, who can we ask for help? They were asking me to help. I said, "Listen, everyone, listen." I said, "We can go to the trade union and they can help us. Who wants to go?" "Good," some of them said, "we'll go"—about thirty women. It took us forty minutes to walk there and we asked to see the secretary of the trade union. We told her what was going on, we talked to her, to the trade union people.

After a couple days it came out in the newspaper that the sugar workers' strike was illegal and they were put in prison. When I found out that they had been tortured for the twenty-two weeks that they were in prison, that's when I made my decision, in 1978, to join *Comadres*. I went to them and they were so nice. They asked what had happened to my husband, how could they help. I asked if I could become a member and work with them.

I went to meetings every Saturday—about forty fathers and mothers of the disappeared came. I was amazed. I had never before belonged to a political party, never, never voted. All I ever did was stay home and take care of the children and fix the meals for when my husband came home. I guess I couldn't see what was all around me all that time—people

131

suffering. All I did was go from school to home to market all those years—all I ever did.

When I realized the agonies of people, I was inspired to try to help. My husband was still in the prison and I didn't have any money. I could only earn a few *colones* to get food to eat. My family was not there. I went back and forth from my house to the meetings, getting a ride back and forth. It never occurred to me what could have happened to me. I did everything from my heart. I never thought of what could happen on the street, like being raped or anything; my mind was clean. When I would arrive in San Salvador, my *compañeras* would ask how I got there and when they found out that I hitchhiked, they were concerned and warned me. But I had to attend the meetings and had no way of borrowing any money. That's how I got to know the mothers and fathers and we began to figure out what we could do. We went to the president's house, the municipal building, legal agencies, asking about the disappeared and the answer was always, "No, we have a democracy here, no disappeared people; no human rights violations."

Then we started to ask how we could denounce this militant President Carlos Humberto Romero for human rights violations. We decided the only way was through the U.N. We would have to get a petition, something in writing to Geneva, so they would see what was going on in El Salvador. But it was difficult because all the embassies were guarded and you had to show documents—not like it is here, where you can walk in easily. We decided to go ahead and enter, and if they didn't let us, then we would sit out in front for two or three days. That's how about five mothers dressed up very well and told them they had come to ask about grants for studying. They were allowed in and spoke to the man in charge. He was very helpful at first. Then one of the mothers went to the door and stood in front of it and said, "Sir, you are talking to the Committee of Mothers of all the prisoners, disappeared and political victims, and we bring you our petition to take to the U.N." He said he couldn't do anything. They asked why not, if he was the representative of the U.N. They said, "If you don't help, we are going to occupy your office." The man was very scared. I was outside with another group. By the time we got near, the police were there and they didn't let us get any closer, but we were looking on. At about two P.M. he said he would help so that the petition would reach the U.N. that day. I didn't know if this was dangerous or not, I didn't think about it. We went on talking to the press, to churches and we even went on strike. I participated in a hunger strike for eight days, asking for the liberty of twenty-two prisoners.

More people joined because they were afraid of what was happening

in the fields, in the country. There was great solidarity and the mothers sought the help of lawyers to expose the case of the sugar union. I remained on the committee and became more active. I have seen mothers who have died of pain when they haven't found their loved ones.

My husband was released, but there are mothers who have never found their children. There is no greater pain than that of a mother who has lost her son after being taken out of her house. To this day I remain involved, looking for justice and the punishment of their murderers. Because of the war there are about seventy-five thousand killed, about eight thousand disappeared and large numbers of prisoners. Many people are afraid of being killed, and thousands of us have left the country. Living through a war is very difficult and because of our work, the government claims that we are communists or guerrillas—because we want justice for the people. Who is the justice system for? The government and the rich? We want liberty and justice for the poor.

The civil war has been going on since '32. That's how long our people have suffered, but no one said anything until the sixties. Who is part of the cause of all this suffering? The U.S. government—ever since Jimmy Carter sent arms to El Salvador and trained the military.

In my case, I feel that my life has changed completely. I now understand what unemployment is, and mass poverty, and we are not poor because we don't work.

I was captured for the first time during the government of Duarte. They told me that if I collaborated with them, they would help me with money, that they were my friends. They would put my family through their studies and give me the security we needed from the military. But I would have to denounce the Committee of Mothers and say that the government was the only way to achieve democracy. They wanted me to give them names. I told them that I didn't live in San Salvador [the capital], that I had come to visit an aunt, because they wanted my address. They would mention names and ask me if I knew them. But I wasn't sure if those names were real or used by the mothers to hide their identities. I only knew them by their first names, Maria, or Marta, etc. If you let them know your friends' names and addresses they come and get them. That's what had always happened in the past. I told them I didn't know them. They threaten you so much that sometimes it's easier to say yes to them. Maybe one gets to a situation where they start the tortures. And there was a time where I, with my head down, just said "yes." That's when they grabbed me very firmly and asked if I was going to talk now. I said yes, and they kept on hitting me. "We won't be your friends," somebody would say— that's when their strategies change. Another would come in and say,

"Don't hit her like that, she'll talk, you'll see." When they saw that I didn't know anything, after three days and three nights, they played recordings of children's voices and would say, "Here are your children. We will torture you in front of them" or "Do you want us to torture them in front of you?" They told me that because I didn't want to collaborate with them, that my children would despise me. I asked to be killed; they laughed. Then that day a man came and said they had the wrong woman—"She's not the one." They said, "You lucked out. Don't say anything about what happened here—if you do, we'll come back for you and your family. Say you were assaulted." They started beating me again with something—I couldn't see because I was blindfolded and my hands were tied. I pleaded with them to kill me. They left me in downtown San Salvador. I couldn't see at first after three days of not seeing anything. My hands were bleeding. I met a woman and she was scared when she saw me. I asked for help. She asked what had happened. I told her I had been assaulted and she gave me five *colones*. I didn't know whether to go home, to a hospital or to the office. I hailed a cab and asked him to take me to the office. He looked at me and asked what had happened. I told him too that I had been assaulted. I got to the office and just then, the mothers were coming to find me after three days of not going home and not coming to the meeting. I fell down and they called a medic—the kind we have in El Salvador who collaborate—and he stitched my wounds. The press came—the mothers had called them—and I told what had happened. Then on the twenty-eighth of May, everyone in the office was taken. Ten men arrived in a blue bus, no license plates. They blindfolded me and took me to the general headquarters and asked all the same questions as the first time. They took off all my clothes because they said I was a guerrilla and that I would have a mark here or there because they say that guerrillas crawl on the floor! Where my bra left a mark they said was the mark of holding a rifle. They gave me a tee-shirt and then started to hit me, against the walls, with my hands up against the wall. Five days and five nights, one interrogating and one hitting me.

Twelve days later I was transferred to a woman's prison, where I was for four months. Thanks to our solidarity, I gained my liberty September 23—letters written and visitors I had. Duarte finally said, "We have investigated her case and there is no evidence against her to keep her in prison. She's free."

That's how in '87 I left El Salvador, very afraid, and went to Mexico. It was very difficult, going from place to place with my children. Here [in the United States], my entry had always been declined. I had asked for a visa in '84, when we first received the Robert Kennedy Award for Human

Rights. The Department of State said "No, those women are dangerous to U.S. security." In '83 some churches invited me to Mexico—entry denied. And in '87 again, churches in Mexico invited me and my entry to the U.S. was denied again. The computers said that I was a terrorist.

So after being in Mexico for a while, I decided to enter the U.S. illegally with my two small children. In Mexico, we traveled by bus—a few days in different states—the churches helped the refugees to get through the day. Then we walked along the border with Mexico on the side of the desert, with our children. It was difficult. We arrived in Tucson March 3, where we had some friends I had met in El Salvador when they visited the office of the *Comadres*. They helped. Then I went to L.A., then to New York, where I asked for political asylum. I was told it was very dangerous to be here illegally with my two children, that I could be deported. Some lawyers in New York helped me and we presented the papers.

I still work here for the poor in El Salvador. Fourteen powerful families—but the majority of the people have nothing, no work, no medicines. If the government is receiving one and a half million dollars in help, they use it to destroy our country with bombs. It's the government which doesn't provide the basic opportunities for the people. We ask for work, not only food, but there is none.

ANGELICA R., 1985

When I decided to come here it was because of the troubles I had in El Salvador. I was detained for ten days by the military. They accused me of being a commander of the guerrillas. Not me! I didn't know anything about it. I knew that there were guerrillas, but things like this I simply didn't understand.

The Red Cross got me out after ten days. My little boy was only two months old then. I was desperate about that. I couldn't sleep. During the whole ten days I was detained, I only slept one night. I just about went crazy crying—I cried and cried. My little baby didn't take the bottle yet. I was so worried—how would he eat? I had this feeling that the government soldiers were going to kill my baby and nobody could get that idea out of my head. When I was in that state, I cut my veins open with my teeth, so that when I died I would be united with my little son. In my mind I thought that my spirit—that no one could detain my spirit. I didn't want my son to be a martyr.

Then, with the help of the Red Cross and human rights organizations,

135

I was set free. But I was very, very frightened. They left me at my mother's house and I felt like I was floating and drifting on air. Just that day a letter came from a niece of my mother in the United States, who said now she was able to help one of my mother's children. My mother wanted me to go to the United States so that they wouldn't continue to persecute me. But I felt so destroyed at that time—not being able to hold and love my two-month-old son—I just didn't have it in me to make the decision to go. I told my mother I was not going, I couldn't. I prayed to God, please, don't abandon my children. I suffered too much in prison; I suffered partly because we had sent my children to a rural part of El Salvador for safety, where I was supposed to go and join them.

After I got out, I went to the ranch in the country to join my children, and then about two months later there was a large military operation, and in this operation, they killed my husband. I felt like I would die. Even though he was not with us, he was far away, I always felt that he was protecting me from a distance. When he died, I felt so desolate. I don't know how to explain. It's something you can't imagine. I don't know how to explain how I felt. We stayed there in my town for a long time. I used to pay some workers to clear land for planting, but I couldn't find anyone to do this work then because the military had prohibited workers to come from the higher ground to come do this work. I couldn't find anyone to do it. In El Salvador you don't have another alternative—if you don't work, you don't eat. In the countryside you live with the help of God. It's not like in the city where you can go clean someone's house for money. There you just plant seeds and do the harvest. If you have your little animals, you have to maintain them and then you can have your eggs and chickens. But when that opportunity is closed off, you go crazy just about. I was filled with anxiety. I went to my mother and told her I didn't know what to do. I had six children then. What were my children going to live on? I told her I'm going to go [to the United States].

I went to see my mother-in-law to see if she would take care of my children. She didn't want to; she said no. So when my mother-in-law wouldn't take care of the children, I changed my mind and said, okay, I'm not going to go. I felt very sad, but I said whatever is God's will. Eight days later, my mother-in-law came back to me and she said, go ahead, I'll take care of the children. So with this trust, I came to the United States.

When I had just crossed the river, the Rio Grande, I was taken prisoner for one month by the INS [Immigration and Naturalization Service], the immigration people. They charged me three thousand dollars [bail posted because she had inadequate travel documents while she applied for asylum status]! I didn't have a single penny. So then my anxiety

was even greater because I didn't know anything. When I was prisoner, I would have visions. I would see airplanes and in my imagination the airplanes were flying. I would be very sick. Ever since I was taken prisoner in that place I get a pain in my chin and my neck—something that up to the present day, I still have. It goes away and then it comes back when I get emotional or get angry. And then I get fires in my mouth and that's the consequence of that time.

So then my sister in the U.S. borrowed money here to get me out of that jail. I got out but I still needed twenty dollars for my bus fare. So I stayed three more days without even any food to eat and finally borrowed some money. To this day I still owe that man twenty dollars because I lost my way and I don't know how to return the money to him. I forgot his name. I lost the paper that had his address, so I still—without wanting to—still owe that person twenty dollars.

Coming here, you can't imagine it's easy without even five dollars, without a place to live. My sister took me to a house run by the wife of an uncle of hers. An uncle [of mine] came out to change me to a different place and said that the woman there would help me get work. But when I went to her house, she never helped me find work. I spent one month without working at all.

I wrote to my brother every day and this uncle gave me money for stamps. Six months went by and I never got any letters back. I imagine my mail was being held by authorities in El Salvador. Some of the letters I wrote arrived, but letters back to me never got here. Six months later I found out my brother talked to my mother on the phone and said, "Is Angelica crazy? What's the matter, why does she keep asking the same questions?" Every single day I wrote the same questions because I never got an answer back. I became more desperate. I tried putting another name on the letter and when I used another name, then yes, the letters started coming.

Another aunt came to help me look for work. I went to work two days a week. They gave me a huge bunch of keys—I didn't do well at that job. I didn't return—I just couldn't deal with the keys.

But with three thousand dollars in debt, it's enough to make anyone crazy. When my aunt would leave the house, I just stayed there cooped up like a chicken. If I did go out, I stayed outside because my sister had the keys. For me, so I wouldn't just roam around outside all the time, I just stayed inside. I was very hungry.

Then my sister found me a job. I worked for three months there and I began to pay back the loan. But they kicked me out. I got another job at a big hotel. I worked six months there. I worked from eight in the morning

until two or three in the morning. I couldn't sleep, I felt like I was floating on air. But I kept my strength up, put all my strength into working there. There was a black woman who tried to help me. In the daytime I worked as a salad person and at night I worked as a temporary dishwasher.

Then there was some confusion. A young girl punched my card, the one who was supposed to be helping me. I came and punched it again, not realizing it had already been punched. I guess I didn't trust that it had already been punched, so I punched it again. The bosses thought I was trying to trick them. They thought I was trying to get double pay and they kicked me out of my job. From then on I just had part-time work. In another job I began to build up my savings to bring my children here. I spent a year and a half trying to pay off the three thousand dollar debt to my brother. He paid someone else, I never knew who he had borrowed from.

I kept struggling and then that same sister found another job, so I got a place there too. But by that time I was a little wiser. Usually, for better or for worse, because of my character, I always wind up in trouble. With God's help, though, I was able to work more than two years in that place. But there was a person there who had it in for me. They stole some good pieces of meat and the manager might have seen that. At that point I was about to have my second child here in the United States. When I returned to my work—they had told me I would have two months off—when I returned to work, they reacted indifferently. They told me I couldn't do what I was doing before, that they had changed my work. They sent me to do a job that I couldn't do, in the kitchen. Maybe because of my nervous condition, I can't stand to have a lot of heat or a lot of cold, so. . .

I had been trying to save my money and I put it in the Latin American Investment Bank [a Latin American-owned private savings institution without bank credentials or insurance which collapsed in a scandal] in order to bring my children from El Salvador. They didn't want to take my money at first because I didn't have a social security card then. I went for help to the father of my children here to help me put money in there. But I believe those people who owned the bank were actually from the government of El Salvador because they looked at me with this kind of look and once they even started talking about me behind my back. I really felt desperate then and I told my companion to go and get the money out. He said, okay, he'd go. He said he was going to take the money out, but he never did. Three months later they closed the bank. There all my sacrifices stayed. Once again, I was back to worrying how I was going to bring my children.

I went to work at Hardee's from eleven P.M. to eight A.M. I finally said,

EL SALVADOR (Angelica R.)

I can't stand it any longer. I'm going to take a risk and go and bring my children. I got a [false] travel document and I went to Guatemala. From Guatemala I managed to get through without identifying myself to the Salvadoran authorities. Then once I got there I had to look for who would help me to return. But because of bad luck or stupidity, my one little girl had to stay behind. Because of my nervous condition, I brought the wrong birth certificate—it was not right. When we were presenting the passports, my daughter failed to pass inspection because there was one name on her passport and a different one on the birth certificate. That's my big concern now—how to get my little girl here.

I'm thinking about risking myself again to bring her here as a wetback. It took them five years to give me my asylum status. Now on the one hand I feel a little more tranquil, a little better, kind of like a new person, but on the other hand, no. I applied for help from the government for a house and now they've given me a house [public housing] that's far away from the Hispanic section of town. Because of the housing I'm happy, but I don't like the neighborhood. There's only black people and it's a bad neighborhood. I had an orange tree I was keeping for five years, a beautiful orange tree. I had put it outside and they stole it.

That's my story.

14

LAOS

Laos, a former French protectorate and member of the French Union until 1953, was caught up in the Indochina Wars along with Cambodia and Vietnam. Coalition governments, formed after the 1954 Geneva accords for independence, struggled as their rightist, leftist and neutralist factions fought for control. In 1972, Lao communists publicly proclaimed their existence and launched an insurgent campaign. The struggle continued, however, until the April 1975 collapse of Saigon and Phnom Penh hastened the end of any coalition in Laos. In December 1975, the monarchy was abolished and the communist Lao People's Democratic Republic established. The new government arrested and imprisoned thousands from the previous government and military. It also sought to control dissidents, especially the Hmong tribespeople. These moves prompted a refugee exodus.

MAHASAY P., 1975

I am a working woman from Laos. I have been a student, worker, volunteer, mother, wife, writer, artist, teacher, professor and publisher. My last occupation in Laos was as Assistant Director of Social Services for Lao Public Health Service. I was president of the National Women's Association in Laos. I want you to know me not just from what I say, but from what I do and from my family and the people I work with. I worked thirty years in my country for women and children and the elderly.

I have been here in this country, in this land of America, since 1975. I had known this country from a long time before—thirty years ago I came to study in different states of America. I was sent by my government. But this time is not like the other time. This time I came as a refugee. I have been forced to leave—no choice—along with other persons from my country, my compatriots. We—I don't know—it's very difficult for me to

describe how we feel, how we hope, how we adjust ourselves. I had had to leave my country before as a refugee, because my small country has been the victim of many aggressors, many *coups d'état*, many changes in government. We fled to Cambodia once, to Thailand more than three times because of military *coups d'état* or changes of government. But the events of 1975 are what led us to so many directions in the world, as refugees to many parts of the world. It's difficult as wife, as mother, as citizen, as someone who loves his or her own land—the mountains, the rivers, the tombs of our forefathers, the trees, the dogs and cats. But as persons who understand, who accept the reality of the event, we come with hope and more courage. Yes, and all the time, in my heart, from a long time ago, even as a victim of the event, I have in my heart a hope that I can do something for the others—be useful to my compatriots, for my people Lao—to help them understand what is in front of them, how they can face it, how they can cope with what we have been through.

In 1975 we fled to Thailand. From the border of Thailand, we arrived in Bangkok and arranged to come to America. For myself, it was easy because I know American culture somewhat. Many times I worked in Laos with Americans who I love; we collaborated together as workers for humanity. The volunteers with the Peace Corps in Laos—we worked together.

But this time I feel different from the time I was here before. I have no home anymore. But we managed. And in 1976, I started working and being useful for my people who need to go to the supermarket, who need to talk on the telephone, to pay bills, to take the children to school. I started working for refugees at the career center. And then, you know, I felt I was not alone. I wasn't alone to suffer, to think that I am a victim. The whole of Indochina—Vietnam, Laos and Cambodia—we are in this together. We lost our countries the same month, the same period of time the new regimes came. So at the career center I met many Vietnamese, some of them sitting down and saying nothing. He or she thinks of the husband or wife they have lost at the airport because there was such confusion. One man wanted to jump from the sixth floor to kill himself because his six children died. And the Lao people, my people—one man came to me, "Auntie, my wife, she drowned in the Mekong River and one of my children, she was hanging on her neck and both of them died in front of me. I could do nothing in the current of the Mekong in flood season." I tried to help my Vietnamese neighbors who also came to the career center to study English. A lot of tragedy. That time was a time of killing in Cambodia. No Cambodian women arrived in America then [1976], only some men, rare ones, because the borders were sealed then.

So I survived by working hard, working hard, forgetting myself and letting myself go into the flow, the current of being useful, of thinking that others are like us, humans together, thinking of other lands in trouble.

I have four daughters and three sons. We sent our children to study abroad—to Australia, to the U.S.A., to Europe. So my husband and I had only four children with us on the day we went to Thailand. At the border we met many of our compatriots.

To come to America we first had to reach Thailand. The Mekong River is the border with our neighbor Thailand. It's not only the border, it is like a link of blood between the Thai and Lao, because we all are originally from Thailand, having moved from South China to that part. So we know each other, we all lived along the river. After crossing the river, we had to get to Bangkok. We stayed in Bangkok for three months, meeting many people, trying to get a permit to come to the U.S.A. Finally we were able to come.

I want you to know what I feel—being a part of that land we left. Being a mother, daughter, granddaughter, great-granddaughter of our ancestors—a wife, a person with many responsibilities and also a person who accepts and recognizes that we left our country, we left our land. This departure has no time limit and no hope of return.

From that time, the separation, the loss of what we used to do and used to be, is suffering. I feel like others who came—we own nothing and will have nothing as easily as we used to have it before. We should recognize that we can't have everything we want; we should accept that with patience and endurance. Still, we also watch how others feel toward us. Like when I have guests, relatives from Thailand, for example, we went to the Thai market. People who knew us from before, they looked at us like people who just came ashore from the Mekong River.

I have promised myself that I will always be useful to others, to try to be a comfort to others, to be good to others and to help our people as best I can. Sometimes my morale is very low, but I tell myself I must support someone else—I will talk to the woman who sits down there, waiting for her husband who will never come to her because he went a different way and got lost. She needs support and I will help her to think that this life is a series of separations. Not only us, but our neighbors in Vietnam, in Cambodia—they have the same destiny. I like to tell people to learn about others, not only about us Lao, not only about today, but about yesterday, last month, a hundred years ago. Many other peoples have had the same kinds of calamities—these unfortunate destinies.

If you were to ask me what I think about being a refugee, sometimes it's difficult and confusing. I try to accept life, to face life as a person who

is homeless with no future. But then again, the future is in front of us. The future belongs to us; you build it yourself today—it's not too late. Hope is always there as long as you breathe air, pure air away from your enemy. But not everyone thinks like me.

I have studied the history of other peoples, other lands, studied about revolutions in Europe, about war, about the first Americans to come to this land. You know, nothing is easy. We should be courageous and should make an example—like a wife to her husband or her children—we should make an example to other refugees, so they see that we are not so sad that we cannot eat, cannot sleep. That will affect them. We must try to make ourselves joyful and talk about good things, be smiling. Inside is something else. I tell my refugee friends sometimes when things are not going right, that's not your husband today, it's not him when he talks not very nicely to you. It's his worry. He used to be very good, but it's not him the day he was not very polite to you or acted badly—it's not him, it's the situation. If the husband or wife will not understand each other, the family will break down. I think that coming to America, or any other land, but especially coming to America—this country has a long history of national construction, of building a nation. It is not easy for us to learn who are the Americans. If we had arrived in America two hundred years go, we would not have had hospitals then, or roads or communications like today. But we arrive now in this land and we go to the supermarket, we go to the hospitals, we send our children to schools and we watch them study with success in high school, in the university. That's our happiness—it's the future of our children.

Even the old lands we call Vietnam, Cambodia and Laos—even the old lands back home, they change also. If we stayed behind, if we could not have come to America, we would not be the same anymore like when we lived there in what we remember as the happy time. When you become a young girl and you marry a husband—in the old time in Laos I'm talking about—your husband took you to his family home. You should go to the mother-in-law and it's not your home then. And then other people look down on you, the father-in-law, the mother-in-law, even the husband's young brother will be an authority in the family. Everything changes. I tell my Lao people, enjoy yourselves. I talk to the elderly who have many problems with grandchildren who go to school and do not speak the native language and don't want the food the grandmother cooks or the mother cooks, because they go to school and they eat American food. Misunderstanding can happen in our own families, not just with the new country. We should not think, oh, here I am in America and nobody understands us and we are not accepted—Americans think we're just Asians, like

Chinese. But do we accept each other well here? Even in the same family? If the granddaughter goes to high school, how does she look at the grandfather who stays home, sitting down in one corner and never looking at TV and cannot read the newspaper? There is no communication between them. The old man always tries to talk about the past, about his authority at home or the history of our country. But the granddaughter does not like to hear that. We have many things to adjust ourselves to, to arrange. We see that in this country, we can buy a house, we can buy a car. If we work hard and are honest, we can have money. We can send our children to school and our children can continue to be in this country, to be American citizens with dignity. Of course we never forget our origins, our background, just like many from Europe. But if you study, if you learn, if you educate yourself about many things, you can learn to adjust yourself here in this society. It's easier here than living in our own country now. Learning to live in this land, we have more advantages. Of course we lost much, but we gained many, many more things than we lost.

EPILOGUE

I mentioned in the Preface that all the women who have told me their stories are alive and well. They go about their new lives by turns nostalgic, puzzled, excited, angry or content. When I telephone or visit one or another of them, there is always some change to report. Those here longer, and those in Germany, whom I see less often, tend to report change that sounds like the kind of change they expect. Two of the older women are hampered now by age-related ailments which have affected their mobility, and one of the women has filed for the divorce she contemplated. Those here less time tell me about a new apartment, the purchase of a house, a new job, a child's acceptance to college.

Probably any group of women or men invited to tell their stories would talk about changes in roles and identities during their lifetimes and about periods marked by such changes. We expect change in our lives, but we expect it along lines that we have seen in the lives of people we know and that society has led us to anticipate. The change of refugee flight is never anticipated and the changes these women refugees talk about now in their new homes are less dramatic, intense and condensed than those they describe in their stories of flight and trauma; the changes have become changes in the familiar life course although they are embedded in a new context of the processes of adjustment, of putting down new roots, of redefining the many identities that make up the self. They are no less real for that. Length of time from the events of the flight makes a difference in the story told and the changes talked about.

When I first began to listen to women refugees' stories, I became aware that my listening somehow confirmed their experiences, their suffering, their survival. For some women, it was a chance to talk about things they had reflected on privately but not really told an American before then. For others it was a chance to tell an American how U.S. policy or action was partly responsible for their dilemma and that of their country—to educate an American politically. I often felt like a sounding board. For still

others it was simply a chance to describe something terrible that others did not want to hear about. One woman told me, "No American listens to our stories." For many of these women to survive what they did, they had to know when to be quiet. Having to remain silent, to keep secrets, can be a burden. Telling the story destroys the secret, breaks down the barrier of silence and gives back some sense of control in the situation. Another woman cried as she told me that her children think she is "making up the whole thing," so she doesn't talk about it anymore to them.

The jolt of fieldwork reminds anthropologists how much a part of our own families, societies, cultures, and our own complex of identities we are. I shared these women's assumptions that we had something in common as women; I knew and experienced many of their concerns, changing roles and responsibilities. I did not share the experience of being a refugee, however, and in that, they taught me.

They also taught me, and I hope others, that neither the political right nor the political left has a monopoly on repression and violence against people in the name of something that can sound very grand.

BIBLIOGRAPHICAL NOTES

A number of anthropological and historical works, including the U.S. State Department Background Notes, provided material for the background notes preceding each chapter and World Refugee Surveys (U.S. Committee for Refugees). Individual authors, as well as other works consulted for these notes, are cited below. There are many books and articles about refugees adjusting or failing to adjust to resettlement in the United States. Such works are generally not cited here. Here I suggest only a few of the generally available works in English which help explain how a particular refugee situation came about, as well as works in which memory about the lost homeland is significant.

Chapter 2: Cambodia For a sense of what the Khmer Rouge regime was like and the panic which sent Khmer and Chinese from Cambodia into flight, see Haing Ngor's 1987 *A Cambodian Odyssey* (New York: Macmillan); Molyda Szymusiak's 1986 *The Stones Cry Out: A Cambodian Childhood 1975–1980* (New York: Hill & Wang); Joan Criddle and Teeda Butt Mam's 1986 *To Destroy You Is No Loss* (Boston: Atlantic Monthly Press); Someth May's 1986 *Cambodian Witness* (New York: Random House) and Elizabeth Becker's 1986 *When the War Was Over* (New York: Simon & Schuster).

Chapter 3: Bosnia For differing historical and political views of the complexities involved in the Balkan situation, see Alex N. Dragnich's 1992 *Serbs and Croats* (New York: Harcourt Brace Jovanovich); Jim Seroka and Vukasin Pavlovic's 1992 *The Tragedy of Yugoslavia* (Armonk, N.Y.: M.E. Sharpe); Svetozar Vukmanovic's 1990 *Struggle for the Balkans* (London: Merlin Press) and Walter R. Roberts' 1973 *Tito, Mihailovich, and the Allies, 1941–1945* (New Brunswick, N.J.: Rutgers University Press). For more on the collapse of Yugoslavia and the causes of refugee flight, see particularly Misha Glenny's 1992 *The Fall of Yugoslavia* (London: Penguin); Leonard Cohen's 1993 *Broken Bonds: The Disintegration of Yugoslavia* (Boulder, Colo.: Westview Press) and Branka Magas' 1993 *The Destruction of Yugoslavia* (London: Verso).

Chapter 4: Ethiopia See Andargachew Tiruneh's 1993 *The Ethiopian Revolution, 1974–1987* (Cambridge, England: Cambridge University Press); Judy Mayotte's 1992 *Disposable People? The Plight of Refugees* (Maryknoll, N.Y.: Orbis Books); and UNICEF's *Statistical Profile for the Study of the Situation of Women & Children in Ethiopia* (Addis Ababa: UNICEF). For some idea of how famine in Ethiopia complicates situations producing refugees, see James Waller's 1990 *Fau: Portrait of an Ethiopian Famine* (Jefferson, N.C.: McFarland).

Chapter 5: Haiti For a more complete discussion of the "refugee" dilemma of Haitians, see Frederick Conway and Susan Buchman's 1985 article "Haitians" in *Refugees in the United States*, pp. 95–109, edited by David W. Haines (Westport, Conn.: Greenwood Press). Alex Stepick has also written about Haitian refugees in his 1986 book, *Haitian Refugees in the U.S.*, published by the Minority Rights Group, London. See also Jake C. Miller's 1984 *The Plight of Haitian Refugees* (New York: Praeger) and the report of a hearing before the Subcommittee on Immigration, Refugees and International Law of the United States Congress, on Haitian Detention & Interdiction, published by the U.S. Government Printing Office in 1989.

Chapter 6: Afghanistan For more information on Afghanistan in general and the background leading to the invasion of Afghanistan, see *Afghanistan; A Country Study*, edited by Richard F. Nyrop and Donald M. Seekins (1986 Foreign Area Studies—The American University; U.S. Government Printing Office, Washington, D.C.); *Afghanistan and the Soviet Union* by Henry S. Bradsher (Durham: Duke Press Policy Studies, 1983) and Anthony Arnold's *Afghanistan: The Soviet Invasion in Perspective* (Stanford, Calif.: Hoover Institution Press, 1985). For more information on Afghan refugees, see the several articles in *Afghanistan; The Great Game Revisited*, edited by Rosanne Klass (Boston: Freedom House, 1988).

Chapter 7: Germany Books on the general situation of refugees in Germany and Europe after World War II include Mark Wyman's 1989 *Europe's Displaced Persons, 1945–1951* (Philadelphia: Balch Institute Press) and Michael Marrus' 1985 *The Unwanted* (Oxford: Oxford University Press). Richard Breitman and Alan Kraut's 1987 *American Refugee Policy and European Jewry, 1933–1945* (Bloomington: Indiana University Press) discusses this complex situation.

For more about ethnic Germans fleeing former eastern Reich territories, see Alfred de Zayas' 1977 *Nemesis at Potsdam* (London: Routledge & Kegan Paul); Leo Schwarz's 1957 *Refugees in Germany Today* (New York: Twayne Publishers) and Hans von Lehndorff's 1963 *East Prussian Diary* (London: Oswald Wolff Publishers).

Chapter 8: Somalia Material on Somalia before the 1990 civil war is abundant; see for instance Harold D. Nelson's 1981 *Somalia; A Country Study* (Washington, D.C.: American University), Irving Kaplan's 1969 *Area Handbook for Somalia* (Washington, D.C.: Foreign Area Studies) and John Drysdale's 1964 *The Somali Dispute* (New York: Praeger). Material on current problems, including refugees, in Somalia is less abundant. See Ahmed I. Samatar's *Socialist Somalia: Rhetoric and Reality* (London: Zed Books); Samuel M. Makinda's 1993 *Seeking Peace from Chaos: Humanitarian Intervention in Somalia* (Boulder, Colo.: Lynne Rienner Publishers) and the 1991 MRG Report *Somalia: A Nation in Turmoil* (London: Minority Rights Group).

Chapter 9: Hungary See Sandor Kopacsi's 1987 *In the Name of the Working Class: The Inside Story of the Hungarian Revolution* (New York: Grove Press); and Alan Blackwood's 1987 *The Hungarian Uprising* (Vero Beach, Fla.: Rourke Enterprises). For another aspect, see the U.S. Senate Committee on the Judiciary reports *Emigration of Refugees and Escapees* (Washington, D.C.: U.S. Government Printing Office, 1958) and *Status of the Hungarian Refugee Program* (Washington, D.C.: U.S. Government Printing Office, 1959). The United Nations Department of Public Information in New York also published a report, *The Exodus from Hungary*, in 1957. Molly Schuchat's 1981 article "Hungarian-Americans in the Nation's Capital" in *Anthropological Quarterly* (54:2, pp. 89–93), discusses some adjustment problems.

BIBLIOGRAPHICAL NOTES

Chapter 10: Vietnam See Nguen Hung's "Vietnamese" in David Haines' 1985 edited volume *Refugees in the United States* (Westport, Conn.: Greenwood) and James Freeman's 1989 *Hearts of Sorrow: Vietnamese-American Lives* (Stanford, Calif.: Stanford University Press). Stanley Karnow's 1991 *Vietnam: A History* (New York: Viking) and Marilyn Young's 1991 *The Vietnam Wars, 1945–1990* (New York: HarperCollins) provide background for understanding U.S. response to those Vietnamese forced to flee their country. Two books which cover Vietnamese, Lao and Cambodian refugees are Joanna Scott's 1989 *Indochina's Refugees: Oral Histories from Laos, Cambodia and Vietnam* (Jefferson, N.C.: McFarland); and David Haine's 1989 *Refugees as Immigrants: Cambodians, Laotians and Vietnamese in America* (Totowa, N.J.: Rowman & Littlefield).

Chapter 11: Cuba For more information about Cuban refugees, see Robert L. Bach's 1985 paper "Cubans" in *Refugees in the United States*, pp. 77–93, edited by David W. Haines (Westport, Conn.: Greenwood Press) and Richard Fager et al., *Cubans in Exile: Disaffection and the Revolution* (Stanford, Calif.: Stanford University Press, 1968). See also Felix R. Masud-Pilato's 1988 book, *With Open Arms: Cuban Migration to the United States* (Totowa, N.J.: Rowman & Littlefield).

Chapter 12: Argentina Donald C. Hodges' 1988 *Argentina 1943–1987* (Albuquerque: University of New Mexico Press) provides some historical and political background to understand the 1976 military coup in Argentina. Alicia Partnoy's own book about her experiences, *The Little School: Tales of Disappearance and Survival in Argentina*, was published in 1986 (Pittsburgh: Cleis Press).

Chapter 13: El Salvador See the 1991 *El Salvador: Amnesty International's Continuing Concerns* (Washington, D.C.: Amnesty International USA); the 1991 Americas Watch work *El Salvador's Decade of Terror: Human Rights Since the Assassination of Archbishop Romero* (New Haven: Yale University Press) and Alastair White's 1987 *El Salvador* (San Salvador, El Salvador: UCA Editores). See also Margarita Melville's "Salvadoreans and Guatemalans" in David Haines' 1985 edited volume, *Refugees in the United States* (Westport, Conn.: Greenwood, pp. 167–80).

Chapter 14: Laos See John Van Esterik's 1985 article "Lao" in David Haines' 1985 edited volume, *Refugees in the United States* (Westport, Conn.: Greenwood, pp. 149–66); Ruth Krulfeld's 1992 "Cognitive Mapping & Ethnic Identity: The Changing Concepts of Community and Nationalism in the Laotian Diaspora" in *Selected Papers on Refugee Issues 1992*, edited by Pamela DeVoe (Washington, D.C.: American Anthropological Association).

INDEX

Academy of Sciences 93, 95
Addis Ababa, Ethiopia 52, 53, 54
adjustment 63, 145
adolescence 68; *see also* teenagers
Adriatic 41
Afghanistan 60, 63, 64
Afghans 61
Africa 52, 82
Aideed, Mohamed Farah 84
air raid 72, 73, 74
airport 89; JFK 86; National 86
Alabama 70
Allah 84, 85
ambassador 117, 118
Amerasian 99; program 107
America 43, 59, 70, 71, 93, 95, 105,
 140; arriving in 96, 97; go to 109,
 110, 112, 142, 143
Americans 9, 22, 72, 87, 109, 145,
 146; culture 88; cultural differ-
 ences 103; dream 88; first 143;
 G.I.s 100; in Vietnam 104;
 products 105; spouse 112, 116, 117;
 women 102; work environment 88;
 worked for 100
amnesty 124, 127
Amsterdam, Holland 75, 111
Angka Leu 23, 24
Annapolis, Maryland 100, 101
anthropologists 2, 3, 146
Argentina 3, 121, 126, 128, 129;
 government 126; military 127
Aristide, Jean Bertrand 57, 59
arrest 122
Asians 103, 143; Southeast 2
assassins 66

Asylanten 81
asylum 11, 14, 15, 56; political 57,
 135; refugee 10; status 136, 139
atheist 67
aunt 30, 33, 70, 82, 83, 85, 120,
 133, 137
Australia 142
Austria 93
authority 144

baby 58, 94, 95, 96, 135, 136; had a
 57, 93; no one wanted a 72; lost
 92
babysitter 70, 100
Bahía Blanca, Argentina 121
Balkan states 41
Bangkok, Thailand 111, 141, 142
Bardera, Somalia 83, 84, 85, 86, 87
Bataan, Philippines 22
Batista y Zaldivar, Fulgencio 114,
 119
Battambang, Cambodia 18, 20, 28,
 30, 31, 33, 34, 37, 38, 39
Bay of Pigs 114
Beijing, China 24
Beograd (Belgrad), Serbia 43, 48
Berlin 65, 66, 68, 75
birth certificate 139
black market 120
blackmail 68
boat people 124
Bolsheviks 53
border 19, 20, 21, 42, 43, 62, 65,
 89, 92; Austrian 93; Danish 75; il-
 legal crossing of 78, 92; interna-

English 70; in exile 127; Muslim 43; new roles for 5; raped 21; refugees 1, 2, 5, 6, 9, 12; safe 36, 37; separated from men 18, 37; unmarried 17; Vietnamese 4
work stoppage 131; *see also* strike
worker 131, 140, 141

World War I 41, 65
World War II 10, 41, 52, 65, 98, 99

Yugoslavia 41, 44

Zagreb, Croatia 42